EDGE

Vanguard Productions

Dedicated to Barron Storey,
Marshall Arisman, Dave McKean, Steranko, Neil Gaiman, Bill Sienkiewicz,
George Pratt, Greg Spalenka, Bill Koeb, Paul Theroux, Dean Motter, Bill Marks
and every single EDGE contributor over the past 10 years,
for choosing the exploration of creative freedom as a top priority.

The EDGE 10th anniversary book is published by
Vanguard Productions, 390 Campus Drive, Somerset, NJ 08873.
EDGE™ & © 1992 & 2003 by Vanguard Productions.
Tales From the EDGE™ & © 1992 & 2003 by Vanguard Productions.
McKean cover EDGE TPB ISBN1-887591-46-X • Steranko cover EDGE TPB ISBN1-887591-47-8
1st Printing December 2003. In Store release date February 2004.
Title page logo by Bill Sienkiewicz
creativemix.com/vanguard
Printed in Canada

table of contents

A Disturbance in the field Sir.

DSL

90

19

By early June of 1990, I'd been a professional illustrator and designer for 14 years. But a friend of mine, Ray-Mel Cornelius, was teaching a seminar at Brookhaven College, outside Dallas, with guest instructor Barron Storey. Though I'd seen Barron's work in the Society of Illustrators Annuals and on *Time* magazine covers, it was my studio-mate C.F. Payne who initially turned me on to Barron's work, around 1980. But the ultimate revelation came when we brought Barron in to talk to the Dallas Society of Illustrators around 1987, and for the first time, I saw his personal works. To this day, just thinking of that night releases some sort of natural opiate in my system! In 1990 I went back to school and got to spend many, daylong sessions studying under him. Amongst everything else, Barron described how he often put together magazines with his students, often called W.A.T.C.H.

As well as producing art, I've had an interest in publishing, which dates back to before I could read when I'd copy text from the *TV Guide* and sell it to my mother for a nickel. By fifth grade I was publishing a political paper and drawing comics and selling the original one-of-a-kind items for 15¢ (oh, I wish I had those). By 1990, I was tired of the boring advertising art I was producing and wanted to do either experimental art like Barron's or,

BARRON STOREY'S
WATCH
ANNUAL

DAVE McKEAN
GEORGE PRATT
BARRON STOREY
NEIL GAIMAN

EDGE!

ARISMAN · SPURLOCK · STOREY · WOOD

EDGE

IENKIEW
PALEN
PURLO
TORE

barron storey, j.david spurlock & marshall arisman @ society of illustrators for barron's 2001 award

return to my first love: comics. I talked to some of the top Texas artists (Don Ivan Punchatz, Jose' Cruz, Sean Earley...)about putting together a funky W.A.T.C.H.-like mag which I called **Vanguard Magazine**. Meanwhile, I produced a painting and printed the first issue's cover (seen top-left). The illustration was also used for that year's Dallas Society of Illustrators' Annual Show, Call For Entries.

The **Vanguard Magazine** never went further than the discussions and cover, but that was in effect **EDGE #0**! My childhood interest in comics never waned and after 15 years of less-than-revolutionary, mostly local illustration work, I still hungered to produce comics and work with artists that inspired me. In October of 1991 we opened the original Vanguard Studio on Carlisle Street in an affluent yet decadent section of Dallas. I became president of the DSI, and soon brought another revolutionary, visionary artist/illustrator to town: Marshall Arisman. Marshall and I spent a lot of time together. I told him of

my by then congealed concept to put together a magazine that juxtaposed the most experimental work of illustrators with weird comics including my own EC Comics-style homage sci-fi strip, the Space Cowboy. Marshall was supportive and came on board with 4 covers running between issues 1 and 5, plus a serialization of his long out of print book, **Frozen Images**! He also wrote a character named Spurlock into a murderous short story of his.

I was also in touch and consulting with comic-book revolutionary Jim Steranko from the formative stages in 1992 though his work didn't start appearing 'til Vanguard relocated to the New York area in '97 with the 10,000-copy-selling **Steranko: Graphic Prince of Darkness** special.

The experimental art magazine combined with weird comics anthology yielded the early motto "new-style weird stuff meets old-style weird stuff." EDGE (AKA **Tales from the EDGE**) also has the long running mission statement of: Building Bridges and Tearing Down Walls. Which relates to the celebration of the cre-

ative spirit wherever it may be: fine art, illustration, comics, and the cross-pollination there of.

Though we started about the same time as DC's Vertigo line, EDGE's art-for-art-sake mentality, and early shoestring budget likewise inspired comparisons to Caliber's late **Negative Burn**.

Along the way EDGE, and our related W.A.T.C.H. revival and EDGE card set enlisted the "World's Greatest Cutting Edge Artists." I thank them all! Yet, as time went on what people told me from the start proved true, that anthologies don't sell and Space Cowboy would be better in his own book. The best-selling issues have been specials on single artists like Steranko, Arisman, Boyette, Sienkiewicz... which inspired Vanguard's successful lines of art books and artist biographies.

This 10th anniversary book is a celebration that combines many of the classic EDGE contributors along with new talents for a helluva primordial mix! It's been a long strange trip, and whether you're an old EDGER or new, we trust you'll enjoy the ride.

paul lee, bill sienkiewicz, bill koeb, greg spalenka, j.david spurlock & george pratt @ the vanguard booth, san diego comicon, 1997

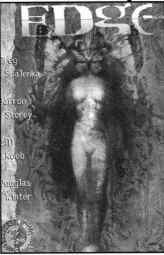

Vincent Diga III has been a professional broadcast designer for eight years and has worked for several video production companies providing concept design and illustration for broadcast, film, and video. These companies include NBC, CNBC, MSNBC, Astropolitan Pictures, Freestyle Collective, Manhattan Transfer, and Reality Check Studios.

He has received two National Emmy Awards in broadcast design as well as several international BDA Awards.

He and his wife currently reside in New Jersey.

DEVIL'S PLAYGROUND

STORY & ILLUSTRATIONS BY VINCENT DIGA III

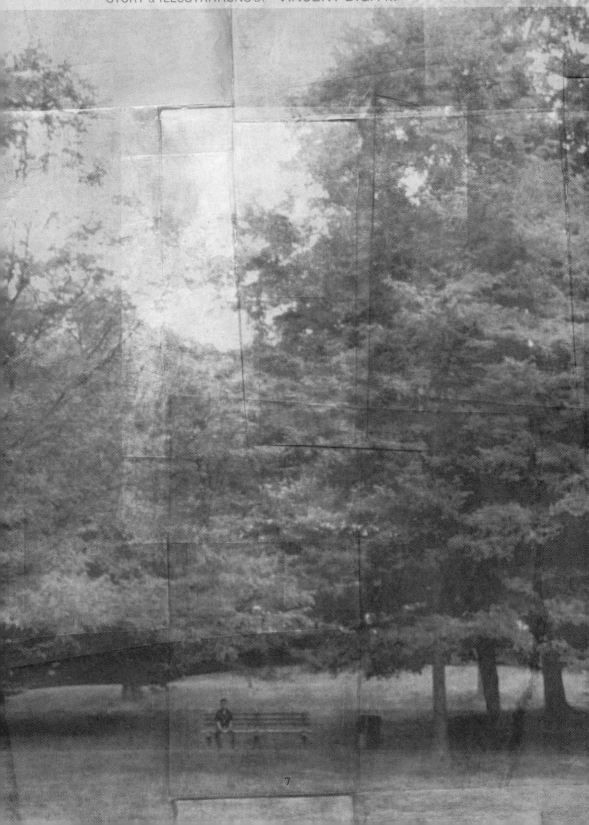

PAIN

LOCAL PARK
ANYTOWN, USA

"I'VE LOST IT ALL!"

"MY WIFE & KIDS...GONE!"

"MY JOB...GONE!"

"I HAVE NOTHING LEFT."
"ABSOLUTELY NOTHING!"
"MY HEART IS NO LONGER IN IT."
"I HAVE TO MAKE IT STOP!"
"I JUST WANT TO DISAPPEAR!"

"I NO LONGER WANT TO LIVE THIS LIFE!"
"I CAN'T FIGHT IT ANYMORE!"

"I HAVE TO LEAVE TONIGHT!"

"I'M BROKEN."

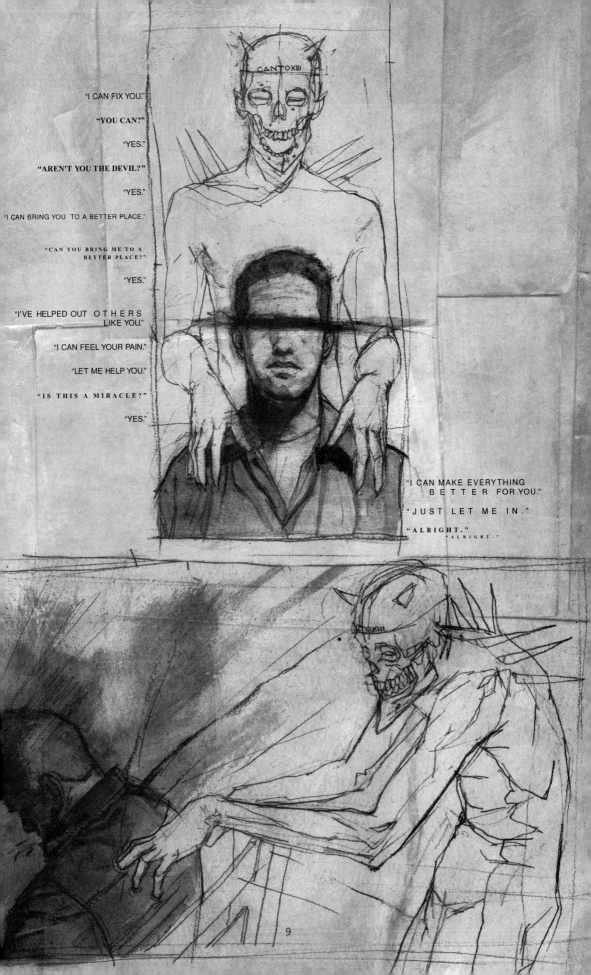

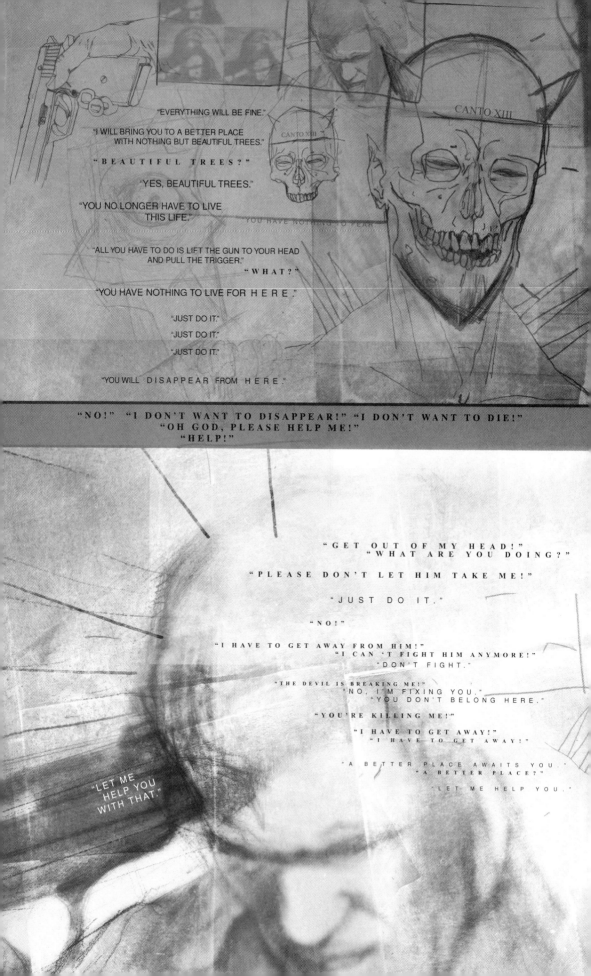

CLICK.

BANG!

"YOU'RE DEAD."

"ONE MORE FOR THE SEVENTH CIRCLE, SECOND RING."

"YOU WILL BE WITH THE BEAUTIFUL TREES."

"A MUCH BETTER PLACE."

LOCAL PARK
ANYTOWN, USA

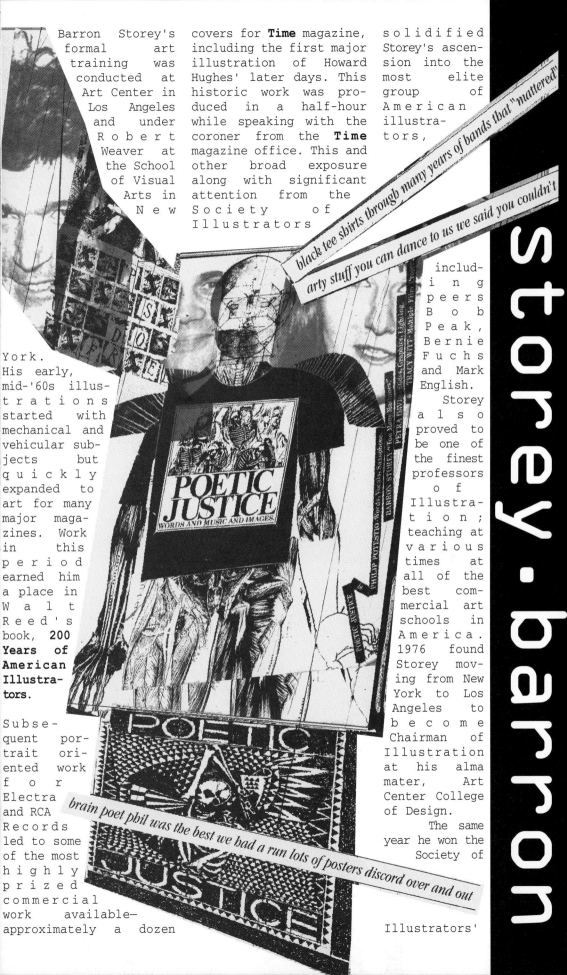

Barron Storey's formal art training was conducted at Art Center in Los Angeles and under Robert Weaver at the School of Visual Arts in New York. His early, mid-'60s illustrations started with mechanical and vehicular subjects but quickly expanded to art for many major magazines. Work in this period earned him a place in Walt Reed's book, **200 Years of American Illustrators.**

Subsequent portrait oriented work for Electra and RCA Records led to some of the most highly prized commercial work available— approximately a dozen

covers for **Time** magazine, including the first major illustration of Howard Hughes' later days. This historic work was produced in a half-hour while speaking with the coroner from the **Time** magazine office. This and other broad exposure along with significant attention from the Society of Illustrators solidified Storey's ascension into the most elite group of American illustrators, including peers Bob Peak, Bernie Fuchs and Mark English.

Storey also proved to be one of the finest professors of Illustration; teaching at various times at all of the best commercial art schools in America. 1976 found Storey moving from New York to Los Angeles to become Chairman of Illustration at his alma mater, Art Center College of Design.

The same year he won the Society of Illustrators'

black tee shirts through many years of bands that "mattered"

arty stuff you can dance to us we said you couldn't

brain poet phil was the best we had a run lots of posters discord over and out

storey • barron

Gold Medal for his portrait of Lotte Lenya. Storey returned to New York in '79 to paint, with top government security clearance, the first major portrayal of the space shuttle for NASA. This huge painting now hangs in Washington's Air and Space Museum and a print of the painting was featured regularly on the set of the popular television show, **Northern Exposure**. Many gallery shows followed as well as landmark work for **National Geographic**, Franklin Library and the record-breaking best-selling book cover to **Lord of the Flies**. Storey then embarked on the Herculean undertaking of a South American rainforest mural for the American Museum of Natural History.

During the early '80s, Storey continued his teaching at Pratt Institute and Syracuse University. Although the caliber of Storey's work placed him in an elite group, his personal drive was away from 'business as usual' and toward the Avant Garde.

He moved away from mainstream illustration and into experimental fine art. Additionally, a habit of keeping visual journals had opened a personal visual vocabulary different from both illustration and fine art.

By 1984 his versatile talent had led him to San Francisco: performing in concerts with his ensemble, composing music for theater and film, and writing and performing theatrical productions around the world. The late 80's and early 90's found many of Storey's students Kent Williams, George Pratt, John Van Fleet, and friends Bill Sienkiewicz, Jon J Muth and Dave McKean, making big names for themselves in the emerging graphic novel field. Recalling how they had been inspired by Storey's journals, some of these associates helped in securing Storey a contract with Tundra publishing. The Tundra published **The Marat/Sade Journals** appeared in 1993 as a limited edition leatherette-bound hardback.

This was the first opportunity many of the artist's fans had to see his personal, non-commercial art which went on to be nominated for a Harvey Award as Best Graphic Album. Since then, his students, including Scott McCloud, Dan Clowes, Peter Kuper and Dan Brereton continue to rise to the top.

Storey feverishly follows his unique muse both in and out of the worlds of fine art, illustration and education. He returned to New York City May 18th, 2001 to accept the **Educator of the Year Award** from the Society of Illustrators.

His sequential art tends to be intensely autobiographical and has appeared in **Heavy Metal**, various DC/Vertigo publications, Vanguard's **W.A.T.C.H.** magazine revivals, the **EDGE** card set and every one of the first 10 issues of **EDGE** as well as this volume!

FOR
JOHN, who was so RIGHT.

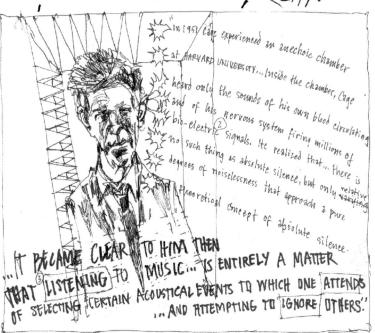

In 1951, Cage experienced an anechoic chamber at HARVARD UNIVERSITY... Inside the chamber, Cage heard only the sounds of his own blood circulating and of his nervous system firing millions of bio-electric signals. He realized that... there is no such thing as absolute silence, but only relative degrees of noiselessness that approach a pure theoretical concept of absolute silence.

"...IT BECAME CLEAR TO HIM THEN THAT LISTENING TO MUSIC... IS ENTIRELY A MATTER OF SELECTING CERTAIN ACOUSTICAL EVENTS TO WHICH ONE ATTENDS ...AND ATTEMPTING TO IGNORE OTHERS."

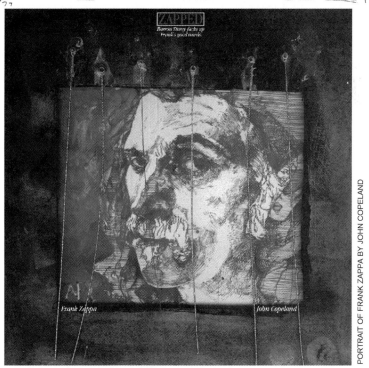

ZAPPED
Barron Storey fucks up Frank's good works.

Frank Zappa John Copeland

PORTRAIT OF FRANK ZAPPA BY JOHN COPELAND

and FRANK,
who is so missed.

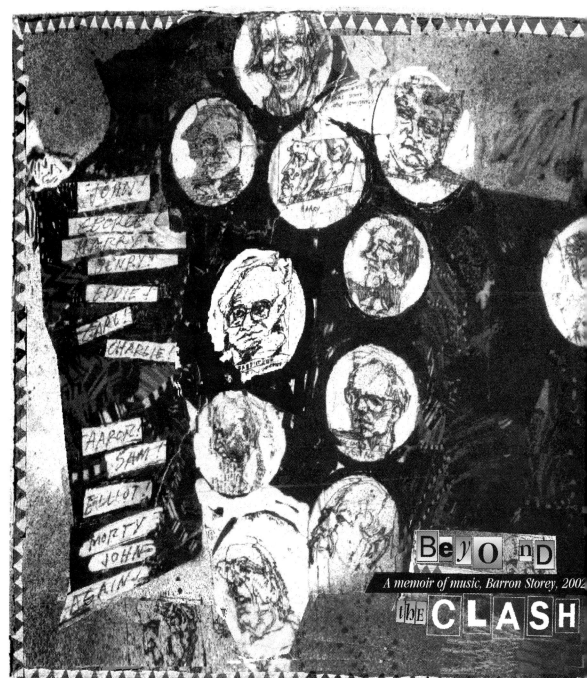

Be y O n D

A memoir of music, Barron Storey, 2002

the **CLASH**

so big city part one part two in
some ways oscillators humming coming
the old Martin gone broken
plugged in new guitar phasing

how i got the

part one was about my ey
seeing was identity and incon
but i also hear thin

to

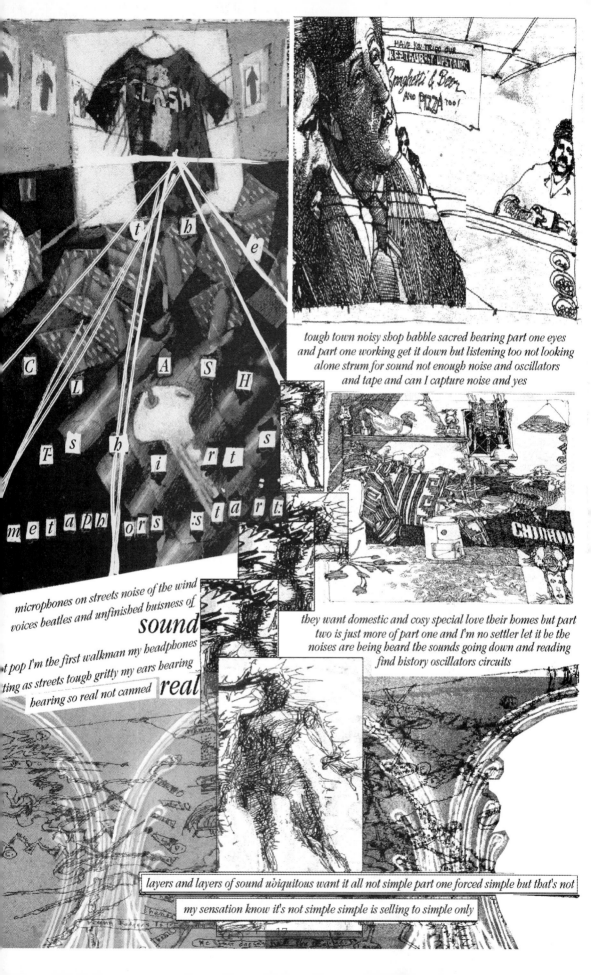

the

CLASH

T shirt

metaphors start.

tough town noisy shop babble sacred hearing part one eyes
and part one working get it down but listening too not looking
alone strum for sound not enough noise and oscillators
and tape and can I capture noise and yes

microphones on streets noise of the wind
voices beatles and unfinished buisness of
sound

t pop I'm the first walkman my headphones
ting as streets tough gritty my ears hearing
hearing so real not canned real

they want domestic and cosy special love their homes but part
two is just more of part one and I'm no settler let it be the
noises are being heard the sounds going down and reading
find history oscillators circuits

layers and layers of sound ubiquitous want it all not simple part one forced simple but that's not

my sensation know it's not simple simple is selling to simple only

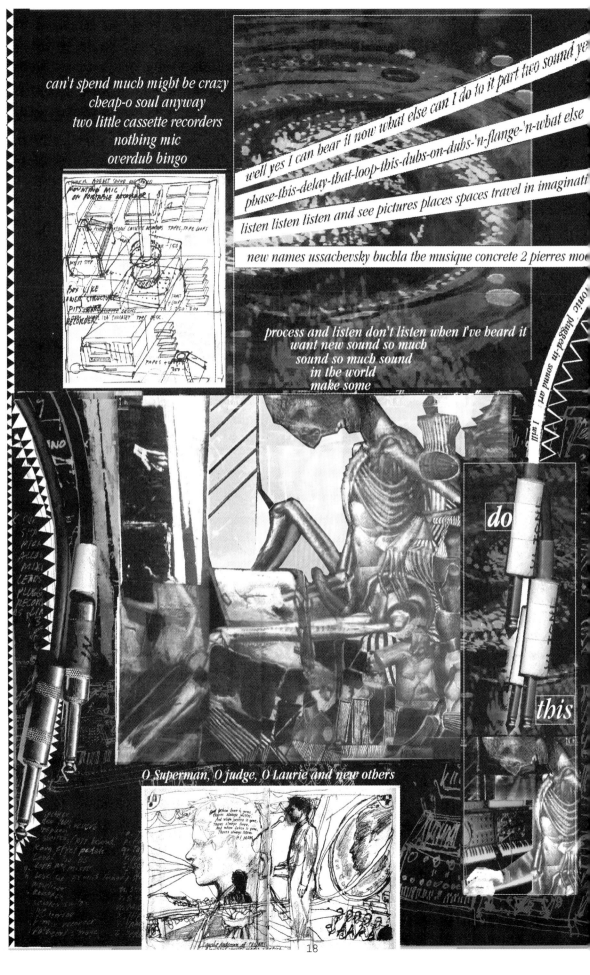

can't spend much might be crazy
cheap-o soul anyway
two little cassette recorders
nothing mic
overdub bingo

well yes I can hear it now what else can I do to it part two sound ye

phase-this-delay-that-loop-this-dubs-on-dubs-'n-flange-'n-what else

listen listen listen and see pictures places spaces travel in imaginati

new names ussachevsky buchla the musique concrete 2 pierres moe

process and listen don't listen when I've heard it
want new sound so much
sound so much sound
in the world
make some

do

this

O Superman, O judge, O Laurie and new others

18

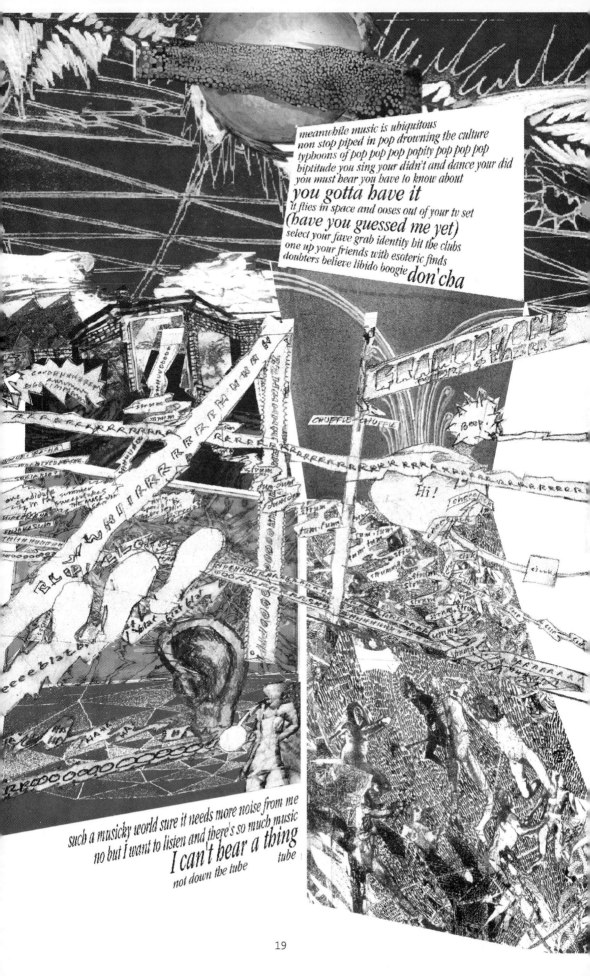

meanwhile music is ubiquitous
non stop piped in pop drowning the culture
typhoons of pop pop pop popity pop pop pop
biptitude you sing your didn't and dance your did
you must hear you have to know about
you gotta have it
it flies in space and ooses out of your tv set
(have you guessed me yet)
select your fave grab identity hit the clubs
one up your friends with esoteric finds
doubters believe libido boogie *don'cha*

such a musicky world sure it needs more noise from me
no but I want to listen and there's so much music
I can't hear a thing tube
not down the tube

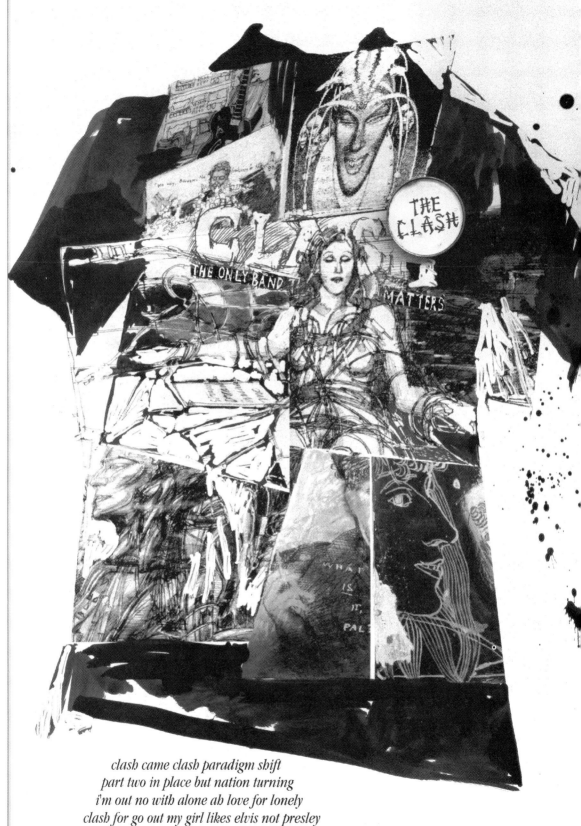

clash came clash paradigm shift
part two in place but nation turning
i'm out no with alone ah love for lonely
clash for go out my girl likes elvis not presley
i'm too old for punk but clash and angry
get into it paint the shirts clash shirts lots of them
woman time
here wear this it's a clash shirt it's black

A Bunch of Stuff that Piled Up in San Francisco.

alone again part two dot two record old and play solo instruments professional now

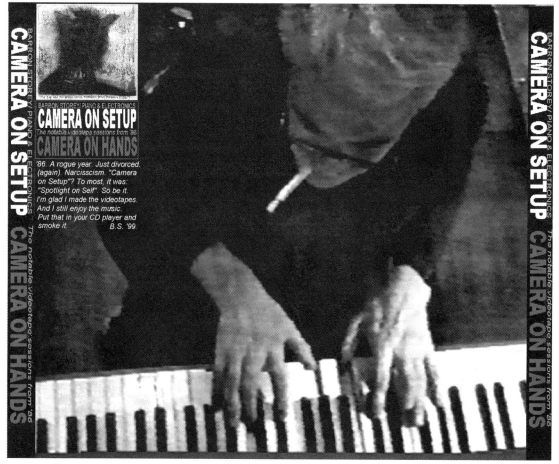

BARRON STOREY: PIANO & ELECTRONICS
CAMERA ON SETUP
The notable videotape sessions from '86
CAMERA ON HANDS

'86. A rogue year. Just divorced.
(again). Narcisscism. "Camera
on Setup"? To most, it was:
"Spotlight on Self". So be it.
I'm glad I made the videotapes.
And I still enjoy the music.
Put that in your CD player and
smoke it. B.S. '99.

the recordings tell my greatest gig osseus labyrint

A: FOLCRUM

and then the tours
go to prague and china
with mark and hannah
and todd and nao and
mark s. thrilling

THE NUDES

NERVWRACKING NUDE NOIZ

The Memorial, The Music

m & h make big time los angeles saw them with tool climbing the walls like always

what did i expect?

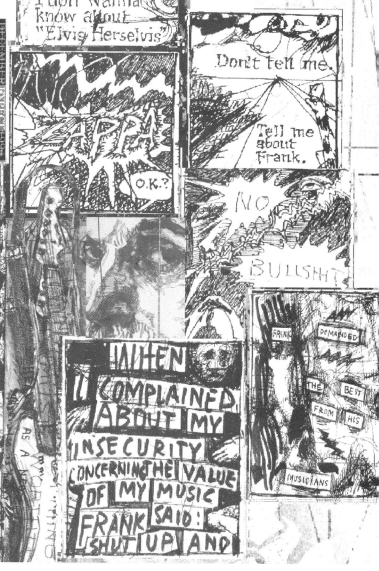

what's this part three solitude gigless
a jillion sounds on recordings listen alone
assassinada splits theater for a while
instruments all over the place

john cage dies frank dies

oh God frank dies

the reasons for it all
part two was you two
i'm sitting here with too many machines

and death

talk to frank a lot
tells me to keep going

try his instument

return to min

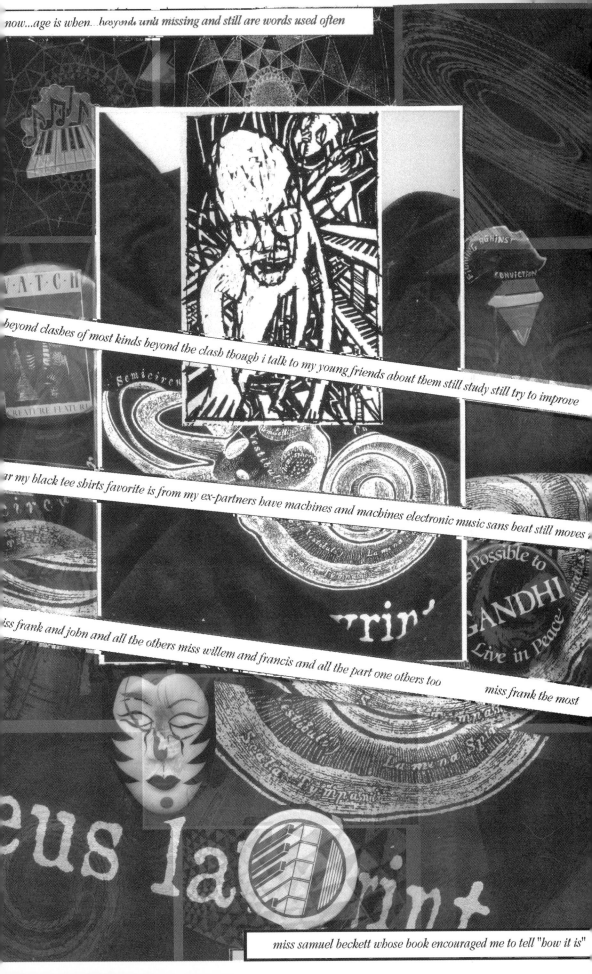

now...age is when... beyond until missing and still are words used often

beyond clashes of most kinds beyond the clash though i talk to my young friends about them still study still try to improve

or my black tee shirts favorite is from my ex-partners have machines and machines electronic music sans beat still moves

iss frank and john and all the others miss willem and francis and all the part one others too

miss frank the most

miss samuel beckett whose book encouraged me to tell "how it is"

1. DEBUSSY: Estampes No. 2 (La Soirée dau...
2. RICHARD STRAUSS: Salome (Scene 1)
3. SCRIABIN: Prelude Op. 35. No. 3 (etc.)
4. SCHOENBERG: Five Orchestral Pieces, Op. 16
5. IVES: General William Booth Enters...

1926–1950

26. BARTOK: Quartet No. 4 (?
27. WALTON: Viola Concerto
28. WEILL: Mahagonny (19
29. STRAVINSKY: Symphony
30. VILLA-LOBOS: Bachiana
31. CRAWFORD SEEGAR: Stri
32. RAVEL: Piano Concerto to
33. WEBERN: Concerto, Op.
34. THOMSON: Four Saints
35. GERSHWIN: Porgy and
36. BERG: Violin Concert
37. SCHOENBERG: Quartet
38. MCPHEE: Tabuh-Tabu...
Carmina Bura
phony N.
Sympho
Alexander
Construc
Quattet for
oncerto f
On the
Serenade
Appal
Symphon
Knoxville
VINSKY: The Rake
TER: Quartet No.
GE: 4'33" (1952)
ULEZ: Le Marteu
TTEN: The Turn of
CKHAUSEN: Ges
AVINSKY: Agon (1
PELAND: Piano Fan
ZE: Kammermu
STAKOVICH: Quat
DERECKI: Threnody
lan C (1964)

Taken Feb. 22. 1941
10 month old —

HARRY PARTCH 1901-197

HENRY COWELL 1897-1965

ELLIOTT CARTER b.1908
ELLIOT

AARON COPLAND 1900-1990
AARON

EDGARD VARESE 1885-1965
EDDIE

SAMUEL BARBER 1910-1981

CHARLES IVES 1874-1954
CHARLES

STRA
WEBERN
VARE

MILTON BABBITT b.1916

of Spring
o. 3 No. / String Quartet
estral Song Op. 4 (A...
Toualis.
Diary
ces
ELAND) Rodeo
r On Which to Dwell
rimes
Simple Variations
tasies No. 2
enspiel
he Four Moons, No. 1
renody for the Victims of
ii Icones
pieces of Wood.

JOHN CAGE 1912-1992

26

Last bit about JOHN—

ee "Nowhere is the Western cult of the individual more obvious than in European classical music... Beethoven⑤ in particular fostered this attitude, and individual expression at any price was the cornerstone of the whole Romantic movement of the 19th century.

THE ATTITUDE IS VERY 99 DIFFICULT FOR WESTERN MUSICIANS TO DISCARD, MAKING THEM FEEL ALIEN AND UNCOMFORTABLE (UNLESS THEY HAVE A STRONG CHAMBER MUSIC BACKGROUND)

...TENDS TO TURN CAGE ENSEMBLE WORKS INTO HORRENDOUS CACAPHONY."

WHY? BECAUSE WESTERN MUSICIANS DON'T (LISTEN) TO EACH OTHER VERY SENSITIVELY.

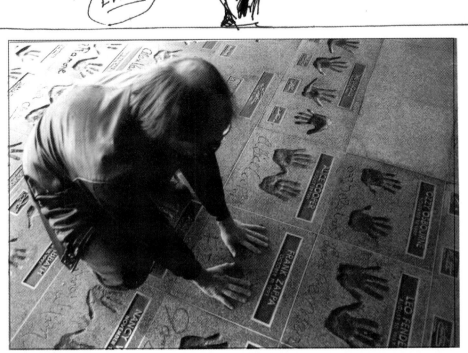

and FRANK 27 Barron Storey 02

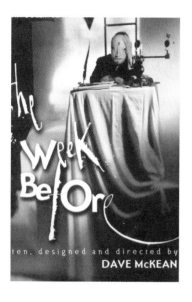

the
Week
Before

ten, designed and directed by
DAVE McKEAN

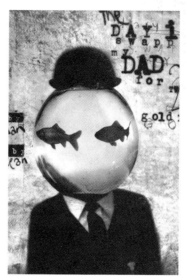

The
DAY i
swapp
my DAD for
two
gold

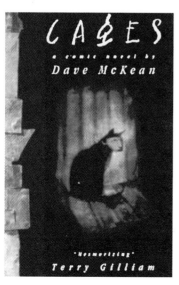

CA$ES
a comic novel by
Dave McKean

"Mesmerizing"
Terry Gilliam

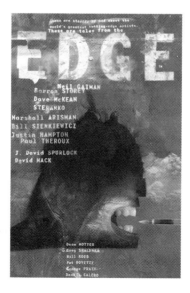

These are stories of and about the
world's greatest cutting-edge artists.
These are tales from the

E·D·G·E

Neil GAIMAN
Barron STOREY
Dave McKEAN
STERANKO
Marshall ARISMAN
Bill SIENKIEWICZ
Justin HAMPTON
Paul THEROUX

J. David SPURLOCK
David MACK

Dean MOTTER
C.Greg SEALENER
Bill XOED
Pat BOYETTE
George FRAZY
Dennis L. CALERO

Barron Storey is a genius...a true
visionary. The mind behind the eye.
NEIL GAIMAN

Dave McKean at a Vanguard appearance, San Diego 1996

No one better defines *cutting-edge artist* than Dave McKean. His work, whether in illustration, galleries, comics, music or film, consistently raises the bar—often to a level previously unachieved. Born 1963 in England. Attended Berkshire College of Art, 1982–86. His award winning graphic novels include **Arkham Asylum** with author/playwrite Grant Morrison, **Signal to Noise** and **Mr. Punch** with Neil Gaiman. He has written as well as illustrated two books, **Cages** and **Pictures That Tick** and has created hundreds of comic-book cover illustrations including the entire 75-issue run of the groundbreaking **Sandman** series for DC/Vertigo.

McKean has also created advertising images for Nike, Kodak, Mini, Eurostar, Smirnoff and the U.K. Government's social work scheme, and over 150 CD packages for Toad the Wet Sprocket, Michael Nyman, Tori Amos, Counting Crows, Bill Laswell, Frontline Assembly, Bill Bruford, and Alice Cooper among others.

He has worked on a variety of book and film projects with John Cale, The Rolling Stones, Milcho Manchevski, Steven King, Lars Von Trier and Ian Sinclair.

As well as directing and designing films, illustrating children's books, and running the jazz record label Feral, McKean and Gaiman have recently contracted with Jim Henson Pictures to produce the new film, **Mirrormask**.

McKean's **EDGE** contributions include cover collaborations with Barron Storey on the '95-96 **WATCH** Annual and subsequent signed, artist-proof print, as well as interior art and an interview in that issue; an introduction to Arisman's **Sacred Monkey Man EDGE Special**; and cover, art and article for this **EDGE** anniversary book.

mckean.dave

HOURGLASS
PRESENTS
A FILM BY
DAVE MCKEAN
EAMONN COLLINGE
EILLEEN DALY
NARRATED BY JOHN CALE

n[e○n]

DIRECTOR OF PHOTOGRAPHY
ANTONY SHEARN
MUSIC BY THE RACHELS,
DAVE MCKEAN AND IAIN BALLAMY
EDITING AND PROGRAMMING
MAX MCMULLIN
PRODUCED BY
SIMON MOORHEAD
WRITTEN, DESIGNED AND
DIRECTED BY
DAVE MCKEAN

Questions: Edge
Answers: Dave McKean

Q: *Why did you set the film in Venice?*
A: I used to go to the Treviso Comic convention every year which is only 20 minutes from Venice, so we would have a day or two in Venice afterwards and I loved the place. Then we had a long family holiday there and during this stay I took many photographs, some of which appeared in **Option:Click**, I shot a lot of footage on Super8 film, and recorded wild tracks on Minidisc.

I had made a short film called **The Week Before** which was light hearted and silly, and I wanted to make another film that had a more somber melancholy atmosphere, and walking around Venice at 2am, I just started imagining seeing ghosts, wondering where the echoed voices were coming from. Venice is a city out of time really, it feels frozen. So I wrote the script while I was there, just a series of monologues that describe the character and his state of mind, and then this scene with a ghost caught in a repeating moment in time. I wanted to do a narrated film so that the imagery could be almost improvised, cut together from my Super8 footage, and 3-d animated sequences that create a mood rather than describe literal scenes.

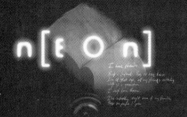

n[ɛOn]

Q: Even though the film has a lot of computer sequences in it,

it feels more like a silent film from the 20's, was that the intention?

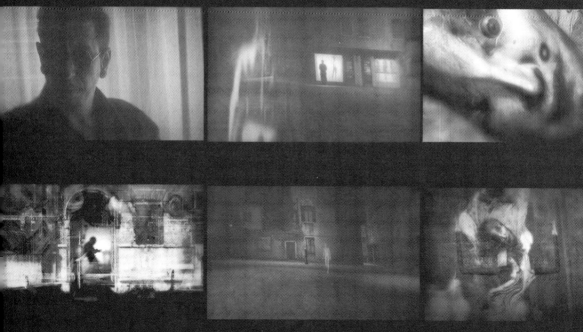

A: Yes, I've been researching silent cinema for the last couple of years.

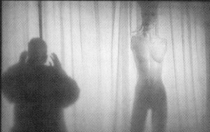

I've managed to get hold of a lot of films I had never seen before, **Faust** by Murnau, **The Man Who Laughs**, **The Magician**, **Fear**, **From Morn Till Midnight**, **The Hands Of Orlac**, **Machiste in Hell**, many others. **Caligari** of course. And I love the fact that when they start, I have no idea what's coming. I have no idea what I'm going to see, I picked up **King of Kings** and **Phantom of the Opera** and the two-strip technicolor sequences are astounding, the shot of the devil spreading his cloak full of sooty plague over the town in **Faust** is one of the most beautiful images I've ever seen in a film and it was made eighty years ago. Films seem to have become very predictable since. After the first minute of film you know where you are, you know the kind on images you are going to see. Only very recently have there been a string of films that really take you by surprise, **Being John Malkovich** does that, and **Fight Club**, and a few others that have really started to use digital tools in a transparent and expressive way to tell the story. But there is something about the energy and the sort of unfettered imagination in those early films, the rules were being written, you could go anywhere, look at those early shorts by **Bunuel** or **Rene Clair**, or **Meliés**. The whole language was created in a period of about 20 years. And everything looks so beautiful, just people standing in a room in a **Murnau** film, **Phantom** or **Burning Soil**, the way the light pulses, the texture of the film, the grit, the vignetting, the narrow depth of field, I just love it all. And I wanted to work with those feelings, not to do a pastiche, but to just try and create something that has that deep texture, you can just swim in it.

Q: But the film was made with digital tools?
A: Yes, as I say, I didn't want to just make a pastiche of 20's cinema, I really think that we are looking at a new silent era now. The rule book has gone out the window with regards to what is possible visually, what I'm interested in are the possibilities of cheap desktop solutions for film making. Special effects movies in Hollywood are still bound by the rule book, they still need many tens of millions of dollars to make visually imaginative films, science fiction or fantasy stories etc., so therefore you have to play by the rules of mainstream cinema, plotting becomes templated, they are dealing with traditional mass market forces, the star system etc. But it's really got to the point that anybody can buy and learn how to use Maya or 3-d Max, this is the same software that **Final Fantasy** or **Shrek** were created with, anyone can buy these programs and start to create imaginative films that go anywhere, without any of the stultifying conservative nonsense that big budgets bring with them. **N[eon]** had no budget at all. We are back with **Meliés**, we can go to the moon, we can go anywhere.

Q: Who worked on the film with you?
A: The same team that I've worked with on all my shorts, Simon Moorhead produced it, functioning really as a Production Manager, sorting out the logistics of the shoot etc.

Tony Shearn shot the Super16mm. footage, Max McMullin worked on the 3-d construction and animation. Eamonn Collinge played the Devil in The Week Before, so he played the man. The ghost was played by Eileen Daly who was cast at an agency in London, I saw several girls and she had a strange elfin quality, quite a brittle beauty. I really liked her. I learned afterwards that she is a scream queen, she has been in a bunch of gothic horror films and she is the face of Redemption Video. The music was half me and Iain Ballamy, and half music from a CD called Music for Egon Schiele by The Rachels, a wonderful and very moving suite of music originally created for a play. I got in touch with them and described the project, and they were happy for me to use the music, I loved the sort of off-kilter waltzes that Rachel Grimes composed, and she recorded three versions in different styles, which was perfect to weave through the different versions of the same slowly expanding ghost scene in the film.

And finally there is John Cale. When I designed his autobiography we did a signing at Borders in London, and he read a chapter and I noticed his wonderful Welsh-by-way-of-New-York accent. He puts emphasis on odd but interesting words, his voice drifts along in a very musical meandering way. It seemed perfect to be, not only a narrative voice, but also a musical voice, a drone, an ambient texture. Unfortunately it means you kind of drift in and out of paying attention to the words, so you have to see the film a couple of times, but I like that. Most of the films I like, I can go back to again and again, not because they have great plots or scripts, but because there is something in the atmosphere that I like to sink into, it's like putting on a great CD, it evokes a feeling.

Q: So what's next?
A: One of the intentions in making these films was to put myself through a sort of crash course personal film school. Another intention was to put together a portfolio. I'm working on screenplays for three features, so I'm hoping to get one of them up and running in the next year or so.

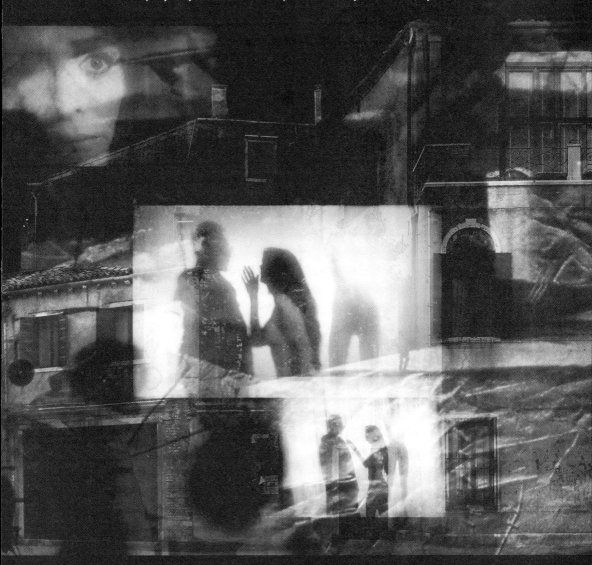

Q: And finally, where can you see N[eon]?
A: It has shown at several festivals in Europe already, it will be showing in Edinburgh, London, Montreal, Sarajevo and an American Festival in late August.
At the end of the year or the beginning of next, I'm hoping to release a DVD with N[eon], The Week Before, Displacements, Sonnet 138, Buckethead, and some other bits and pieces included.

N[eon]. UK. 2002.
28 mins. Super16mm., Super8mm., DV, CG.
Hourglass Studios.

Born in Boston 1961, Mitch O'Connell's interests went from early dinosaur drawings to Big Daddy Roth-like hot rods, to monsters and sexy girls found in the pages of such magazines as **Creepy**, **Eerie**, **Vampirella**, **Famous Monsters**, **National Lampoon** and **Playboy**. The pop-culture junky now works as a fine artist, illustrator and cartoonist. "I've already had my art appropriated in other people's paintings," he says. "I'm flattered. If people are taking the time to look at my artwork and then taking the additional time to bother copying it, then that's great. If someone starts putting out a video game with some of my work on it, then I'll want payment, but other than that, feel free to swipe my stuff."

O'Connell has also worked extensively on anonymous clip art for businesses. These clean black and white drawings that end up on menus, signs, and wedding invitations are an underexposed art form that has provided O'Connell with a lot of inspiration and material for his own work. "These little drawings are just endearingly odd and neat little symbols of America. They're neat little icons of people just happy to have something they just purchased, to make a point."

Though the influence of pop artists such as Richard Hamilton and Roy Liechtenstein is apparent in a lot of O'Connell's work, a great deal of his early inspiration derived from comic strips and, notably, Tarzan artist Burne Hogarth's instructional book, **Dynamic Figure Drawing**. Pretty soon after getting hold of a copy, O'Connell was tracing bulging muscles and creating his own versions of his favorite strips, such as **Swamp Thing** and

*Above: Cover to **Good Taste Gone Bad**.*
Below: O'Connell self portrait from Mitch Makes A Pitch.

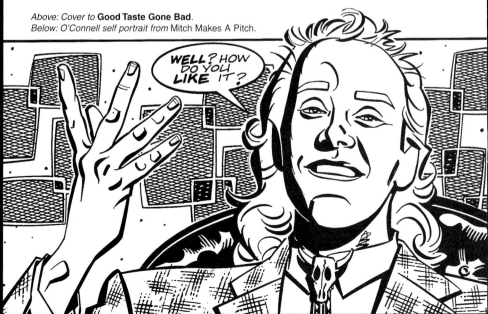

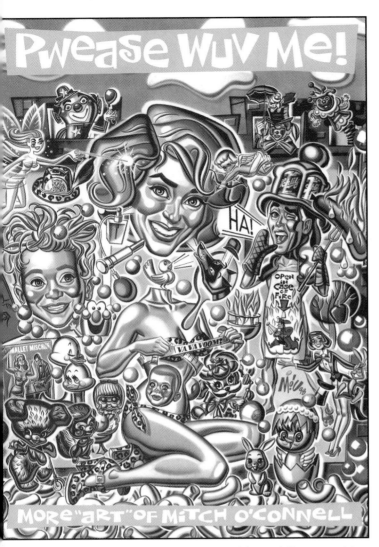

Pwease Wuv Me!

MORE "ART" OF MITCH O'CONNELL

the viewer to laugh with him. Hell, they can even laugh at him; in fact, he positively encourages it in the introduction to his books. Here, he also implores reviewers to refer to him as "drop-dead handsome" and to "avoid use of the phrase 'paunchy, near-sighted, and balding'."

Despite his boundless enthusiasm for his work, his life, and his family, O'Connell does have one weak point. He can't bear to look at the work of other artists whom he admires. "All it does is give me a stomachache," he says "I bought this book about ['50s and '60s pinup artist] Gil Elvgren's artwork, and just the cover made me physically ill, because it was so beautifully painted. I am afraid to open it up. I know there's going to be so much good stuff in there that I don't want to see it."

"With my own stuff, I just do what I like and do the best I possibly can. I try to put out a quality piece and if people like it, fantastic, but at least I know I'm going in the direction I want. I'm doing it because I want to paint, and when you are doing what you want or what you are driven to do, you're going to get the best results." Though he's loath to admit it, it's likely that O'Connell's wonderfully engaging and absorbing paintings have other artists reaching for the Pepto Bismol, too.

To obtain **Pwease Wuv Me: the Art of Mitch O'Connell**, send $17.95 plus $3.85 postage ($6.00 overseas) to
Good Taste Products,
PO Box 267869,
Chicago, IL 60626.
www.mitchoconnell.com

Conan. These efforts culminated in a job working on role-playing games and the publication of his noticeably '80s-looking graphic novel, **The World of Ginger Fox**, in 1986. His first art collection, **Good Taste Gone Bad**, followed in 1993.

O'Connell still draws comic strips, though these are now in the same clean-lined and crazily overcrowded vein as the rest of his work, with not a level 12 wizard in sight. Currently, he is working on an animated version of one of his comic strips, and if television executives have any sense, then you could soon be dribbling your cereal milk down

your chin while watching Poodleman—a half-man, half-poodle superhero bedecked in peach-colored spandex. "It'll look like how Marvel comics used to have these pseudo-animated cartoons back in the early '60s," explains O'Connell. "It looks like they photographed the panels and maybe whited out the backgrounds. This way, we get to cheat a little, make it a tribute to that, a little less expensive, and a little less time-consuming."

One thing that pervades all of O'Connell's work is his sense of humor. While some artists try to retain an icy-cool distance, O'Connell encourages

Police Log

Maine *Morning* Sentinal

In Fairfield at 8:15 a.m., a Lynn Street woman reported a man wearing thick glasses parked in a four-wheel-drive vehicle was staring at her. He did not say anything.

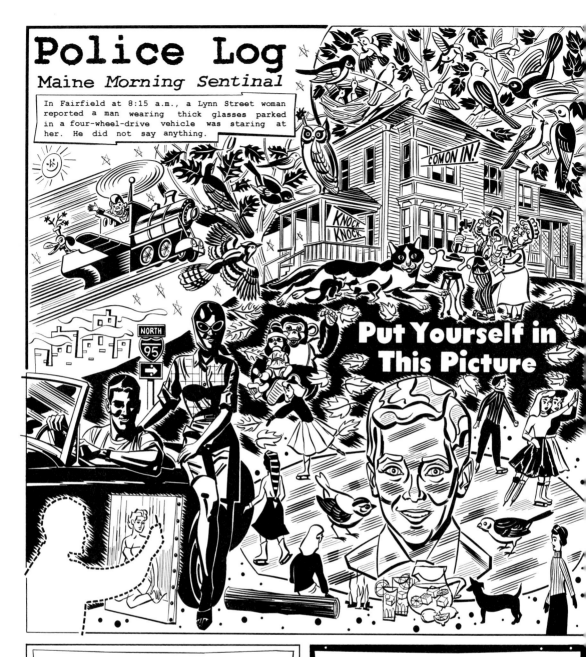

8:58 a.m, a Western Avenue woman reported her finger was caught in the footrest of her chair.

9 a.m., a Norridgewock Road resident reported that her pigs had run off. Pigs returned home after playing at the neighbor's house.

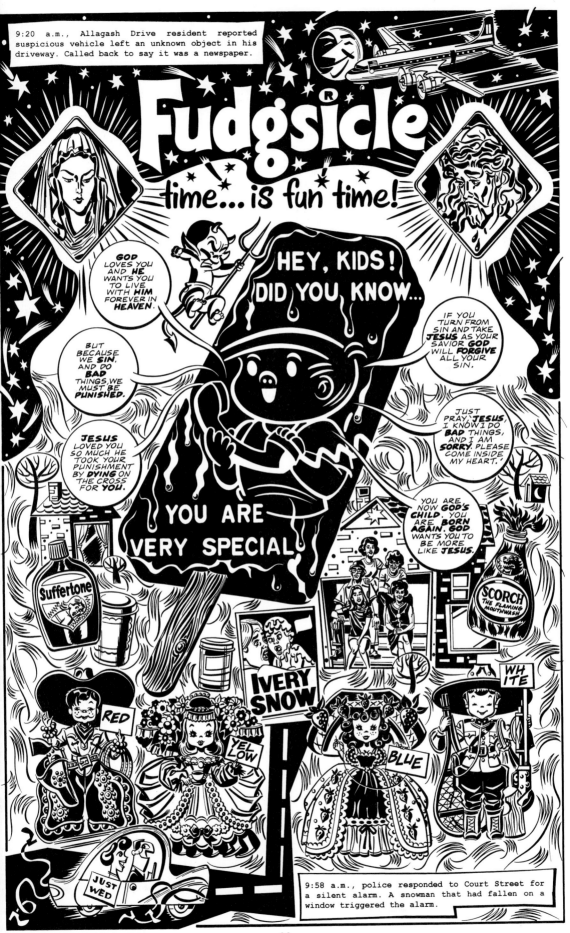

10:15 a.m., a Main Street man reported a block of cheese was stolen from his apartment.

10:19 a.m., Houghton Street resident reported someone got into his porch and poured salad dressing on his canoe.

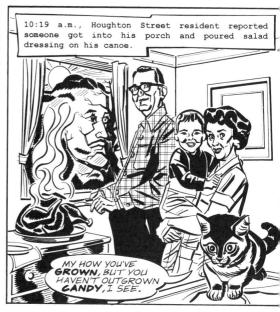

10:40 a.m., a subject on Maple Street reported tomatoes had been speared on his car antenna and topped off with a carrot.

10:45 a.m., a woman reported a man claiming to be from a lung charity called and asked her to breathe into the telephone.

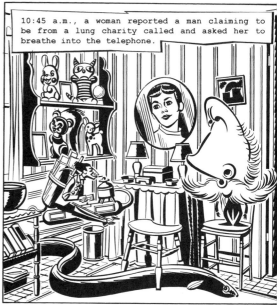

11:55 a.m., South Street resident reported that her neighbor has been walking the neighborhood with a toilet seat over her head and a bathroom rug pinned to her coat.

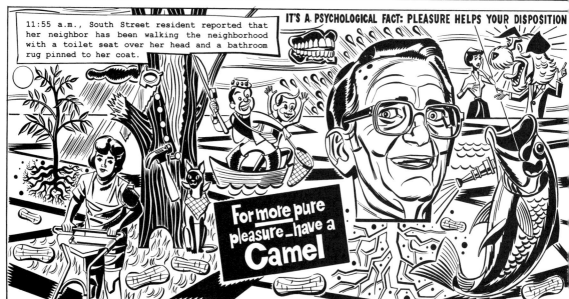

1:10 p.m., a resident reported a mysterious footprint on the carpet in her residence. Checked and believed it to be her own.

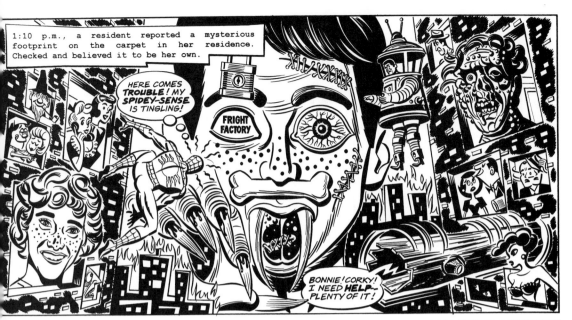

2:03 p.m., Cottage Street resident reported someone had moved all his lawn ornaments around his lawn.

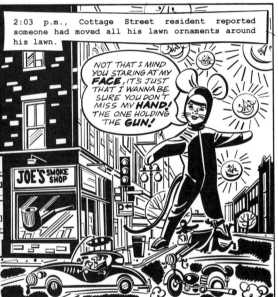

2:49 p.m., Union Street caller reported that someone lifted her ceiling tiles and was peeking in. Police determined movement was caused by the wind.

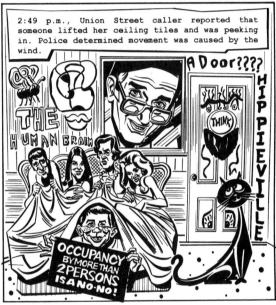

3:37 p.m., People Against Crime, 135 College Ave., new employee reported everything was gone from the office.

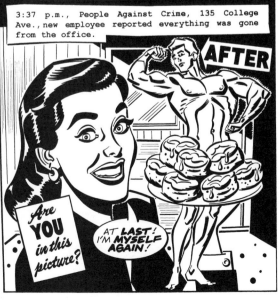

4:33 p.m., a woman reported that a "well-built man in his 30's" came out of bushes at St. Francis cemetery, wearing nothing but bikini panties.

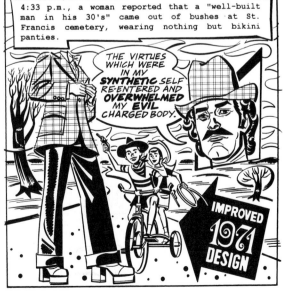

5:15 p.m., Grove Street resident complained that neighbor was allegedly using very vulgar language on CB radio, and transmission was coming over her television set.

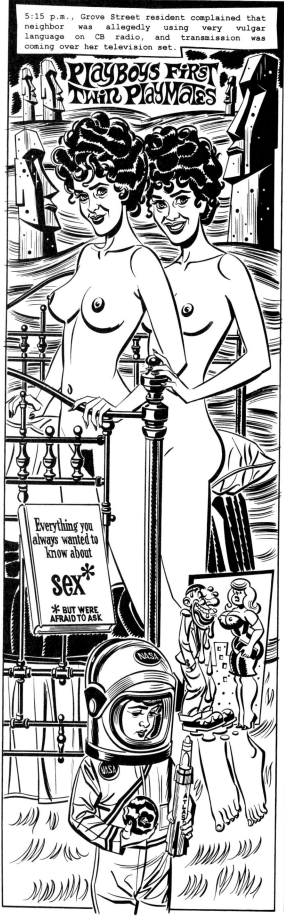

5:23 p.m., rescue called to Main Street for 2-year-old reported stopped breathing: turned out little girl was holding her breath in a temper tantrum.

7:50 p.m., investigated domestic complaint, Elm Street Mobile Home Park, woman claims that husband threw her out of their home because he is unhappy with her new religious beliefs.

10 p.m., a Boutelle Avenue woman reported several boys got in her garden and broke a zucchini.

1:20 a.m., Currier Road man reported a prowler because his dog, which had never barked before, barked. Police found no prowler.

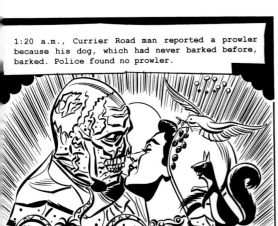

4:06 a.m., noises reported outside Newhall Street apartments, possibly sounds of a fight. Police found it was not a fight, but something much different.

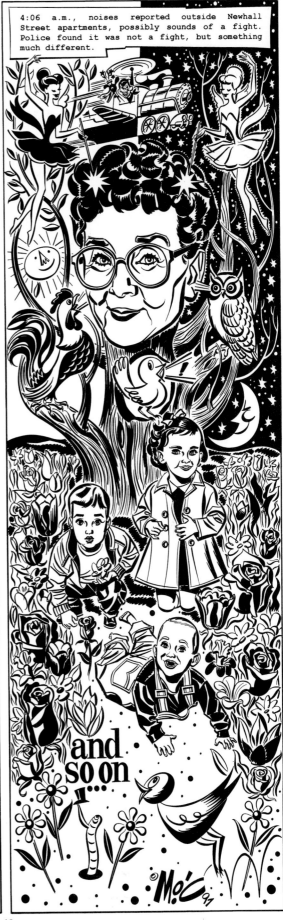

2:45 a.m., a resident of Alpine Street reported someone had thrown an ear of corn through the front window of his house.

3:49 a.m., a Cumberland Farms employee reported a customer threatenng to commit suicide. At the same time, another customer was threatening to kill people in the store.

**Dean Motter
ruminates to J. David Spurlock**

Before there was EDGE, before there was Vertigo, there was Mister X. The grim reaper visaged Mister X was the cult favorite for comic book buyers of the eighties, maybe the foremost. Certainly the most obscure. His contemporaries such as LOVE & ROCKETS or CEREBUS sold more copies. But that was also around the same time that Spiegleman's serialized version of MAUS was pushing 'soft' numbers.

His creator describes him thusly: "He was the poster boy for the new wave that brought us FACE MAGAZINE, THE CLASH, O.M.D., ERASERHEAD and other post-graduate art school chimeras."

The torturously published fourteen issue run and sought-after promotional posters are treasured by those of us who made our regular pilgrimage to the comic book stores with the hopes of possibly being taken seriously.

Motter is the first to admit that the popularity /notoriety of his comic book series was as much due to fortuitous timing as to upscale design and marketing savvy.

Warren Magazines and HEAVY METAL had tilled the soil of the new frontier. They had appropriated the aesthetics as well as the production values of the ubiquitous European publications like PILOTE, FLUIDE GLACIAL and, of course, METAL HURLANT. Marvel made their similar effort with their 'home-grown' version EPIC ILLUSTRATED.

But the American demographic didn't seem to crave high-priced, slick magazines as much as it demanded higher quality 'comic books'. The idiosyncratic format was not only inextricably deep-seated in American pop culture, but was also engaged in its battle for legitimacy that the European creators didn't appear to need to address or wage.

The American undergrounds and independents had been beating the drum for years, but to mix musical metaphors, they were playing to the choir.

It took the work of provoca-

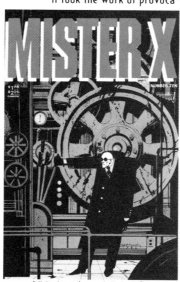

Bill Sienkiewicz cover to Mister X #10

teurs such as Howard Chaykin (AMERICAN FLAGG!) and Dave Stevens (THE ROCKETEER) to show the way.

DC came forth with Frank Miller's RONIN. Marvel followed suit with Miller/Sienkiewicz ELEKTRA as well as Kaluta / Lee STARSTRUCK.

Technique notwithstanding, these series all had a common thread: The self-referential thumbing of the nose and parody of the typical superhero protagonist (a case might also be made for Keith Giffen's AMBUSH BUG but that's another story.) They were all taking their cues consciously or unconsciously from the master, Will Eisner. This is all obvious to those of us who enjoy the exploits of The Spirit's progeny.

Motter concedes that as originally conceived Mister X was the most derivative of the lot. "He was just supposed to be an art-deco shamus earning a buck in Fritz Lang's METROPOLIS."

Style with a capital 'S' was of paramount concern to the award winning graphic designer. It was also something that seemed to be irrelevant or beyond most comics creators of the time.

"Steranko was the only American comics artist who had successfully bridged the various worlds and eras of commercial design with his work." recalls Motter.

"Chaykin and Kaluta took occasionally on the challenge in their books, but Steranko's level of experience and sophistication hadn't been matched by anyone else. That certainly figured in my decision to give the series a knowledgeable presentation, a major design concept that had some attitude. I concentrated on the combination of deco/ moderne industrial design, Russian constructivism, film noir, and depression-era pulp maga-

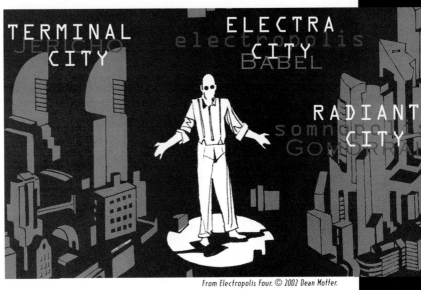

TERMINAL CITY ELECTRA CITY RADIANT CITY

From Electropolis Four. © 2002 Dean Motter.

zines. My own personal hobby horses."

Today, of course this kind a high-concept approach is virtually des rig-ors But in the pre-desktop publishing design world such a mission was expensive and time consuming, if not down-right complicated.

As a result the series genesis was far more protracted than it should have been (the silver lining: the memorable set of posters, buttons, stickers and ads that appeared the year before the book premiered.)

And the longer Dean refined and re-worked the book with illustra-tor Paul Rivoche, the less enthused they became with his initial vision.

"As a writer, whatever who-dunit' I managed to concoct seemed trite, especially when weighed against the zeitgeists that Chaykin, Kaluta, Miller, Sienkiewicz and Stevens, (not to mention patron saints Eisner and Steranko) seemed to have a hold of."

"While the imagery we were developing was provocative, the prem-ise began to seem rather banal by com-parison. I became convinced that it was not going to live up to the anticipation that had been created with our posters. We had sold the sizzle, but we needed a better cut of steak." quips Motter.

"The character's cache was, after all, his ambiguity. His mystique. His aura of menace. His sheer uncon-ventionality. To be Mcluhan-esque about it he was simply a mask that any-one in the audience could wear. But that all seemed to be falling by the wayside the more he was defined. Some major tampering was required."

Ultimately what evolved was the perfect anti-champion. A character out to save the world, (and himself)- not because he had any heroic motives, but out of a maniacal drug-driven sense of guilt that compelled him to repair the disastrous results of his own well-intentioned but reckless machinations.

"I was relieved with the fact that the character that emerged was the epitome of the mad scientist, as opposed to the trenchcoated gumshoe. Like Dr. Frankenstein he had created a monster (his city) and was struggling to somehow undo its reign of terror over the innocent citizenry." says Motter.

"We built the three cities: Radiant, Terminal and Electra ' they all fell like Babel- each in its own terrible way. One drove its citizens insane. The population went from suffering from disorders like simple kinephilia and luxophrenia to full-blown omniphobia within a single year."

"Another succumbed to a titanic social depression caused by the termination of the commemorative fair it had been built to celebrate."

"And this township became overpowered by the very industry that had created it, paralyzed by electro-magnetism and avarice."

In Motter's Image Comics series, ELECTROPOLIS, Mister X describes his cursed architecture this way:

"But, in the spirit of Dr. Jekyll, Mister X also was slave to his own designer drugs." Motter continues, "Insomnalin- poltercaine whatever. The fact that he physically resembled Nosferatu and was only at home in the darkness completed the archetype. He was a classic. People 'remembered' him without ever having seen him. Fans often sought me out to tell me how much they enjoyed reading Mister X when they were younger (?). He had become a Mcluhan-esque archetype.'

And that's where other cre-ators fell in love with the character. Though Motter's original col-laborators became somewhat uncomfort-able with this direc-tion, others found the plight of the misan-thropic architect very compelling. Artists such as Chaykin, Kaluta, McKean, Seth, Sienkiewcz, and Ty Templeton were eager to participate.

"I was lucky to have wised up to the '80's primary haz-ard in the nick of time—that of simply vamping." says Dean feigning a wipe from the brow.

"I immedi-ately looked to the works of my favorite authors: J.G Ballard, Philip K. Dick, Ellison and Vonnegut for guidance. "

"But it was the pan-generics-Thomas Berger, Damon Runyon and even P.G. Wodehouse -that actu-ally informed my thinking. I was set on a course of dark, retro-nostalgic humor. An

motter·dean

...nsemble piece where the characters were not simply the cast in a play, but where they were the story itself. Hence the tale of a city of madmen where the

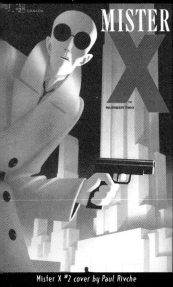

Mister X #2 cover by Paul Rivche

maddest of all was its creator and the only sane person was his brooding girlfriend. A Cyber – Wooster gone awry in the Drones Club with no Virtual Jeeves to be found! A Marks Bros. Night at the Bradbury!" "*Don't print that.*"

Motter once theorized that a collective unconsciousness had been accessed. It was sheer (or perhaps no) co-incidence that new wave exemplars ULTRAVOX had recorded a song entitled HERR X and that Jon J Muth featured a Mister X` in his TALES OF AN ABANDONED CITY around the same time, with similar themes.

It was obvious that the character had acquired a life all its own.

filmmakers. Jerry Gilliam has cited the book as one of his influences for his film BRAZIL as did Anton Furst, the production designer for Tim Burton's first BATMAN movie.

Other cinematic futurists would make reference to the world of Mister X in films like DARK CITY and THE MATRIX (and discuss it in the director's SAP commentary on the DVD's.)

The influence is very obvious in the BATMAN and BATMAN BEYOND animated television series. No surprise, since Dean's original co-visionary Paul Rivoche had been tapped by Warner Animation to create some very somnopolitan environs.

Of course Motter went on to write and illustrate THE PRISONER miniseries for the seething post DARK KNIGHT /WATCHMEN DC Comics. He was

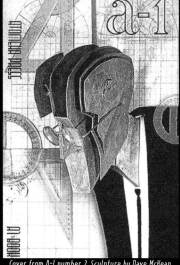

Cover from A-1 number 2. Sculpture by Dave McKean.

also the designer and art director for Byron Priess Visual Publications' Ray Bradbury, Roger Zelazny and Douglas Adams comics adaptations as well as editor for their Raymond Chandler graphic novels. He began to investigate his own brand of Worlds Fair 'antique futurism' (as he calls it) in Vertigo's TERMINAL CITY and TERMINAL CITY: AERIAL GRAFFITI.

His work has also appeared in such eclectic venues as FLINCH, HELL-BLAZER, GRENDEL: BLACK, WHITE & RED, STAR WARS TALES, and 9/11: ARTISTS RESPOND as well as numerous book and record jackets... often engaging themes or licks that he began to explore in the pages of MISTER X.

...Motter's work is, in retrospect, largely the result of his having labored for several years as an art director/graphic designer/conceptual

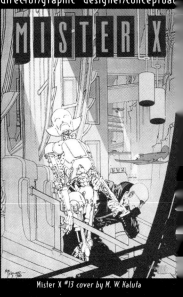

Mister X #13 cover by M. W. Kaluta

expert in the entertainment industry, as well as the comics field.

Creating graphics for album covers, coffee-table books, stadium rock concerts and motion picture promotions has accustomed him to collaborating with other creative visionaries, sometimes at their side, sometimes from afar. His ability to take influences from one idiom to another has become his hallmark.

Motter brought his expertise to Vanguard's own archival efforts for John Buscema, Frank Brunner and Michael Wm. Kaluta.

Last year Motter re-united with his TERMINAL CITY collaborator, Michael Lark to create the film a.i...

lseworlds BATMAN: NINE LIVES graphic novel as well as continuing to supplement the Mister X legend in his self-illustrated ELECTROPOLIS mini series.

Motter next turns his attention to THE SECRET LIVES OF MISTER X: THE DEFINITIVE COLLECTION from ibooks/Simon & Schuster. This archive edition anthologizes the issues written and designed by Motter (including the Hernandez Brothers numbers and a completely redrawn finale) as well as the pre-requisite covers, posters, sketchbook pages and work from unseen (except here in the pages of EDGE) unrealized Motter/Sienkiewicz graphic novel THE BRAIN OF MISTER X.

HEARTSPRINGS AND WATCHSTOPS

To demonstrate just how Mister X provoked other cutting edge creators we now present this obscure appearance from the very rare A-1 all-star anthology series from England's Atomeka Press. Editors Dave Elliot and Gary Leach commissioned such luminaries as Brian Bolland, Philip Bond, Dave Gibbons, Michael Kaluta, David Lloyd, Brendan McCarthy, Mike Mignola, Jon J Muth, Paul Rivoche (!), Matt Wagner and others (as well as Motter himself) to create tributes to Motter's City of Dreams/ City of Nightmares in the first two issues. Notable was the inclusion of an early Neil Gaiman / Dave McKean collaboration.

This was during McKean's unique ascent in the comics field. One that would often involve or parallel that of long-time friend, Gaiman.

They would create a variety of works such as VIOLENT CASES, BLACK ORCHID, AND MR. PUNCH, a century worth of SANDMAN covers, SIGNAL TO NOISE for FACE magazine and even children's books such as I TRADED MY DAD FOR TWO GOLDFISH and THE WOLF IN THE WALLS. Each time they collaborate they break new ground. While their separate efforts continue to advance their careers, their combined efforts have always been watershed events. One could easily argue that McKean and Gaiman played seminal roles in creating the VERTIGO imprint itself.

" I have always had a special admiration for Neil. I first met him in

london in the early days of his professional career. He proclaimed that it was his dream to one day be able to match the contribution of the then- superstar of DC Comics, SWAMP THING's Alan Moore." says Dean.

As it turned out, he wasn't as presumptuous as he sounded. He kept to his plan and now has television productions, radio plays and even a couple of best sellers under his belt (AMERICAN GODS, CORALINE.)

" My only regret is that the single chance that I had to collaborate with Neil was scuttled by love. Karen Berger offered me a Gaiman scripted HELLBLAZER, but its production schedule collided with that of my honeymoon. I attempted to rush it through- but my bride wasn't too happy with the fact that I even entertained the idea of completing the project during our connubial plans." bemoans Motter.

As fate would have it McKean would step in and illustrate it instead, thus making 'HOLD ME' in issue 27 one of the series' more memorable episodes.

Dave had already contributed to the MISTER X comic book in the form of a short TALES FROM SOMNOPOLIS back-up feature in issue eleven (and eventually the cover to issue fourteen.)

While attending UKAC in 1986 Motter was introduced to Dave by Neil in the convention pub.

"David had completed a short comic book vignette for a design course, I believe, and wanted to get my reaction to it. I immediately coaxed Vortex into publishing it (though it didn't take much.)"

"What was remarkable was that the piece was not a burlesque, as the series had become, but a grim portrait of the Mister X that had originally intrigued the market during the year long advance poster campaign. Dave was clearly sympatico with the character"

This was also McKean's first published comic book work—well before his groundbreaking work on DC's ARKHAM ASYLUM.

A year later the first issue of A-1 hit the stores in the UK. It featured a single Mister X illustration by Bill Sienkiewicz, Motter's own EPILOGUE/PRO-

LOGUE (a two page farewell to Mister X reprinted in issue three of ELECTROPOLIS) and HEARTSPRINGS & WATCHSTOPS by Gaiman and McKean.

As it turned out Neil and David's take on Radiant City was a much truer realization of Motter's vision than had been pulled off under his own tenure.

"Much of what I wanted to do with the series had been compromised by artistic changes, an erratic publication schedule, my own missteps and other business factors." laments Motter. "Neil and Dave had managed to do in eight pages what I had been struggling to do all along. I was thrilled—and terribly envious."

For more on MISTER X visit http://home.earthlink.net/~deanmotter read the interviews in COMIC BOOK ARTIST issue 15 'The 80's Vanguard' and Motter's essay 'Alice in Metropolis or It's All Done With Mirrors' in ibooks EXPLORING THE MATRIX.

IF ALAN MOORE IS THE HUNTER S. THOMPSON OF COMICS, THEN NEIL GAIMAN IS THE TOM WOLFE

BY DEAN MOTTER

Like Wolfe, Neil made the transition from essayist to epic storyteller fairly naturally. Wolfe's histories such as The **Right Stuff** were told as colorful, expansive stories. So his first foray, **The Bonfire of the Vanities**, was not remotely jarring. Similarly Neil had been a poet and writer of short fiction in the fantasy genré for only a few years before he and Dave McKean first collaborated on **Violent Cases** in 1986. To the casual reader this seemed ingenuous and even effortless. But this was the work of an artist with a vision, not only for a particular story, but for his own career.

He continued to gain notoriety with his *Curiosities* articles in **The Magazine of Fantasy & Science Fiction**, and observations in **Locus**.

But it was **Violent Cases** that caused the stir and caught the eye of Karen Berger. This led to the **Black Orchid** miniseries and eventually the **Sandman** franchise itself.

It may have appeared that Gaiman was intending to emulate the critical success of Alan Moore, in the manner that many accused Wolfe's early observations as attempting to share the iconoclast mantle with Thompson. Of course both premises have since been summarily disproved.

The importance of his **Sandman** oeuvre cannot be understated. What could have easily been a retread of a forgotten Golden Age funnybook character, is universally regarded as one of the most thoughtful, consistent comic book series ever created. Its zeniths such as the *Midsummer's Nights Dream*, or *Ramadan* episodes are themselves crown treasures of the genré.

In the 90's Neil was charged with reconciling the disparate magical realms of the DC Universe. The result was **The Books of Magic**, featuring a bespectacled English schoolboy who is ushered off to a mystical boarding school to one day become the world's greatest wizard (pre-dating Ms. Rowling's sorcerer's apprentice by nearly a decade).

That alone would constitute laurels enough to rest upon for years, certainly. Yet even **Sandman**'s supporting cast, **The Endless**, earned its own distinction. Their solo tales were as compelling as those of the Sandman. Indeed Neil himself has been tapped to make his directorial debut with a film version of **Death:**

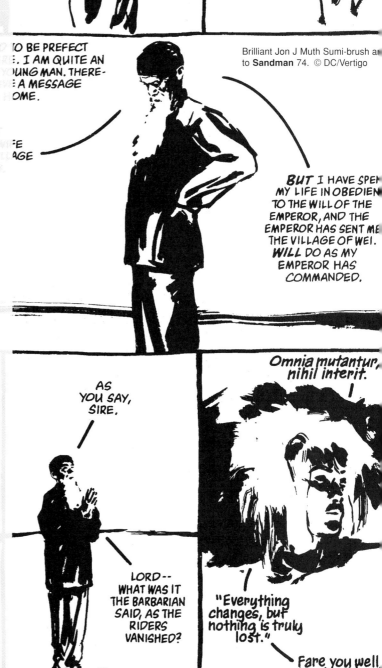

IO BE PREFECT
. I AM QUITE AN
)UNG MAN. THERE-
A MESSAGE
OME.

E
AGE

Brilliant Jon J Muth Sumi-brush ar to **Sandman** 74. © DC/Vertigo

BUT I HAVE SPEN MY LIFE IN OBEDIEN TO THE WILL OF THE EMPEROR, AND THE EMPEROR HAS SENT ME THE VILLAGE OF WEI. **WILL** DO AS MY EMPEROR HAS COMMANDED.

AS YOU SAY, SIRE.

LORD -- WHAT WAS IT THE BARBARIAN SAID, AS THE RIDERS VANISHED?

Omnia mutantur, nihil interit.

"Everything changes, but nothing is truly lost."

Fare you well, Master LI.

The High Cost of Living for Warner Bros.

In 1990 Neil co-authored **Good Omens** with Terry Pratchett. His accolades include the World Fantasy Award, two Bram Stoker awards, not to mention a burgeoning mantle of Eisners, and Harveys.

Neil's first novel, **Neverwhere**, published in 1996 was widely acclaimed, and described as '**Alice in Wonderland** with a punk

edge', but really had more in common with Dante than Carroll. His next, **Stardust** was released both in prose and graphic novel (illustrated by Charles Vess) editions.

Neverwhere was more accessible to anglophiles, but in **American Gods** expatriate Gaiman takes on the 'Great American novel'...of course it is with his prerequisite supernatural allegory. Our hapless protagonist, known only as Shadow, is guided through the magical realm of the American Midwest, this time with 'Mr. Wednesday' playing Virgil's role.

Comic-book work is a highly collaborative endeavor, and Neil continues to embrace this practice as well. Over the past seven years he and long-time colleague Dave

Above: Neil Gaiman photo by Kelli Bickman

McKean have created children's books such as **The Day I Swapped My Dad for Two Goldfish**, **Coraline** and **The Wolves Within The Walls**.

Currently he is revisiting the Marvel Comics Universe via the 17th century in 1602, with ancestral dopplegangers of Spiderman and Nick Fury. His return to the world Sandman and the Endless instantly hit the **New York Times** bestseller list

with **Endless Nights**, the first graphic novel since art spiegleman's **Maus** to show up there. He is writing his next novel, **American Boys** and is working with McKean and the Jim Henson Co. on the feature film **Mirrormask**.

In his self-illustrated

vignette, **The Man Who Always Peaked Too Soon**, Wolfe seems to suggest that someone like Hunter was always three years ahead of the trends. And indeed Moore may have proved more of a precursor to Neil than a model. The comics business certainly owes a colossal debt to these two vindicators, but it is their readers that have paid it. And they have been rewarded.

Indeed, if there's one thing more impressive than the near fanatical loyalty that Neil's following bestows upon him it is just how loyal he is to them. He is prolific almost as much out of obligation to them as he is to his own muse.

gaiman•neil

MISTER

heartsprings & watchstops

neil gaiman
dave mckean
after HELMUT NEWTON

MR. X CREATED BY
dean motter

This has got to be the place.

Yeah. Where's the light-switch?

No, it's okay. I got it.

C'mon. Move it! The party will be here in less than half an hour!

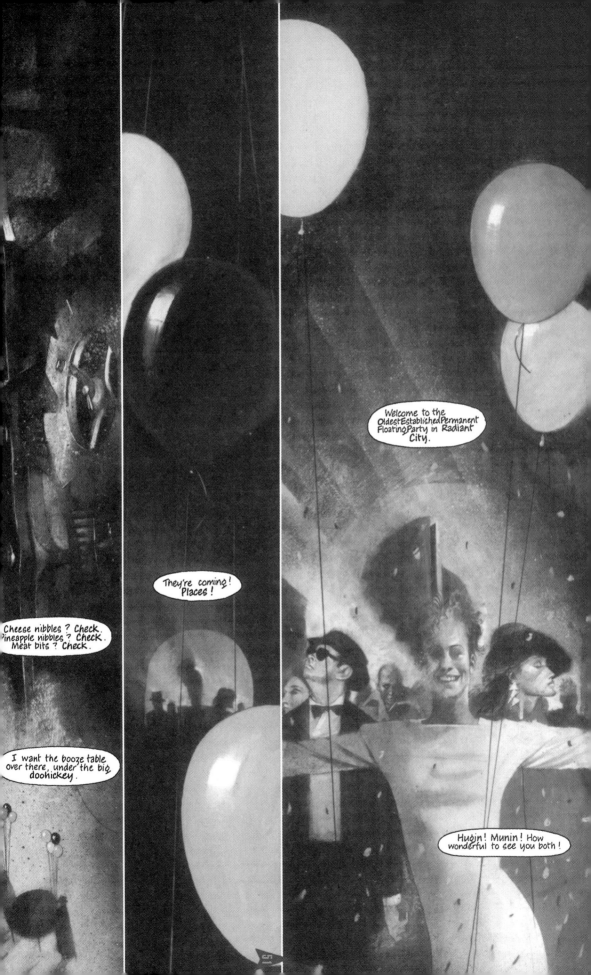

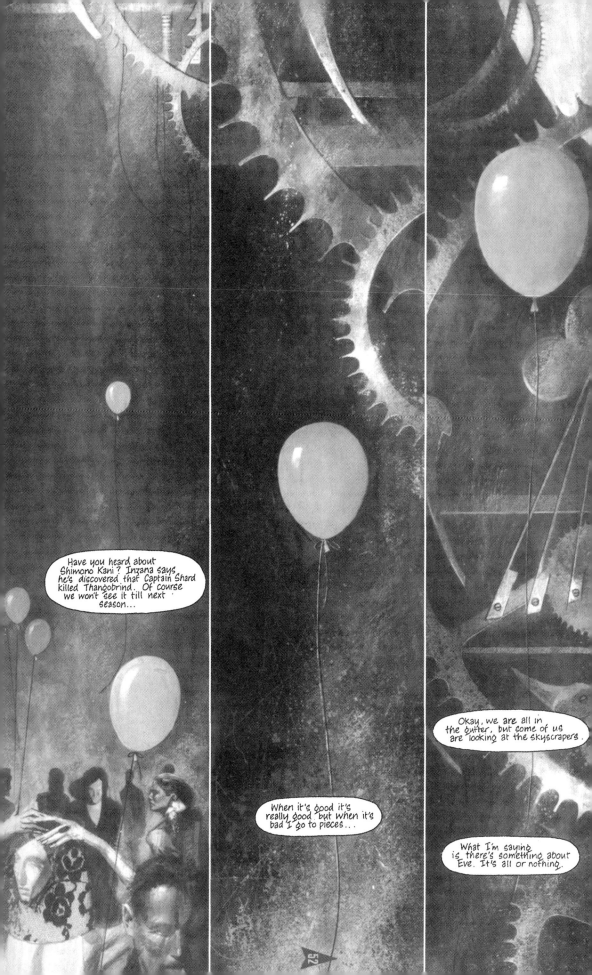

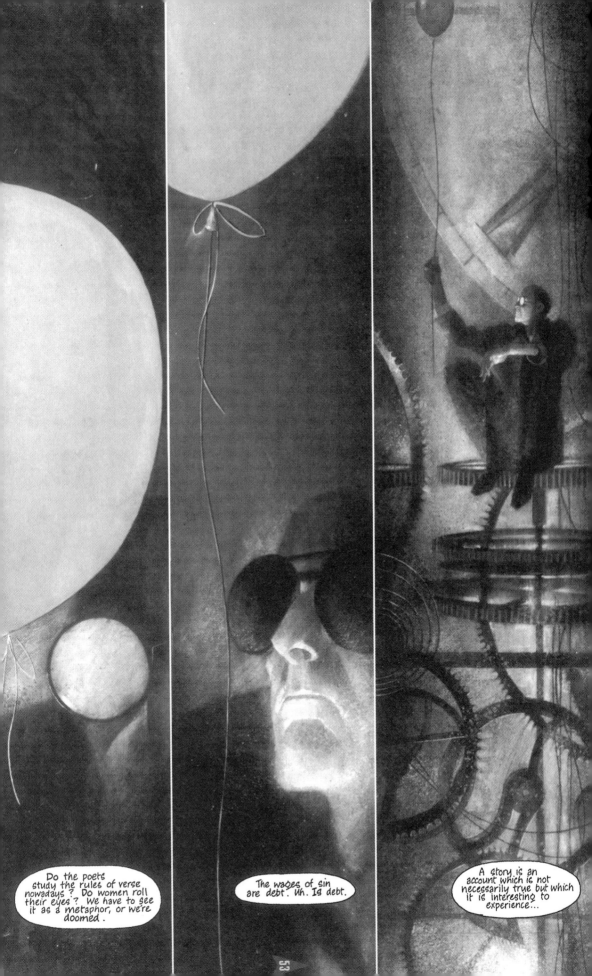

Do the poets study the rules of verse nowadays? Do women roll their eyes? We have to see it as a metaphor, or we're doomed.

The wages of sin are debt. Uh. Is debt.

A story is an account which is not necessarily true but which it is interesting to experience...

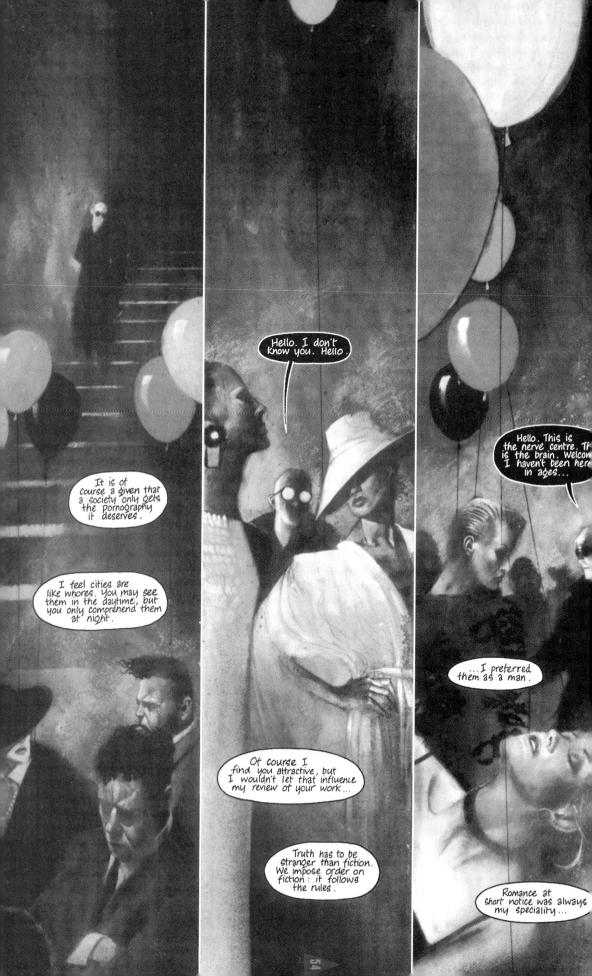

It's the clocktower. It runs the city. Most people don't know that. I know that.

Every cog punches a clock somewhere.

Every egg that you time, every order, every deadline, every timepiece in Radiant City echoes out from here, takes it's cue, in slave and tandem from this one huge chronometer.

This is the place that time struts on for always into forever.

Time falls slowly, softly, measured in seconds.

I have peculiar thoughts about this place. Crazy ideas. Fuguestuff. Perhaps it's possible that if I stopped this clock ... time in this city would stop forever...

Listen to it: Tick, tick, Tick ... Like heartbeats we listen to the firing of synapses in the city's brain.

It can't stop.

...the completeness man's machines and the continued corruption of his motives...

No thanks, blossom. I only smoke Ziggies.

...the price of liberty is eternal videotaping.

When they said she did not look like the portrait he'd painted, he replied, never mind. She will.

Power corrodes? Oh, Absolutely.

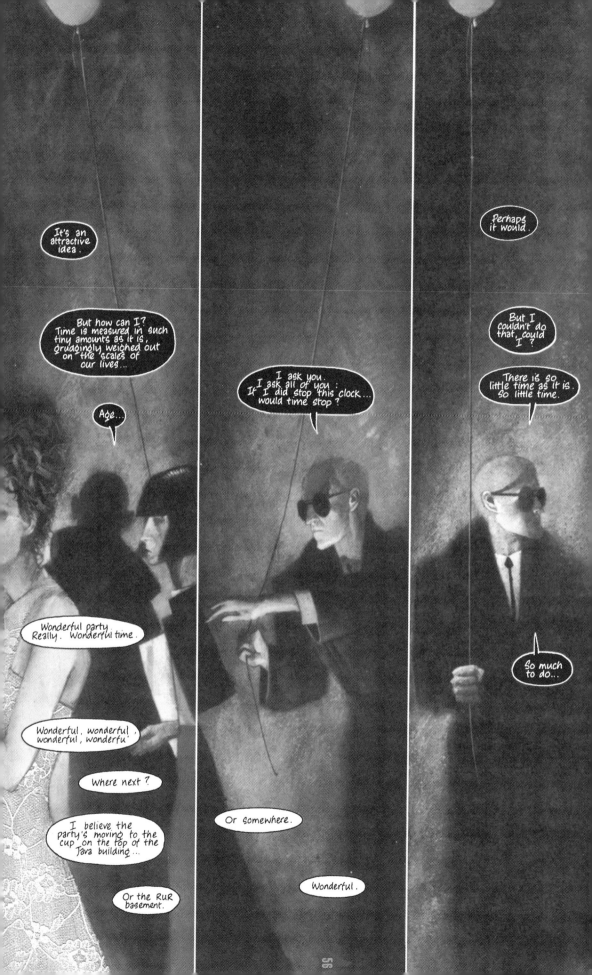

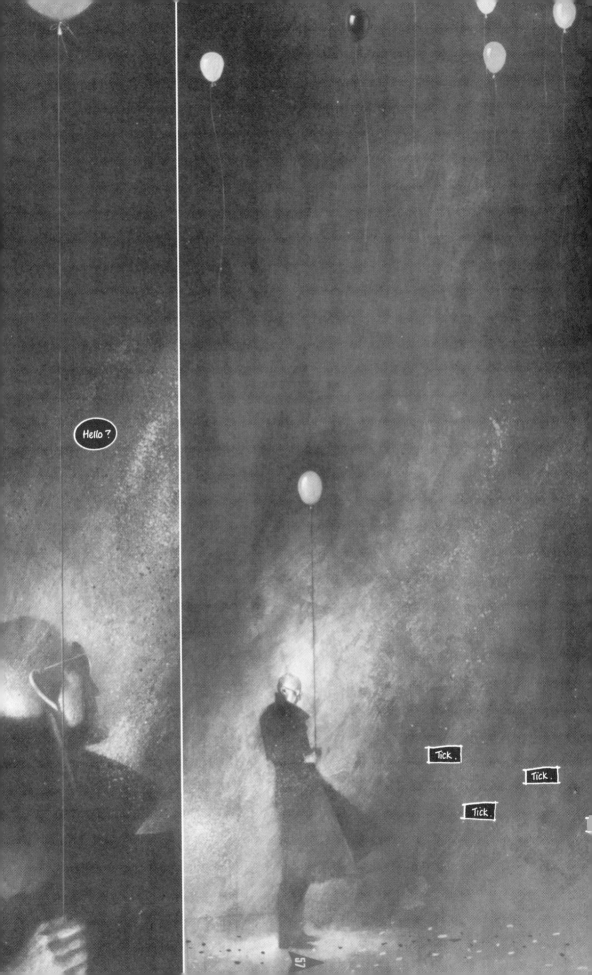

Marshall

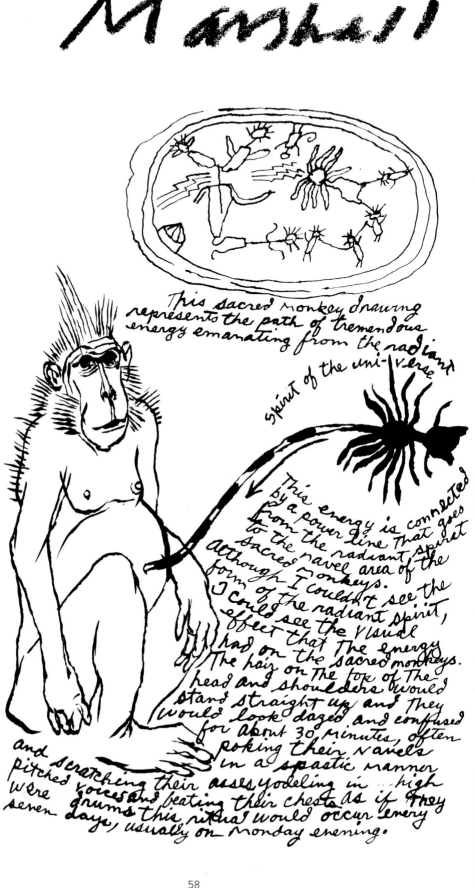

This sacred monkey drawing represents the path of tremendous energy emanating from the radiant spirit of the uni-verse

This energy is connected by a power line that goes from the radiant spirit to the navel area of the sacred monkeys. Although I couldn't see the form of the radiant spirit, I could see the visual effect that the energy had on the sacred monkeys. The hair on the top of the head and shoulders would stand straight up and they would look dazed and confused for about 30 minutes, often poking their navels in a spastic manner and scratching their asses yodeling in high pitched voices and beating their chests as if they were drums this ritual would occur every seven days, usually on monday evening.

Arisman

Marshall Arisman's razor-sharp images scream in outrage at a passive world. They have earned him a permanent place both in the Smithsonian Institution and the Brooklyn Museum. After completing his BFA at Pratt Institute, Arisman achieved critical acclaim with the publication of **FROZEN IMAGES**, his book of black and white graphic commentaries on violence. His regular contributions to **The New York Times** Op-Ed page furthered his reputation for dealing with hard-edged and controversial subject matter. Feature articles on Arisman's work have appeared in **Graphis Extra** 1979, **Omni** January '82, **The Creative Review London** '85, as well as cover stories on his work in **Graphis** in 1986 and again in 1990.

Arisman's bare-boned editorial illustrations appear frequently in major publications including **The New York Times Magazine**, **Rolling Stone**, **Esquire**, **Playboy**, **Sports Illustrated**, **Time,** and **Omni**, among others. You could define whether a magazine was of consequence based on whether they'd ever run an Arisman illustration. He has co-chaired the Media Arts Department of The School of Visual Arts in New York since the '60s, now directs its unique master's program, "The Illustrator as Visual Journalist," and has a long association with the Society of Illustrators.

Arisman's graphic essay, **Heaven Departed**, in which paintings and drawings describe the emotional and spiritual impact of nuclear war, was published in book form by Vision Publishers (Tokyo, 1988). Arisman's exploration of the darkness in the human psyche has led some to think of him as America's answer to Francis Bacon and others to attack him for "glorifying the underbelly of American society." But gradually, through works such as **Light Runners** and **Sacred Monkey Man**, both the spiritual side and humor of the man—who is as at home with such divers company as the Dalai Lama and Woody Allen—are being revealed.

Marshall Arisman was the first American invited to exhibit his artwork in mainland China. His series, "Sacred Monkeys," appeared at the Guang Dong Museum of Art in April 1999. Mr. Arisman is the subject of a full-length documentary film directed by Tony Silver entitled **Arisman Facing the Audience**. The film premiered at the 2002 Santa Barbara Film Festival winning the Award for Creative & Artistic Achievement.

Vanguard publications featuring Arisman's work include **EDGE** issues 1-6, **WATCH** 1994, **Light Runners**, **EDGE** card set, the Arisman graphic novella *The Sacred Monkey Man* with intro by Dave McKean (**EDGE** 11) and his most politically-incorrect contribution to this volume, *The Endangered Species Cookbook* with renowned author Paul Theroux.

Thank you, Marshall, for everything.

—J. David Spurlock

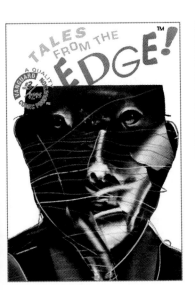 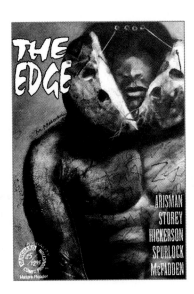

theroux . paul

Paul Edward Theroux was born April 10, 1941 in Medford, Massachusetts, the son of a French-Canadian father and an Italian mother. Theroux spent most of the 1950's reading and then studied premed in college.

He attended the University of Maine where he wrote many anti-Vietnam war editorials and refused to join the required Reserve Officers Training Corps. He transferred to the University of Massachusetts and took a creative writing course from the poet Joseph Langland. That decision changed the way Theroux would perceive writing as a career. Theroux graduated with a Bachelor of Arts degree in 1963.

At Syracuse University, Theroux trained for the Peace Corps and then lectured at the University of Urbino in Italy. In Malawi, Africa he taught at Soche Hill College and wrote for **Christian Science Monitor**, **Playboy**, **Esquire**, and **Atlantic Monthly**. He won the Playboy Editorial Award for Best Story in '72, '76, '77, and '79.

Theroux was involved in a failed coup d'etat of the Malawi president-dictator and was thrown out of the Peace Corps. He returned to Africa to teach English at Makerere University in Kampala, Uganda. Here he met not only his future wife, Anne Castle, a schoolteacher from London, but also V. S. Naipaul, (2001 winner of the Nobel Prize in Literature). This writer was to become his mentor. His first son, Marcel, was born in Uganda in 1968.

Waldo, Theroux's first novel, sold 4000 copies. Theroux went on to write **Fong and The Indians**, published in 1968, **Murder in Mount Holly** and then **Girls at Play**, a novel about "the futility of African politics and the disintegration of tribal life." When an angry mob at a demonstration threatened to overturn the car in which his pregnant wife was riding, Theroux made the decision to leave Africa.

Theroux was next hired on at the University of Singapore, where he wrote his fifth novel, **Jungle Lovers**. His second son Louis was born in Singapore in 1969. It was in Singapore that Theroux realized that he had enough of teaching, but taught one last course at the University of Virginia in Charlottesville in 1972. Both **Sinning With Annie** and a criticism of V. S. Naipaul's early works were published in 1972. While in the English countryside, Theroux wrote **Saint Jack**, which was made into a film by Peter Bogdanovich, starring Ben Gazzara, about his time in Singapore. The macabre tale set in the English countryside, **The Black House,** followed.

The Great Railway Bazaar: By Train Through Asia was Theroux's first travel novel and was a best seller (35,000 copies). He wrote **The Family Arsenal** (1976), **Picture Palace** (1978), which won the prestigious Whitbread Award, and **The Mosquito Coast** (1982) which won the James Tait Black Award and the Yorkshire Post Best Novel of the Year Award. **Mosquito Coast** was later (1986) made into a movie directed by Peter Weir, starring Harrison Ford. Theroux's three collections of short stories, **The Consul's File** (1977), **World's End** (1980), and **The London Embassy** (1983), were combined into one: **The Collected Stories.**

At the request of his sons, Theroux wrote two children's stories : **A Christmas Card** (1978) and **London Snow: A Christmas Story** (1979). His **Doctor DeMarr** was made into a movie starring Sigourney Weaver and Michael Caine. More travel novels, **The Old Patagonian Express** (1979), **The Kingdom By The Sea** (1983), **Sailing Through China** (1983) **The Imperial Way** (1985), **Patagonia Revisited** (1985), about Patagonia's influence on literature and **Sunrise with Seamonsters: Travels and Discoveries** (1985).

Riding the Iron Rooster (1988), chronicling Theroux's travels through China, was followed by **My Secret History** (1989). Theroux wrote **Chicago Loop** (1990), **To the Ends of the Earth** (1990), **Millroy the Magician** (1994), **The Pillars of Hercules** (1995), and **My Other Life** (1996). (**My Other Life**, and **My Secret History** were long believed to be Theroux's "closet" autobiographies, until the publication of **Sir Vidia's Shadow**.) **Kowloon Tong** (1997) is a novel on the subject of Britain's rule over Hong Kong. **Fresh Air Fiend** was the title of his 2000 collection, a reflection on his life and travel writings. 2001 saw **Hotel Honolulu** and he edited **Best American Travel Writing**, which contains a short story by his son, Marcel.

In 1977, Theroux won an award in Literature from the American Academy and Institute of Arts and Letters. Theroux is also a Fellow of the Royal Society of Literature and the Royal Geographic Society in Britain. Furthermore, he holds honorary doctorates in literature from Trinity College in Washington and Tufts University in Medford, Theroux's hometown.

Theroux currently divides his time between Cape Cod and Hawaii with his second wife, and has taken up beekeeping.

THE ENDANGERED SPECIES COOKBOOK

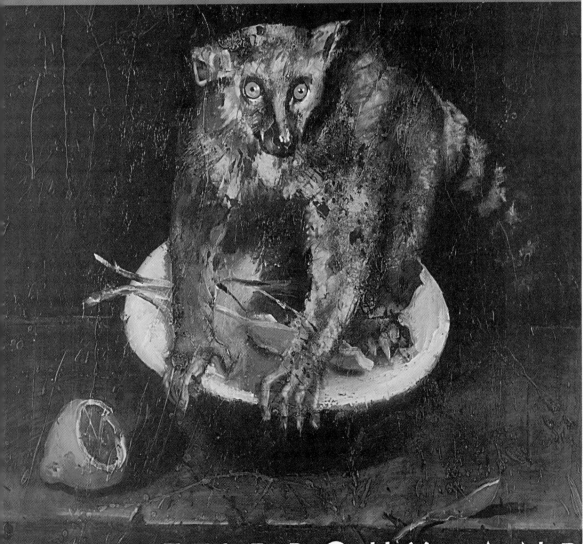

PAUL THEROUX AND MARSHALL ARISMAN

GREEN SEA TURTLE

CHELONIA MYDAS

G reen sea turtles weep when they are killed, their narrow glassy eyes actually filling with tears which drip into the corners of their beak. This phenomenon has been noticed by both the Chinese and the Pacific Islanders, people who have traditionally killed and eaten the Green Sea Turtle—but it must also be added that most American turtle recipes are based on the Green Sea Turtle, which has been listed as an endangered species since 1979.

It is a large creature, its shell averaging about a yard in length; and it may weigh up to 300 pounds. Although its shell may have green tints the turtle is named for the color of its fat, which varies from pale jade to a deeper old-dollar-bill green.

I first set eyes on a green sea turtle in a Panama hotel, cut into rough chunks, and I was surprised at how fatty a dish it was—and on that occasion how badly prepared.

"This is one of the worst meals I've ever eaten," I said.

My companion said, "When did you ever have a good meal in the penthouse restaurant of a second-rate hotel?"

This seemed unanswerable: big dark room, fake candlelight, furtive shadowy waiters, piped music, and — fifteen stories down— the pretty, misleading lights twinkling in the Panama slums.

The hotel was noted mainly for its casino, and that same night I saw a fight between a so-called gringo and a Panamanian croupier. "Throw the dice, senor," the croupier said, seeing the man spitting on the dice and procrastinating, and when the croupier repeated it the man threw the dice into the croupier's face. Then there was chaos.

I saw another Green Sea Turtle in the Trobriand Islands, which are several hundred miles off the northeast coast of Papua New Guinea. This small, flat archipelago of coral islands were first studied by Bronislaw Malinowski in a number of books, the most famous of which are *Argonauts of the Western Pacific* and *The Sexual Life of Savages*. I had been paddling inside the reef off Kiriwina Island, on the windward side, and came across a group of Trobrianders fishing. They yelled for me to join them and I swapped my sandwiches for some of their smoked fish. They shared the sandwiches, which were sloppy things made of stale white bread and slabs of pig meat, and they ate the piggy filling before eating the bread. Their smoked fish—it was a temporary fishing camp, they were smoking the fish there and then—was delicious, and known locally as Reef Trout.

At their feet on the upper part of the beach a large Green Sea Turtle lay on its back. For the two hours or so that visited with the fishermen the turtle continually struggled to right itself and get to its feet. It succeeded three times and each time the fishermen kicked it over. When I asked about this they said that it was too much trouble to butcher properly, and so it would be brought back alive to the village,

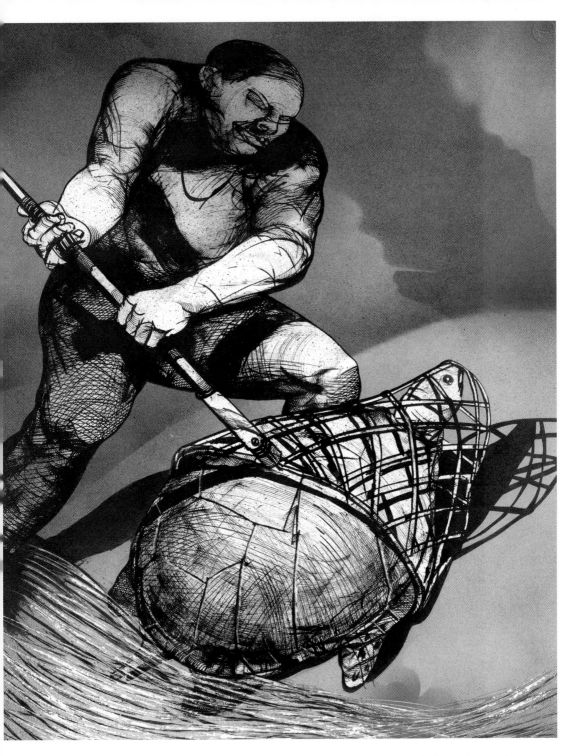

which was on the northern part of the island. Besides, if it were killed its meat might spoil before they reached the village.

I noticed a Green Sea Turtle staring at me as I paddled my kayak on the west coast of Oahu, in Hawaii, off Lanikai. This *honu*, as the Hawaiians call the Green Sea Turtle, wes very curious and hovered, watching me. Its shell was dark brown and the turtle treaded water for eight or ten seconds before sinking from sight. This specimen might have traveled a great distance. Green Sea Turtles have been tagged and discovered to hove swum as much as 1400 miles. They are dispersed throughout the warm waters of the tropical world, though in greatly reduced numbers—probably because they are so tasty and so easy to catch. They are unique among the sea turtles of the world in their habit of occasionally crawling up on the beach, not to lay eggs, but to sun themselves and rest.

PREPARING
A TURTLE
■

The Green Sea Turtle should be taken alive unless it is to be used in cooking that same day. If it is bought it should be alive and kicking, and afterwards killed in this way. Cut the turtle's throat and then cut its head off and hang it on a hook until the blood stops dripping. If the turtle is not large it may be put into a pot of boiling water, shell and all, and cooked for ten to fifteen minutes. When it is removed it should be doused with cold water and the black skin removed from the legs. After washing lt again it should be simmered until tender. What is tender? When the legs can be broken apart with slight pressure and the shells comes to pieces—about on hour for a smaller turtle.

The turtle is then gutted. The gall bladder, liver and sandbag are removed along with the entrails. The gall should be removed intact, and if there are any eggs they too should be removed. The meat of the turtle is then chopped small and is ready for use in any of the following recipes.

GREEN SEA TURTLE

POTOGEE
TURTLE SOUP
■
Ingredients:
1 small green sea turtle,
10 to 12 lbs turtle broth
1 and 1/2 cups
shredded cabbage
1 cup sweet corn
1 cup fresh peas
1 cup dried haricot beans
1 cup carrots, diced
1/2 cup finely chopped celery
4 cups potatoes, diced
1/2 cup onions, chopped
1 quart tomato juice
1/2 cup finely chopped
green pepper
1 tspn ground black pepper
1 tablespoon of salt
1/2 tspn cayenne
1/2 tspn dried thyme
3 tablespoons browned flour
1 cup noodles, uncooked
2 hard boiled eggs, chopped

Boil whole green sea turtle until meat can be easily removed from its bones. Remove meat, discard bones, and save broth. In 10-quart pot, cover with water. Simmer until vegetables wilt; then stir in flour, noodles, and eggs, and continue cooking for another 15 minutes, until vegetables are tender.

Serve piping hot in a tureen, accompanied by fresh rolls and salad.

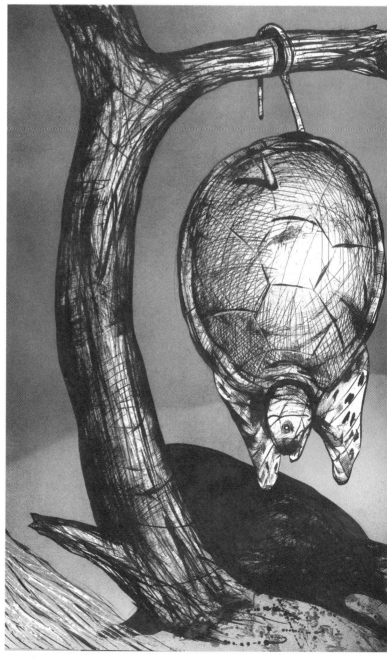

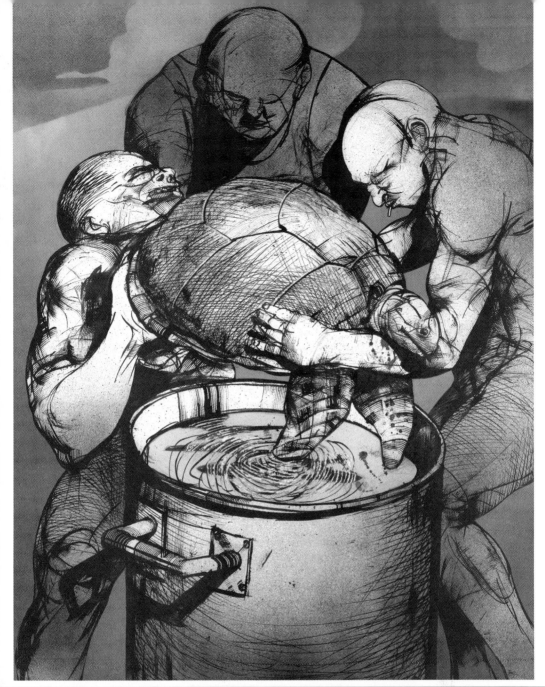

TURTLE RAGOUT

■

Obtain two pounds of Green Sea Turtle meat and dice, removing lumps of greenish fat. Cook one medium onion (chopped) in 2 tablespoons of butter and blend in one tablespoon of flour. When a smooth paste has been achieved, add one bay leaf, one clove of garlic, a cup of water and a cup of wine. Stir until blended, then add the diced turtle meat and simmer for 30 minutes. Serve with rice, vegetables and a crisp salad.

TURTLE A LA KING

■

Ingredients:
2 cups turtle meat
6 yolks hard boiled eggs
2 tbspns butter
2 cups cream
salt and pepper
allspice

Nutmeg

Mash the yolks of the hard-boiled eggs and mix them with the fat. Put the cream into a double-boiler; when it is scalded, stir in the eggs and the fat mixture and beat until smooth; season with salt, pepper and gratings of all-spice and nutmeg. Add the turtle meat cut fine and simmer for ten minutes. Serve very hot.

THE GRIZZLY BEAR

URSUS ARCTOS HORRIBILIS

Throughout history, wherever bears existed they were feared and venerated. The Russians, appalled and terrified by the creature, and wishing to appease it with a euphemistic and flattering name, called the bear *medved*, "honey wizard" —and still do. The aborginal Ainus of Japan saw an ursine affinity in their own hairiness (the Ainus have "body hair as abundant as on Armenians" the *Encyclopedia Britannica* tells us) —these Ainus held elaborate ritual sacrifices of the brown bear once native to Asia, and a subspecies of the Grizzly. North American Indian songs and legends are full of bear imagery—the Blackfoot Indians called the Grizzly "The Real Bear." And the Finno-Ugric people, whose language and culture lives on in a debased and fragmented way in Finland, Hungary, and Estonia, regarded the bear as a sacred animal: killing a bear demanded ritualistic feast to placate the spirit of the bear (a man or woman chosen from the gathering acted the role of the bear's mate). Yet no amount of shamanism or bear worship prevented even the most fearful and simple folk from killing bears and eating their flesh.

The grizzly is the very embodiment of ferocity, known for its enormous size (an adult may weight 900 pounds) and its extreme bad temper and aggression. This is human observation. On its own it may be as sweet as pie. How can we be so sure that is not the case? The Grizzly is swift and can run like a stag—35 miles an hour. Its name derives from the silvery hairs mingled on its hide with brown fur ("silvertip" is another name for the creature). Unlike the Black bear the Grizzly does not climb trees. Its claws are long—five inches or so in a mature adult; and although it eats everything and is opportunistic (in Yellowstone the Grizzlies were "garbage-addicted" and haunted the dumpsters—and when the dumps were closed the Grizzly numbers declined radically). It is mainly vegetarian. Its way of grazing like a cow, and munching acorns, its love of young vegetation and the vast quantities of berries it eats gives Grizzly meat a sweet porky taste.

Early explorers in the west of America marveled at the size and power of the bear. It was the Lewis and Clark Expedition's report describing the Grizzly that resulted in the bear's being recognized as a separate species. A number of Grizzlies were sighted by the expedition and some were shot, but the bears died after only the most arduous struggle, some of them still fighting their attackers with ten rifle balls through them ("& 5 of those through his lights").

Clark said, "This animal is the largest of the carnivorous kind I ever saw." A related species, the Kodiak bear (*Ursus arctos middendorff*) is the largest carnivorous creature on earth—a full-grown specimen might be 10 feet long and 1700 pounds in weight. But Lewis and Clark were in Montana when they sighted the Grizzlies, not in Alaska where the Kodiak bear predominates.

"The wonderful power of life which these animals possess renders them dreadful," Lewis wrote. Their very track in the mud or sand, which we have sometimes found 11 inches long and 7 and a half wide, exclusive of the talons, is alarming; and we would rather encounter two Indians than meet a single (Grizzly) bear."

Until the turn of the century, Grizzlies ranged throughout the Western United States, but as time passed they have been steadily killed—poached, trapped, and shot. They vanished in California in the 1920's, and they disappeared in the Southwest in the 1930s, and by the end of the 1950s they were wiped out in Mexico. There are said to be about 800 Grizzlies in the lower 48 United States now, the majority of them in Montana, where they are still hunted for sport (the limit is 14 a year). The few hundred Griz-

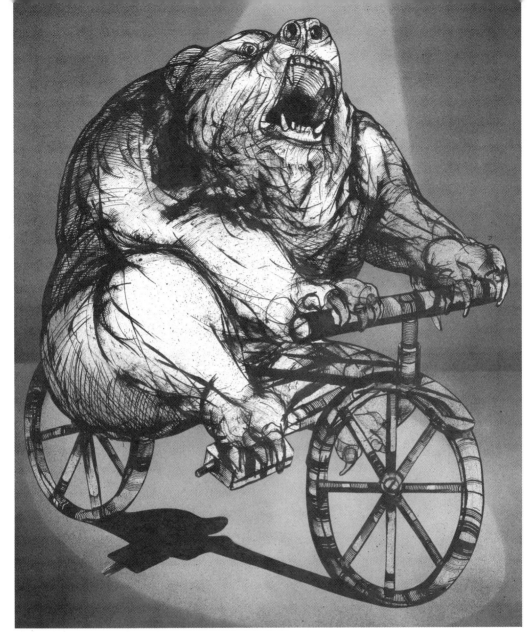

zlies in Yellowstone are diminishing in numbers. There are still large numbers of Grizzlies in Alaska and British Columbia, and even the relatively recent **Alaskan Cookbook** (*For Homesteader or Gourmet*), published in 1960, speaks of the virtues of bear meat: "Bear flesh is delicious, rich, sweet and tender, since the Grizzly and Brown bear feed principally upon vegetables, berries and salmon."

Grizzly bear meat is as fatty as pork, and because of the fat it does not need to be basted. Bear fat can be rendered into lard and this pure white lard is almost indistinguishable from pork lard, for which it is a good and fragrant substitute.

The quantity of fat on a Grizzly is understandable, when one considers their pattern of hibernation. In the Brooks Range of northern Alaska the bear enters its den in October, and there it fusses and sniffs and begins to settle for the winter, taking about two weeks to calm itself. Once it has entered this "winter sleep" it does not stir again. It does not eat, it does not urinate or defecate for the next five or six months. Its dense layers of fat keep it supplied with nutrient.

Grizzlies breed slowly and irregularly. A female does not reach sexual maturity until she is about seven or eight, and after that may have only two cubs every two or three years. She rears them

herself; the male Grizzly does nothing, and indeed may eat one of the cubs if the fancy takes him. Mortality rates for the cubs are high. In Alaska one group of bear litters was monitored and it was discovered that almost half the cubs died within four weeks of birth. The idea that Grizzlies are constantly gobbling up campers is somewhat absurd, since—outside Alaska at any rate—only 14 people have been killed by Grizzlies in the past 90 years. Many more Grizzlies have been eaten by humans.

A Grizzly intended as food should be killed just before hibernation when it is at its fattiest. Bear meat is not marbled like beef and so it is easy to trim, but marinating it always improves bear meat.

PREPARING A GRIZZLY CARCASS

■

The bear should first be bled. This is accomplished by cutting the juguler vein. When no more blood flows, the bear is decapitated—notice the unusually large and blocky head of the grizzly—and the bear skinned as completely as possible in the following way. The hide is cut along the middle of the underside from the neck to the back legs, and then separated from the flesh. The fat that lies immediately below the skin should be removed and can be reserved for rendering into lard. The hardest part of bear skinning is the removal of the skin from the head and paws.

After the bear is skinned, the legs are chopped off just below the knees. Then a large cut is made from the breastbone to the buttocks, as far as the backbone. The carcass is then gutted: the large intestine snipped and the guts hauled out.

Skinning and gutting a grizzly bear is very important, since no grizzly—no bear for that matter—should be hung in its hide. ("Think of the meat and not the rug," one cookbook advises.) The fur and fat hold heat and the meat could easily turn rancid.

MOCHI INDIAN MARINATED BEAR STEAK

■

It's entirely possible that the bear these Californian coastal Indians used for their bear steaks was the now-extinct California grizzly, a golden-haired fish-eating variety that lived on the California coast and was wiped out early in the 19th Century, perhaps in aid of this very dish.

The marinade was obviously an adaptation of a Spanish mission recipe. Marinating the meat gives it both tenderness and flavor.

Ingredients:
4 bear steaks, 1-1.5 inch thick
2 onions, sliced
1 cup water
1/2 cup maple syrup
2 tbsp. spice bush powder
1 tbsp. salt
1 tbsp. bear fat, rendered
pinch coarse ground pepper

In a large pottery bowl mix the onions, vinegar, water, maple syrup, spice bush powder and salt. Let stand for a couple of hours, then put in the bear steaks. Put in a cool place for about 24 hours, turning the steaks occasionally.

Remove the steaks from the marinade, let them

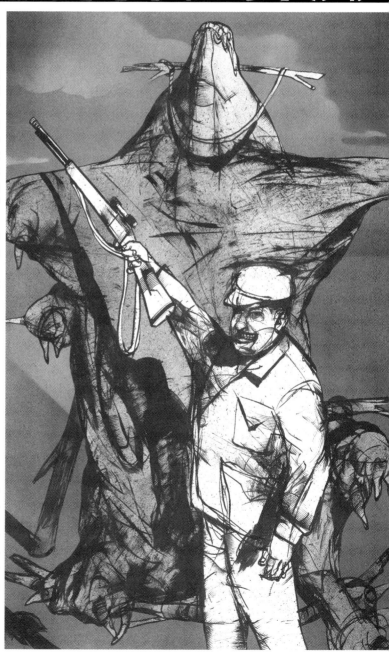

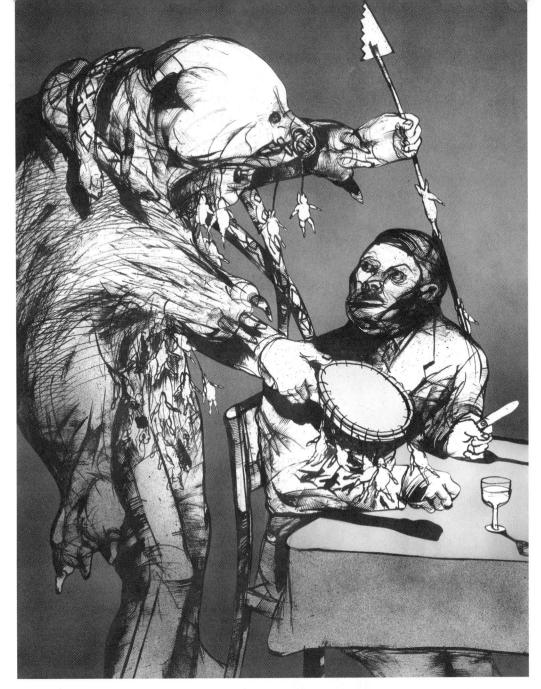

drain and pat them dry. Heat a heavy frying pan and rub the pan with the rendered bear fat. Place the steaks in the pan and sear on both sides. Lower the heat and finish cooking, adding more fat to prevent sticking. Remove the steaks from the frying pan. Add a little flour and water to thicken the gravy. Pour gravy over the individual steaks on the serving dish. Serve with succotash.

BEAR HOT POT

■

Ingredients:
2 lbs bear steak, cubed
2 lbs potatoes
4 onions: flour
salt: freshly ground pepper
1/2 teaspoon cayenne
water or meat stock

Cut bear meat into serving-sized pieces. Peel potatoes and cut them into small, thick pieces; slice onions thinly. Mix salt, pepper, cayenne, and flour, and roll each piece of meat in the mixture. Put a layer of potatoes in a deep dish or bowl (wide-mouthed bean pot is ideal), then a layer of meat, next sliced onions, repeating the process until the dish is filled, ending with potatoes for the top. Fill the dish with water or stock. Bake in a moderate oven for three hours, adding more water if necessary. Serve in the dish in which it was cooked.

SPALENKA

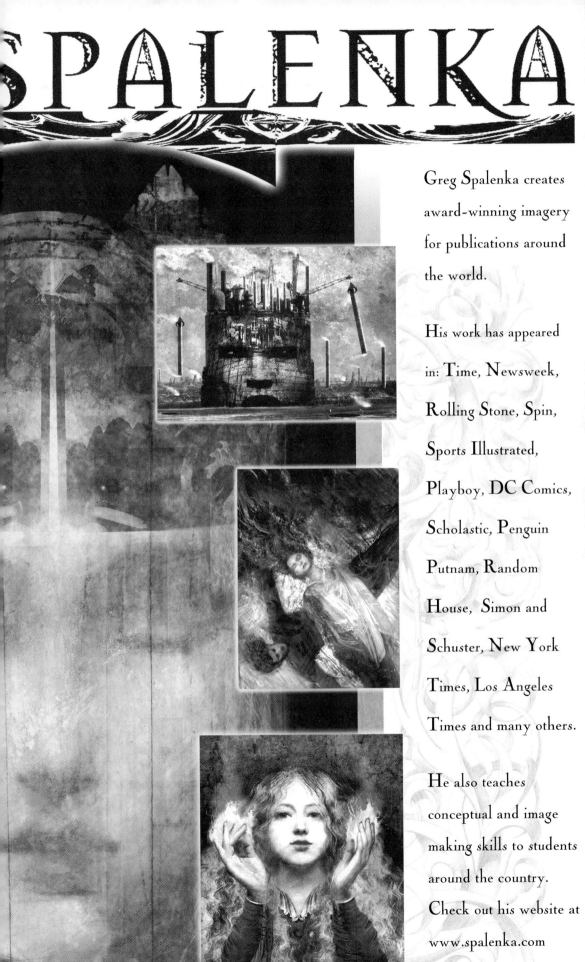

Greg Spalenka creates award-winning imagery for publications around the world.

His work has appeared in: Time, Newsweek, Rolling Stone, Spin, Sports Illustrated, Playboy, DC Comics, Scholastic, Penguin Putnam, Random House, Simon and Schuster, New York Times, Los Angeles Times and many others.

He also teaches conceptual and image making skills to students around the country. Check out his website at www.spalenka.com

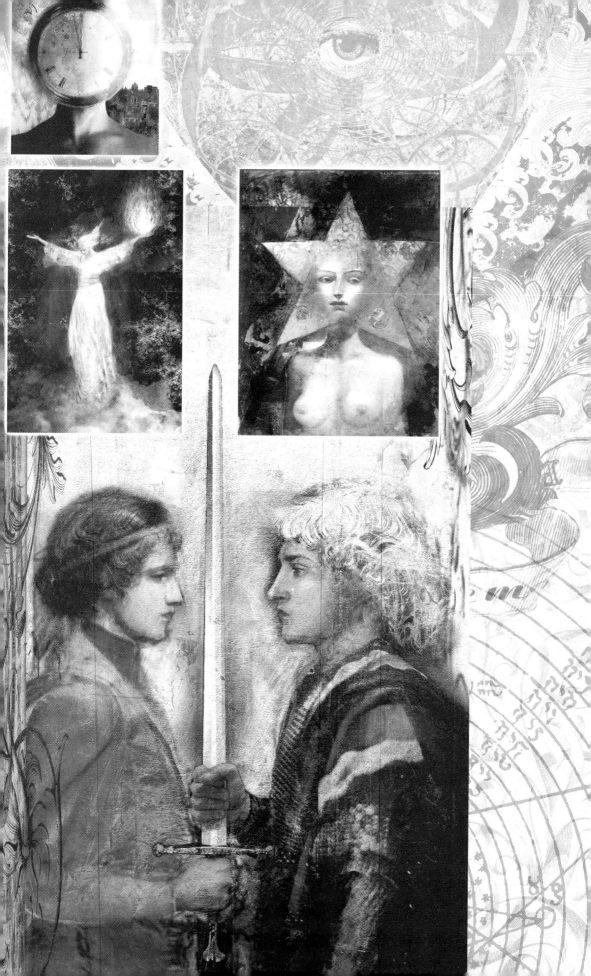

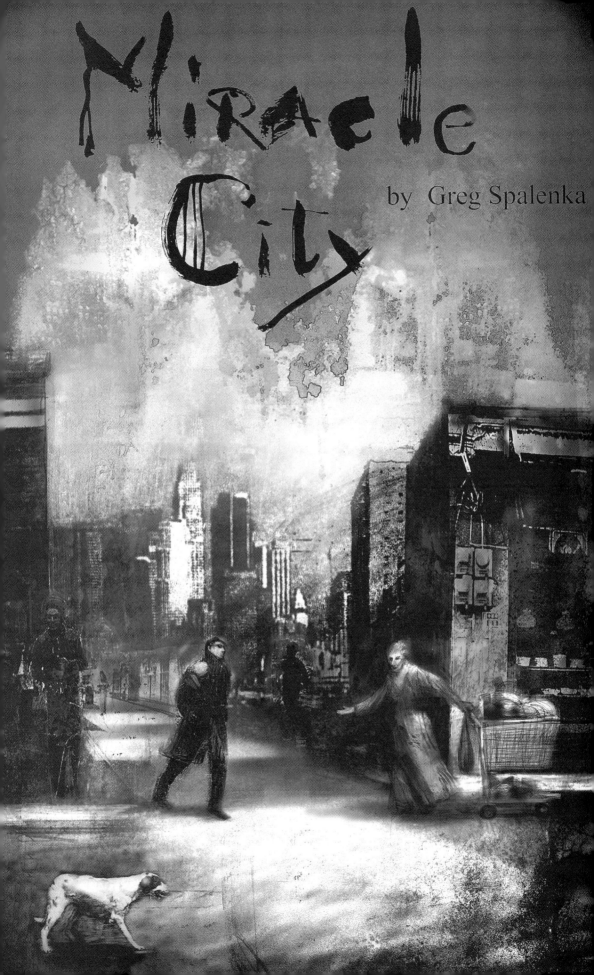

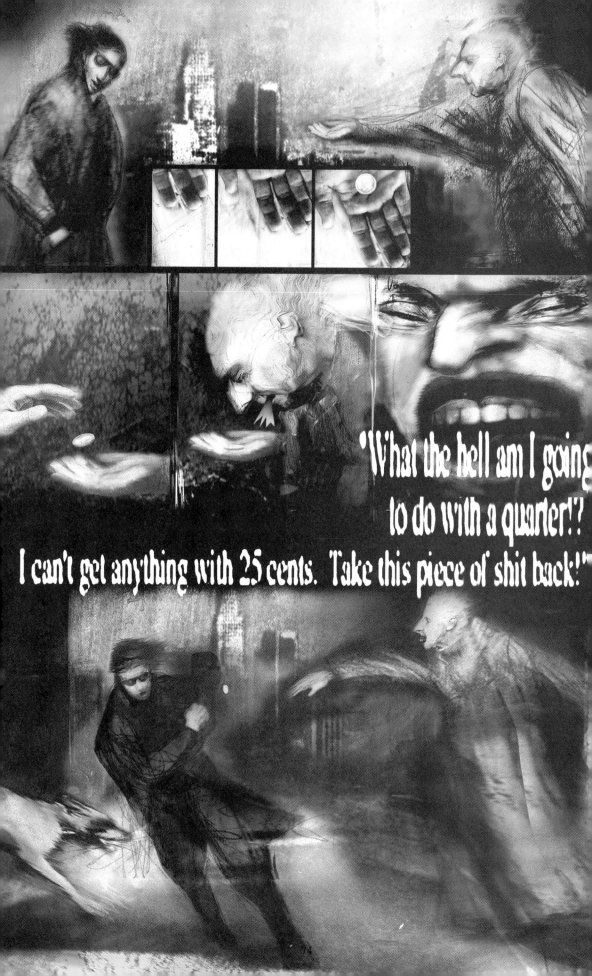

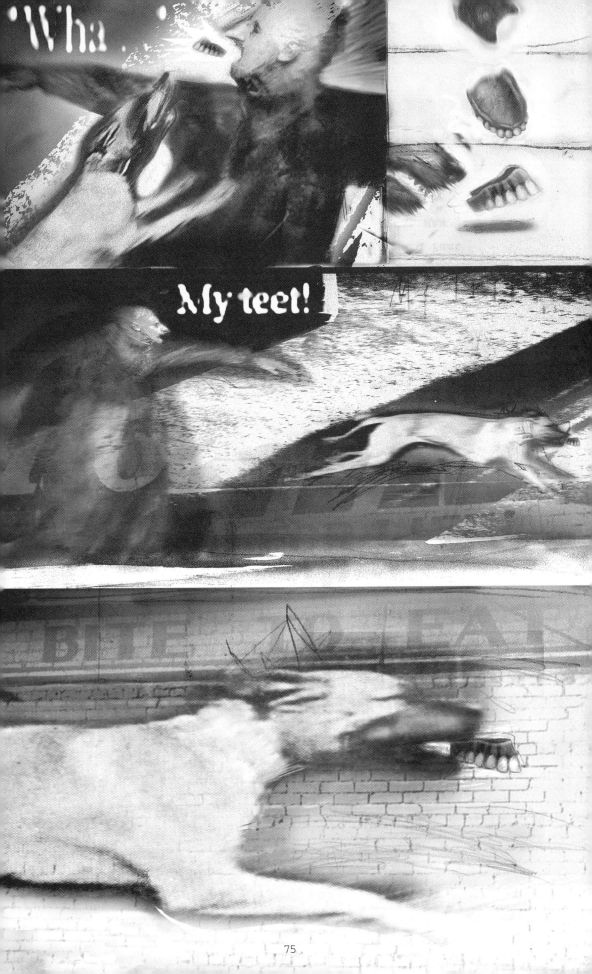

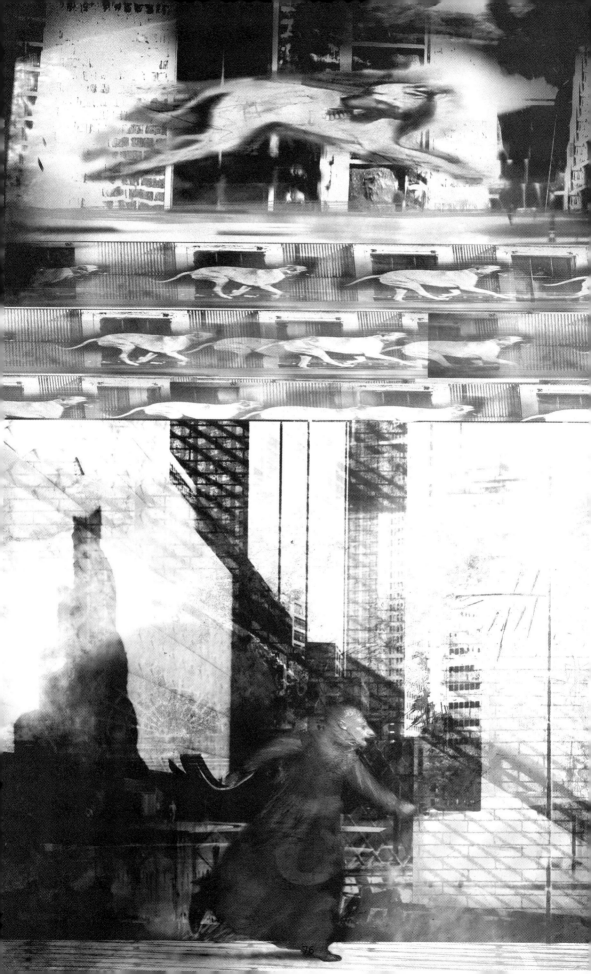

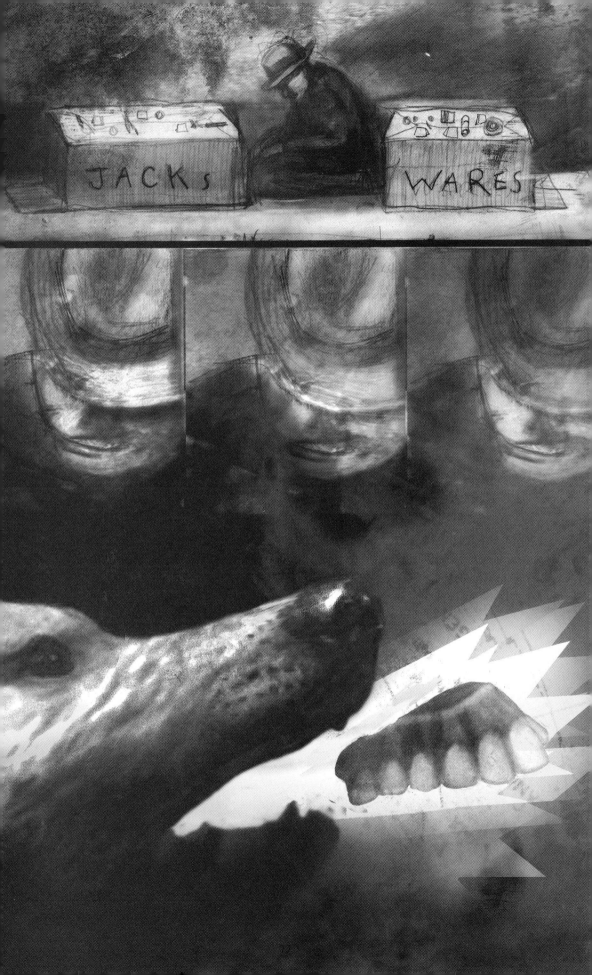

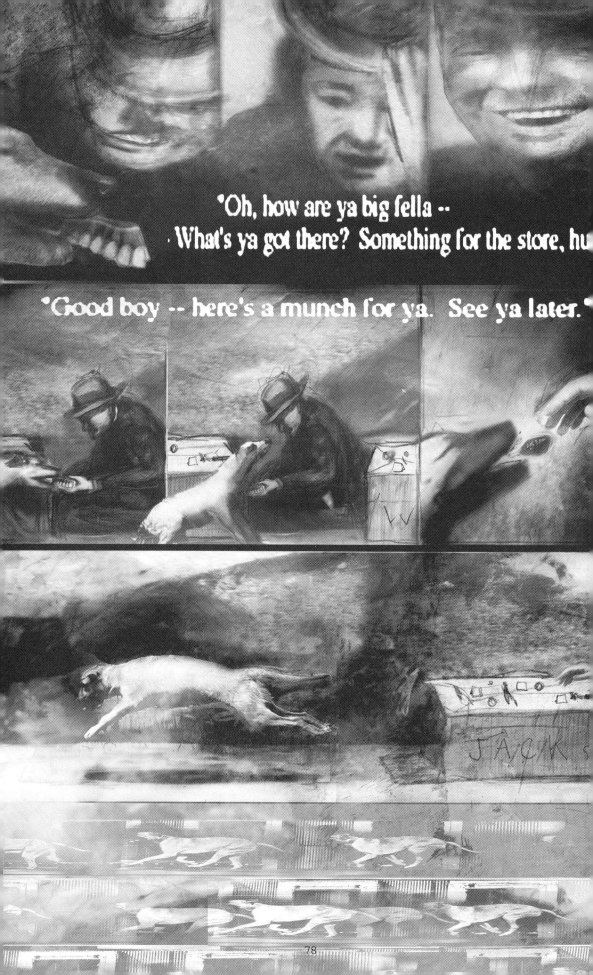

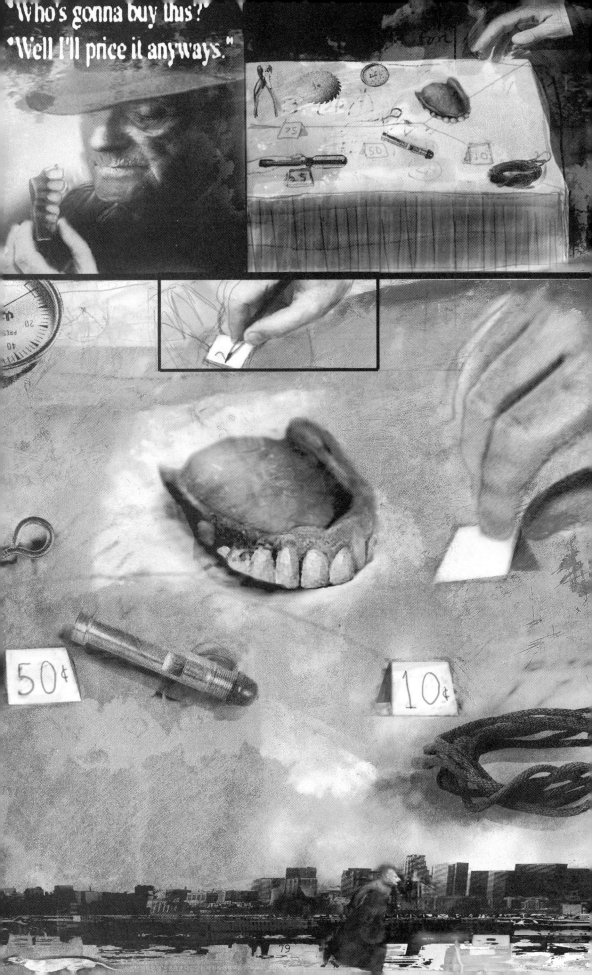

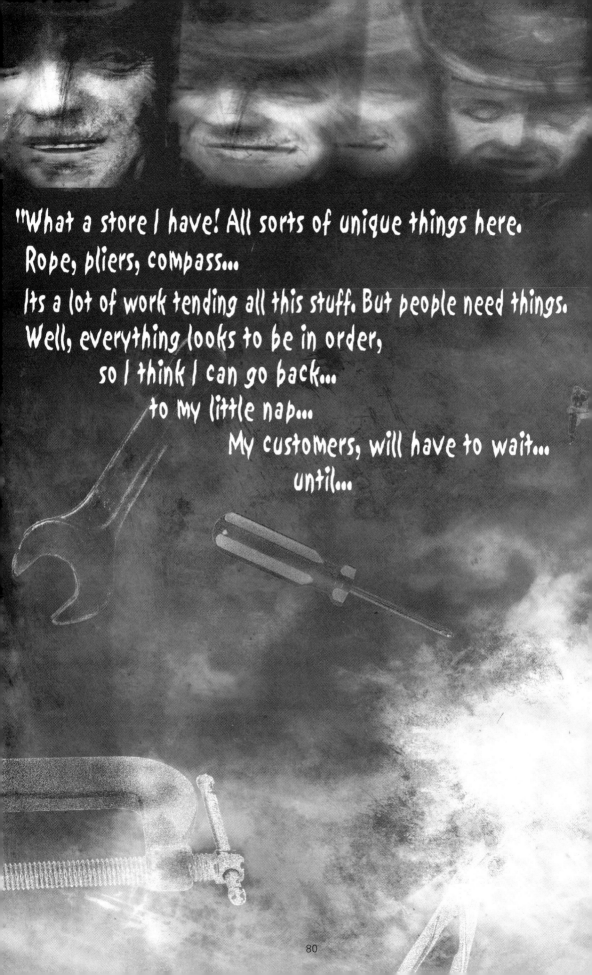

"What a store I have! All sorts of unique things here. Rope, pliers, compass...

Its a lot of work tending all this stuff. But people need things. Well, everything looks to be in order, so I think I can go back... to my little nap... My customers, will have to wait... until...

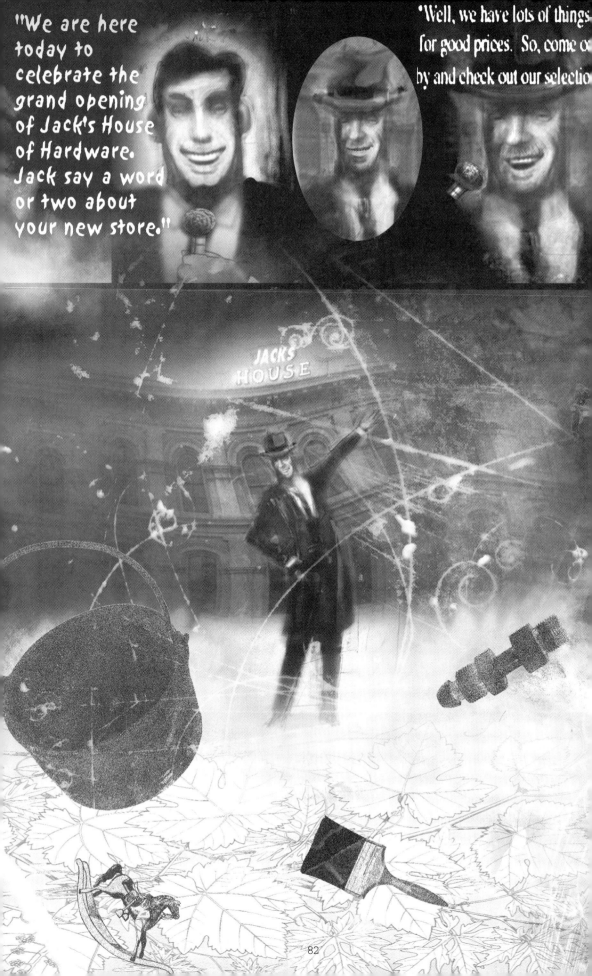

"We are here today to celebrate the grand opening of Jack's House of Hardware. Jack say a word or two about your new store."

'Well, we have lots of things for good prices. So, come on by and check out our selectio

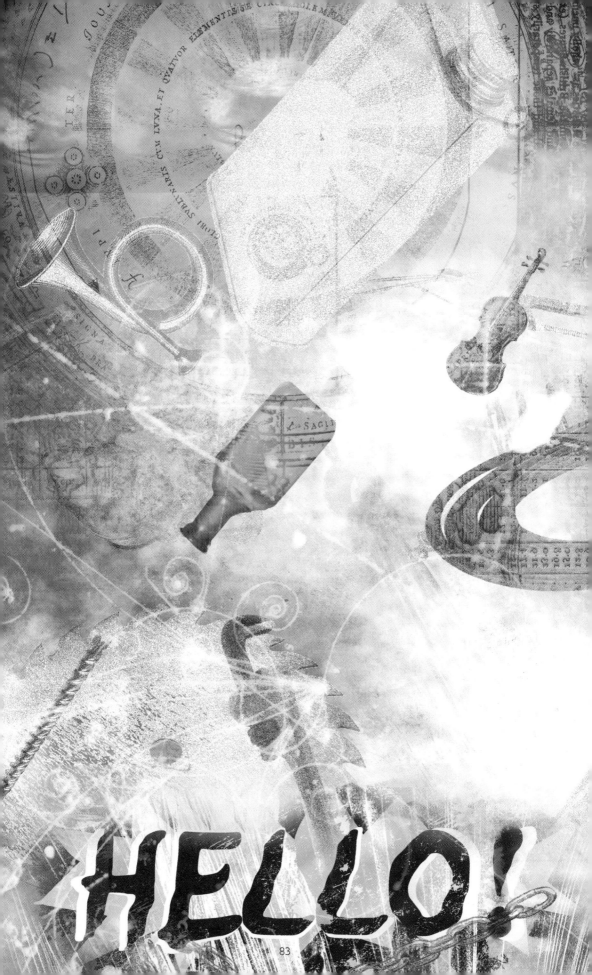

"Hello! Wake up!

"I WANT MY TEET"!

What the... What do you want

I WANT MY TEET"!

"Stop your screaming already! I have something for everybody."

You want these teeth here?

k then, these teeth will cost you...

25¢

25 cents?
"I dont have 25 cents. Those teet are mine!"

hose teeth are yours after you
y for them! This is a professional
tablishment! You dont get merchandise
r free here. I am sorry I can'thelp you.
u will have to go somewhere else."

"Please, I really need those teet. Please."

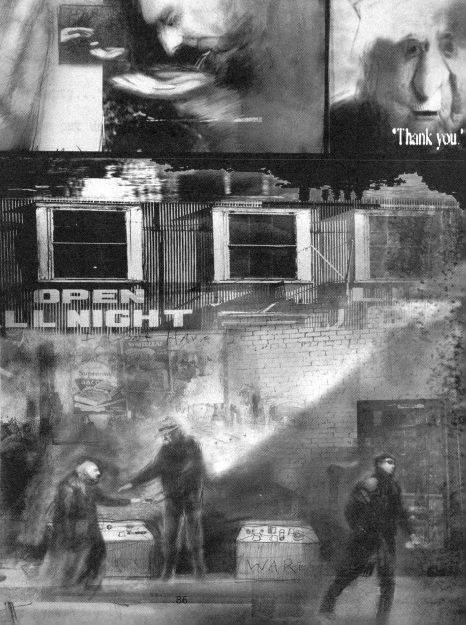

'Yo! Ya dropped something back there.'

'Thank you.'

OPEN ALL NIGHT

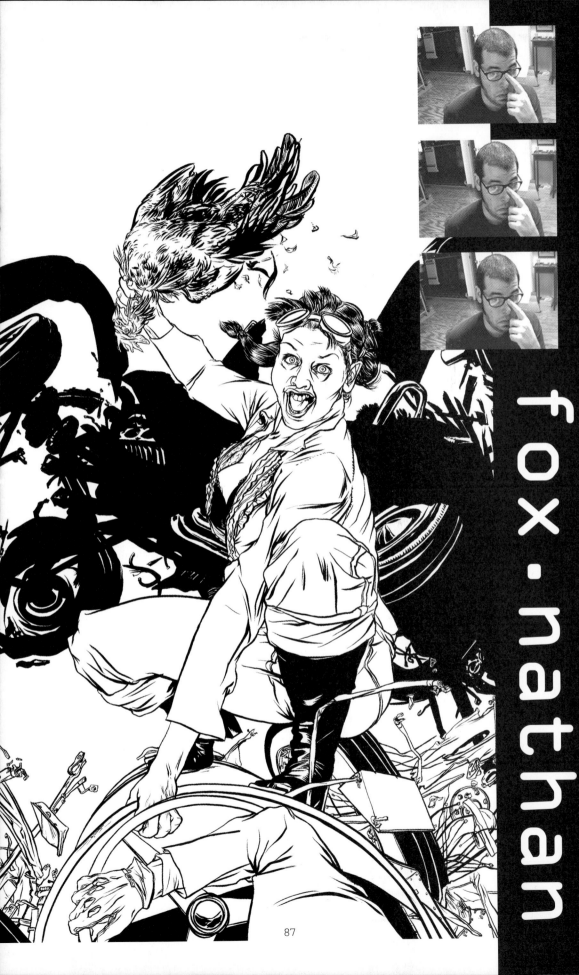

fox·nathan

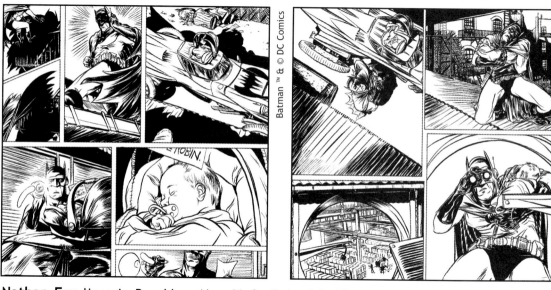

Nathan Fox lives in Brooklyn, New York. Raised in Houston, Texas, the artist fled to Kansas City, Missouri where he received his B.F.A. at the Kansas City Art Institute. Fox then moved to New York to attend graduate school where he recently received his Masters of Fine Arts in Illustration from the School of Visual Arts in Manhattan. His illustration work quickly began to appear in the **New Yorker, Village Voice, The New York Times, Wired** and other top publications. Initially discovered and/or approched for comics work by J. David Spurlock, Nathan produced his maiden story for **EDGE** which, after some delays, finally appears here. Follow up comics work of Virtago's **Fight for Tomorrow** # 4 cover, the **Batman Black & White** story *Sidekick* with Kimo Temperance, and **Harley Quinn** #31 for DC have also appeared.

Log onto *www.foxnathan.com* for further information, and an online portfolio.

Nathan would like to thank: Marshall Arisman, Joe & Whitney, Jim Mahfood, Ben Zackheim, *eaters and sleepers*, Jennifer Hade and J. David Spurlock.

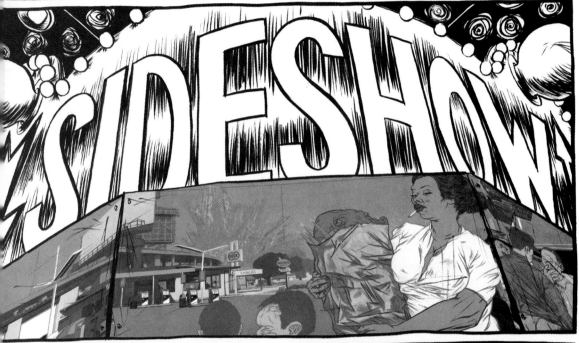
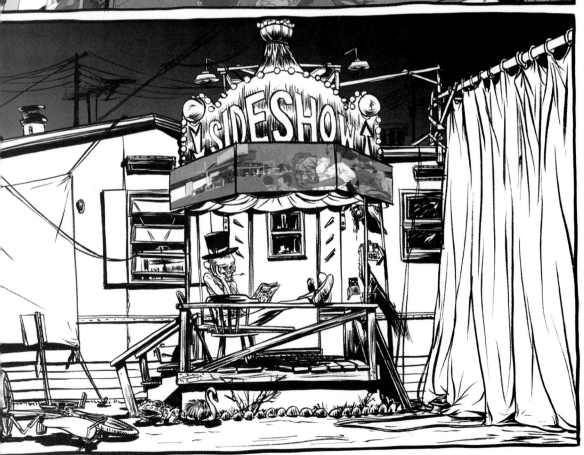

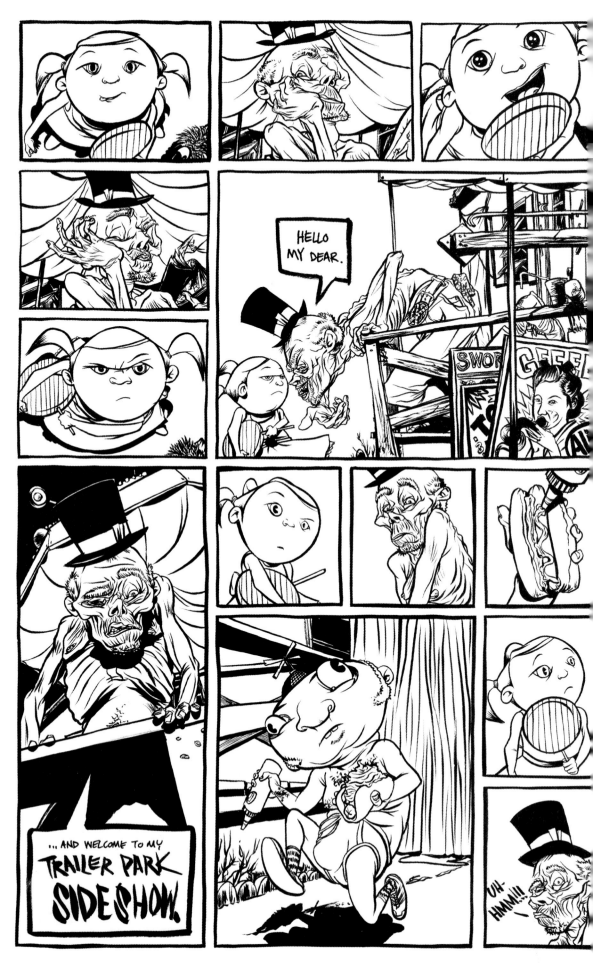

.. STEP RIGHT UP MY DEAR AND [S]E THE GREATEST [FR]EAK'S ON EARTH. [BR]UISED IN [FA]MILIARITY,...

...WHAT LIES BEYOND THAT CURTAIN IS A TALE OF A TRAILER PARK SIDESHOW, NOT UNLIKE **THIS** ONE,...

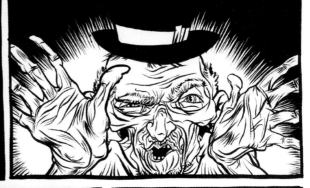
... GONE A WRY AND THE TRAGIC STORY OF THOSE WHO PARTICIPATED.

NOW, TODAY...

TODAY

ONLY!

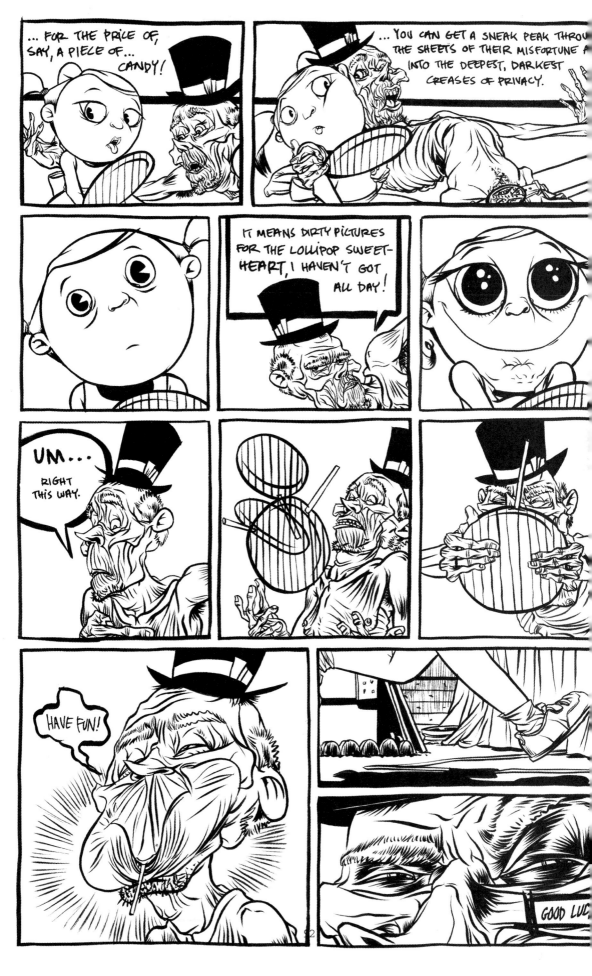

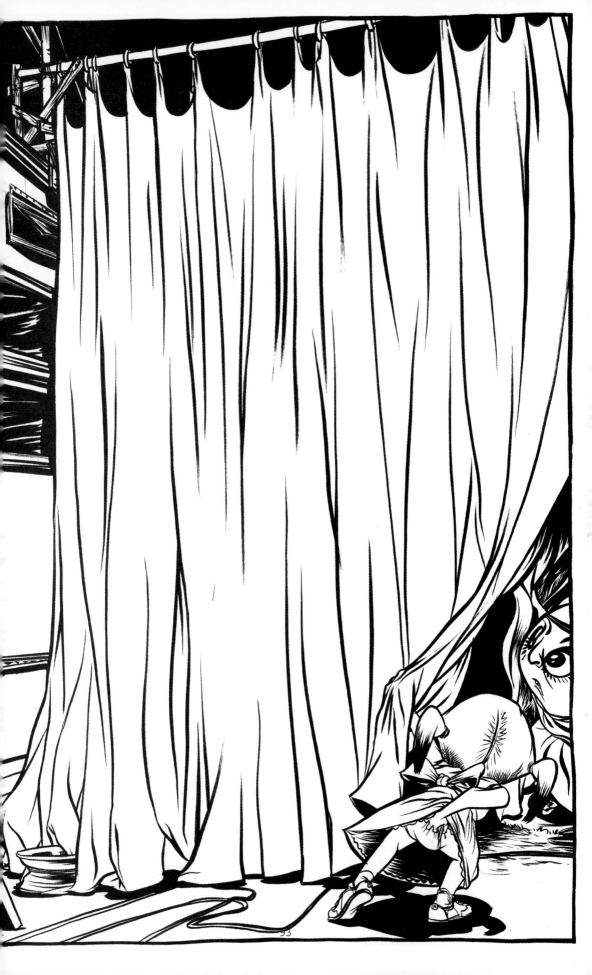

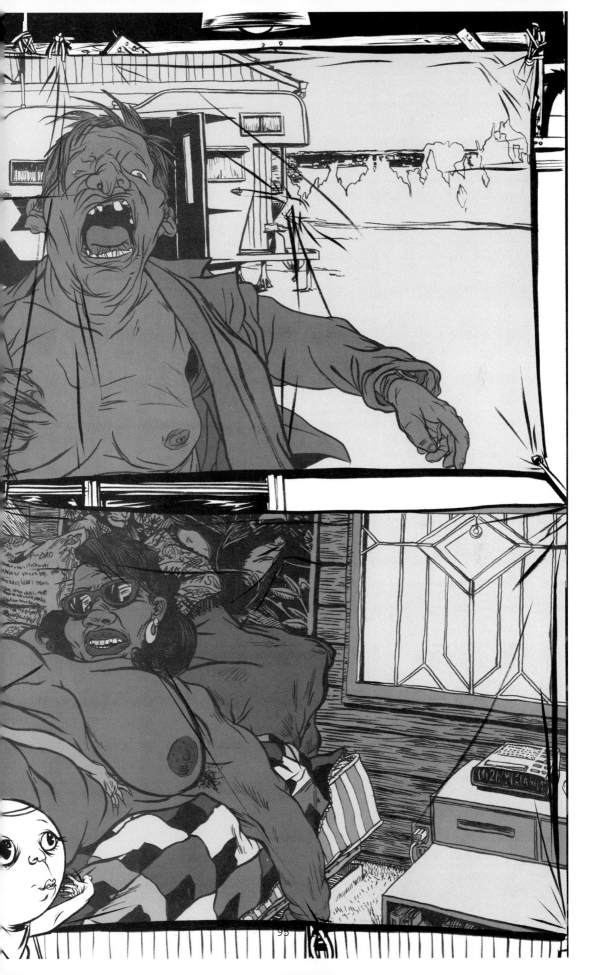

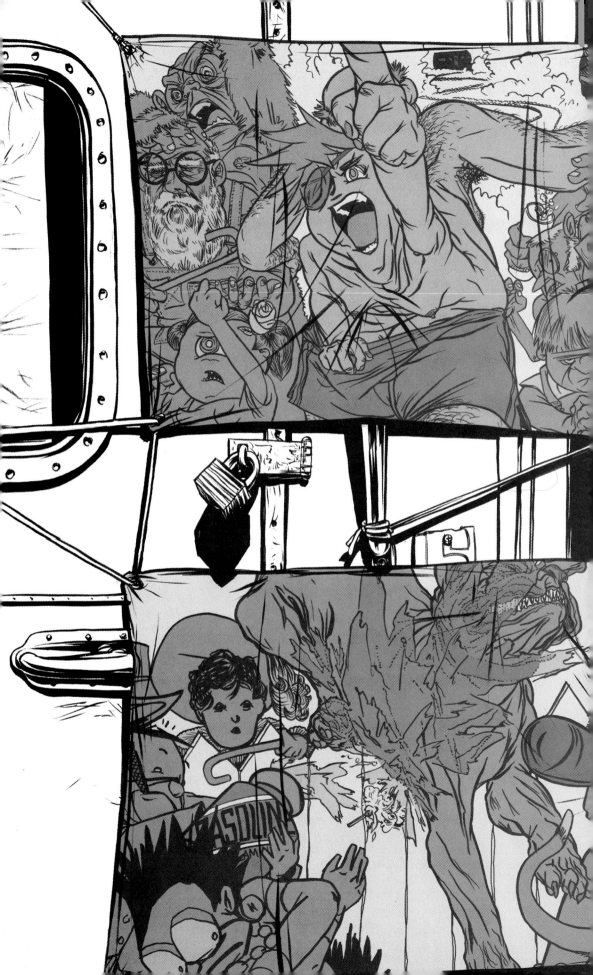

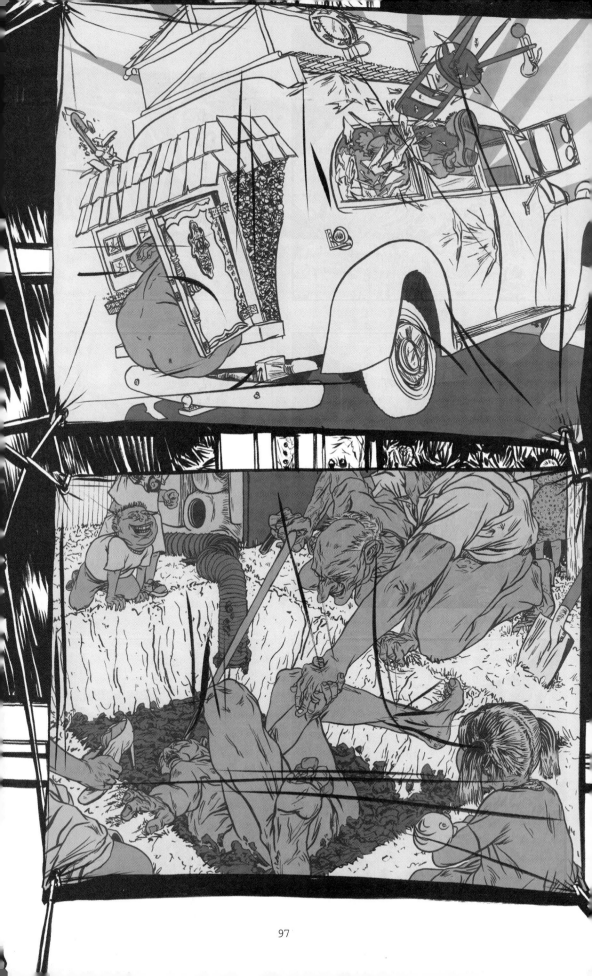

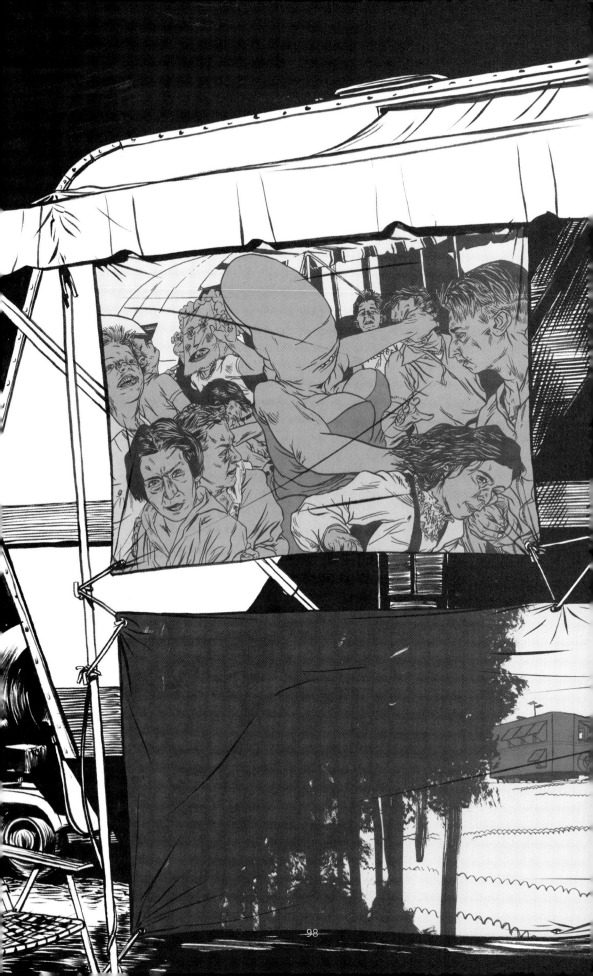

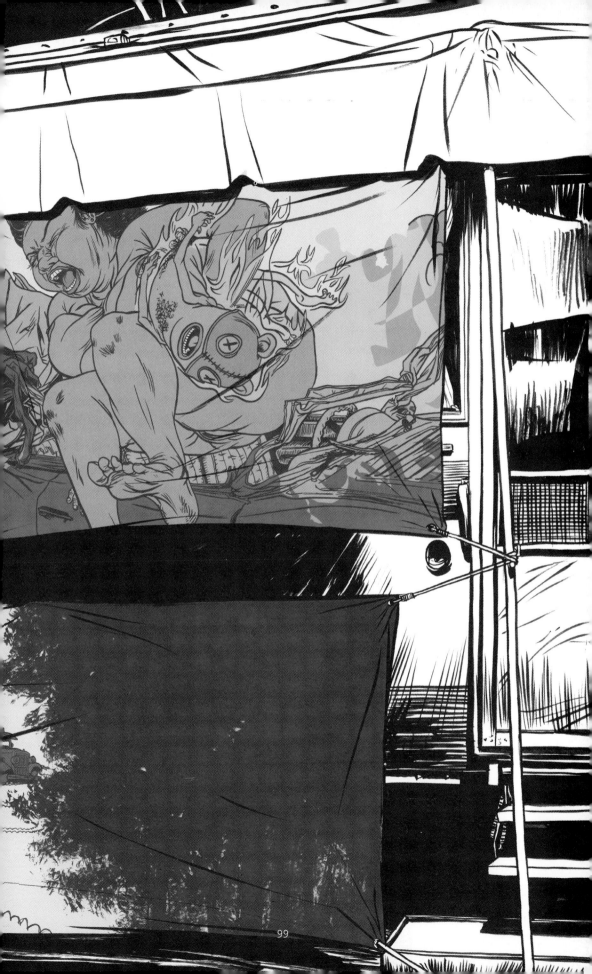

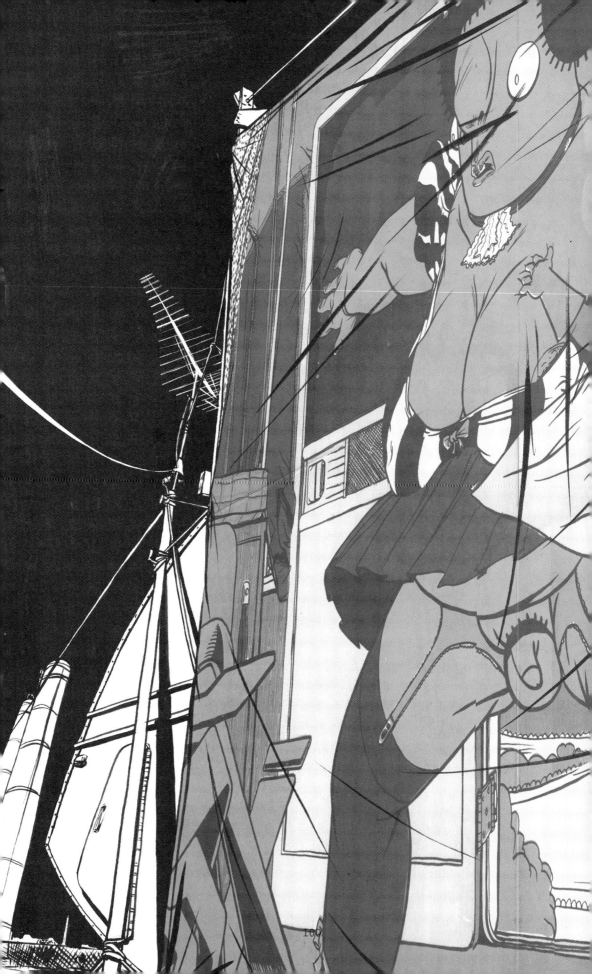

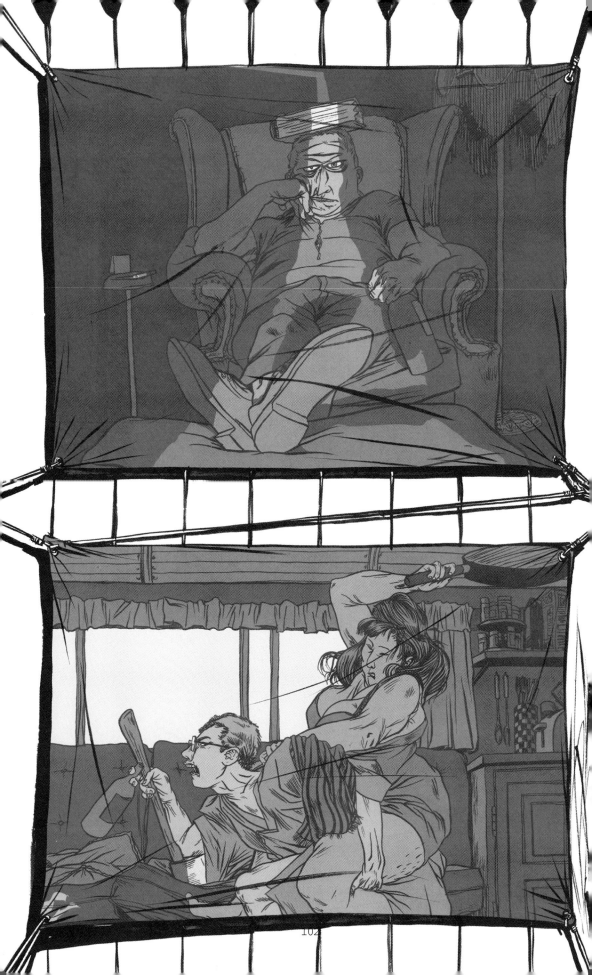

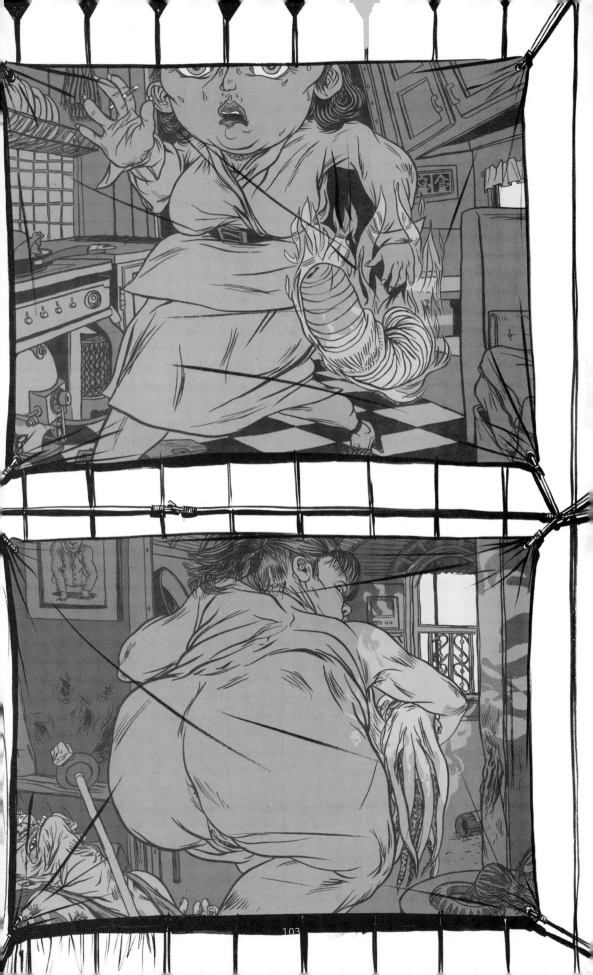

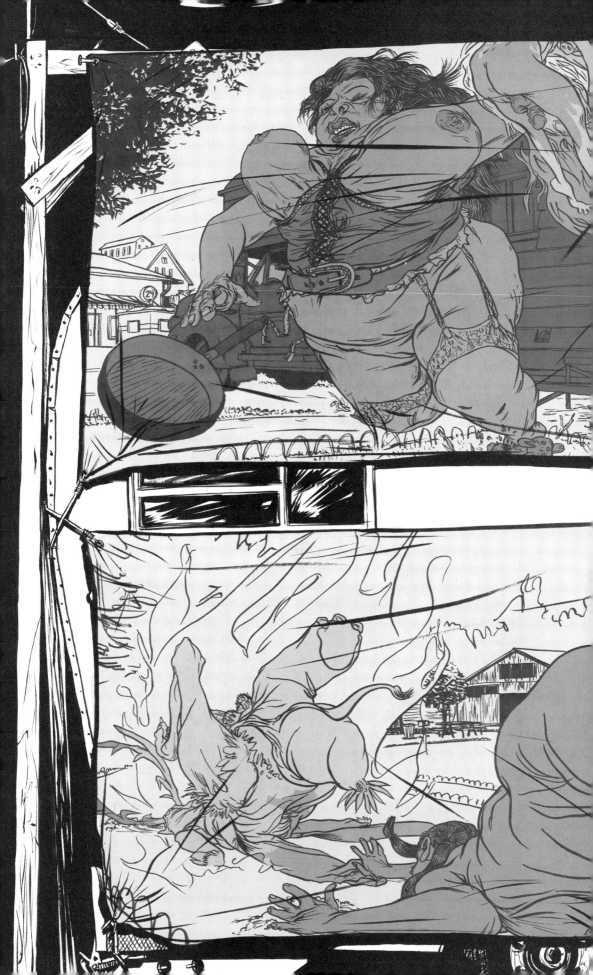

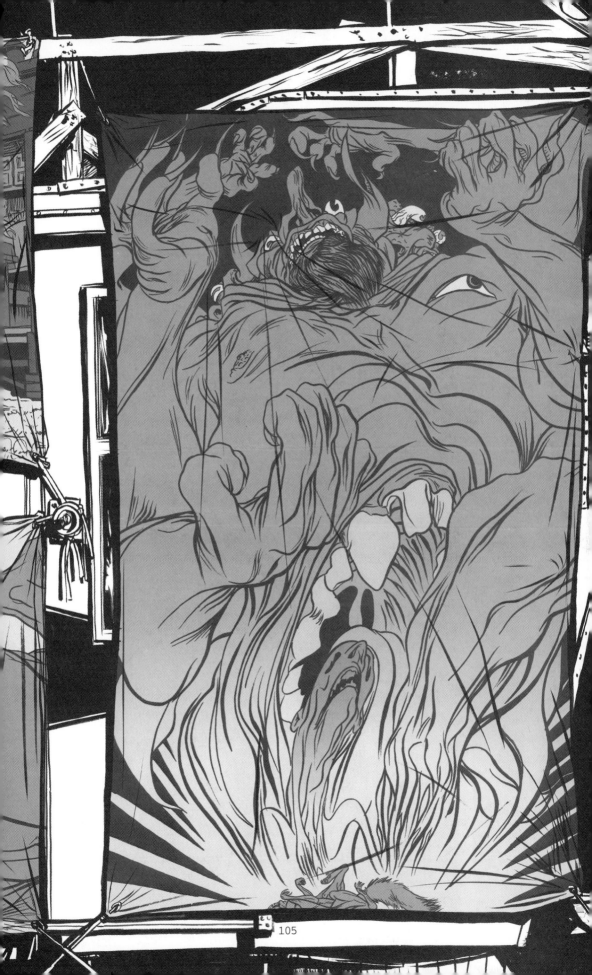

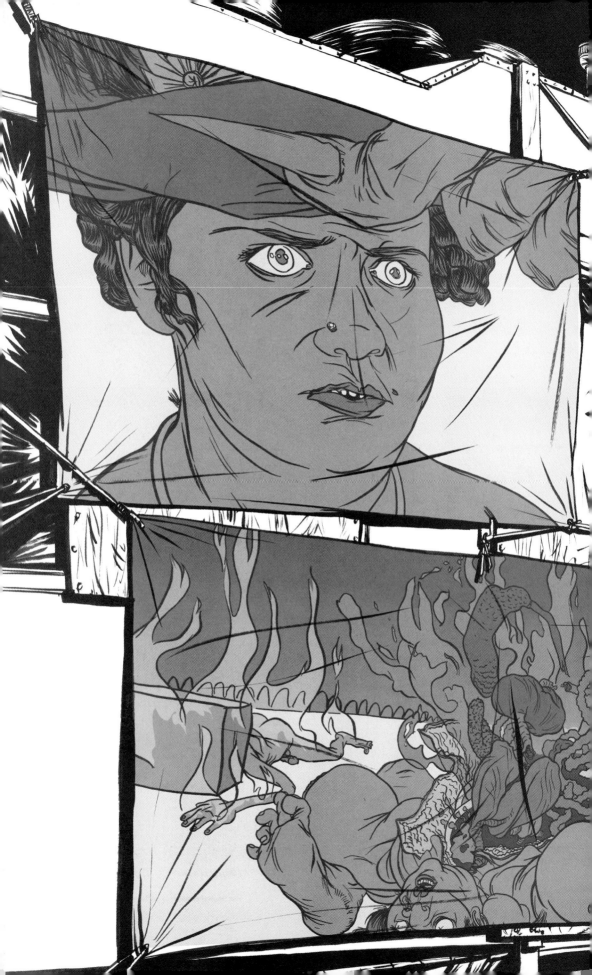

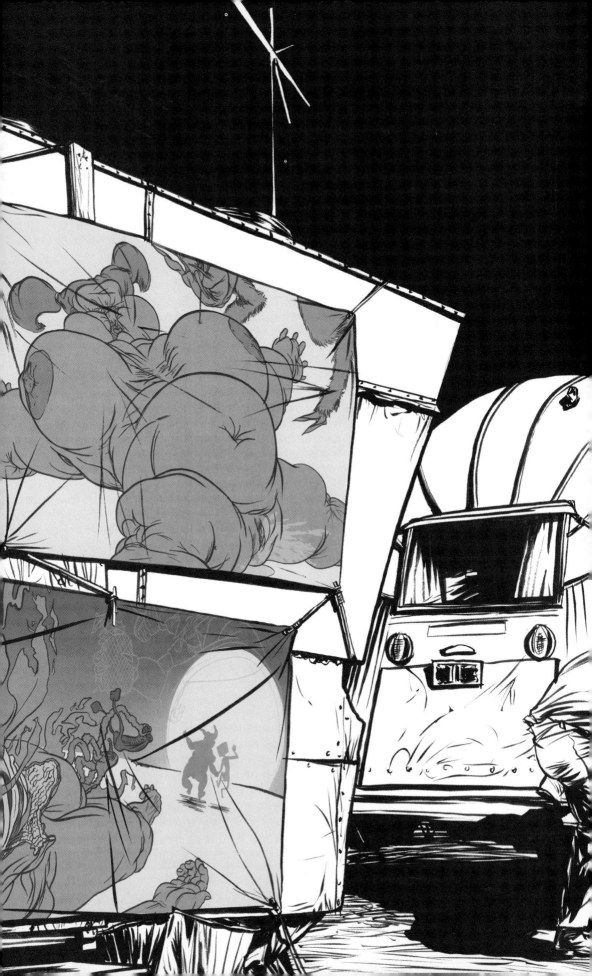

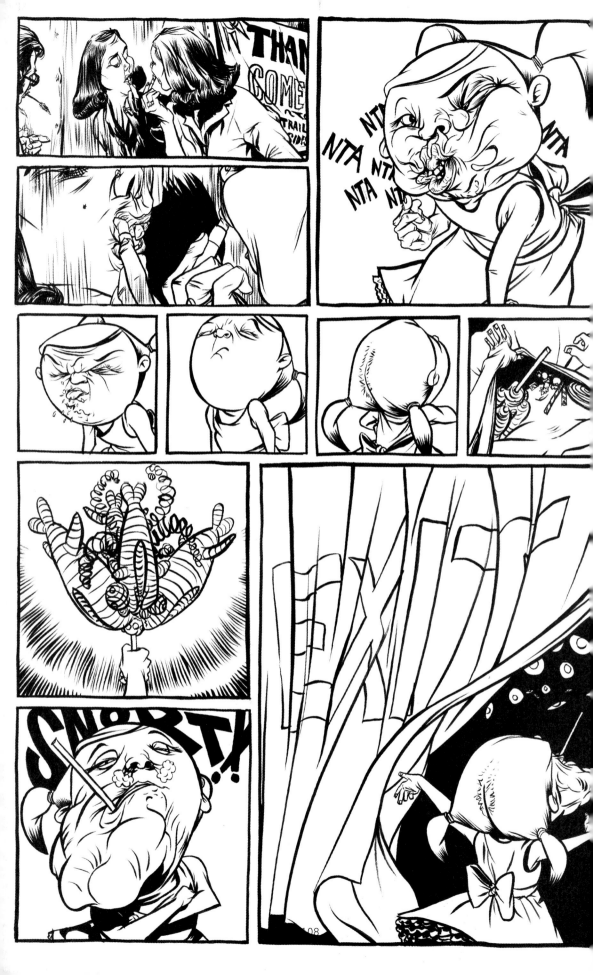

J. David Spurlock is the driving force behind Vanguard Productions, which has quickly risen to be the world's top producer of art books and biographies on the best in Illustration and Cartooning. Spurlock launched Vanguard's publishing division with the groundbreaking periodical **EDGE** in 1993. The combination comics anthology and avant-guarde art magazine actually featured a retro-style strip, Spurlock's own The Space Cowboy, as its lead feature for the first four issues. More recently, Spurlock's Space Cowboy has been awarded his own annual title. Other properties created by Spurlock include Bleugene (**BADGE** 1980), Mutant Force, The Merchandizer, Chrom-e-tek and Cleopatra Risen.

The publisher-illustrator is known to editorial and advertising art directors around the world as the Prince of Pop Art for his 20+years of commercial illustration work which melds the best of pop-art styles in a manor that inspires comparisons to Warhol, Liechtenstein, classic comicbooks, and Peter Max. The artist has collaborated with **Indiana Jones** designer Jim Steranko, **Flash** co-creator Carmine Infantino, **Mars Attacks** co-creator Wally Wood, **Mad** magazine associate publisher Joe Orlando, **Star Wars** artist Al Williamson and more.

A long-time promoter of artist's rights and multi-term president of the Dallas Society

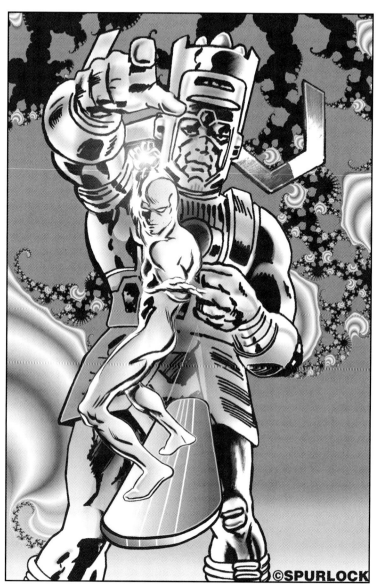

of Illustrators, Spurlock has expanded his endeavors to include representation of top talents including Steranko, Infantino, Julius Schwartz and both the Wally Wood and Pat Boyette Estates.

As well as serving as Publisher of Vanguard Productions, Spurlock's illustration and editing career includes work for Disney, Sony Records, Dark Horse Comics, Beckett Publications and MTV.

The artist's knowledge has been shared through many years of teaching at the University of Texas, the Joe Kubert School and NYC's School of Visual Arts in Manhattan. As a pop-culture historian Spurlock has authored or co-authored many books including **John Buscema Sketchbook, Steranko: Arte Noir, Monsters & Heroes for Film & Comics, Al Williamson Sketchbook, Sienkiewicz: 10,000 Gygabite Man, Wally Wood Sketchbook, Echoes: Drawings of M. W. Kaluta, John Romita Sketchbook and Eyes of Light: Fantasy Drawings of Frank Brunner.**

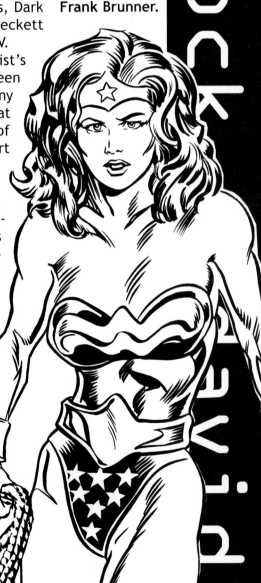

J. David Spurlock's *Stone Cold Fever: A Tale of Sledge Iris*
originally ran in EDGE #s 7 & 9. The ad below ran in EDGE 8.
Spurlock shed his traditional pop-art style to show some edgier technique
in the 1995 tale of trans-dimensional rock-star excess!

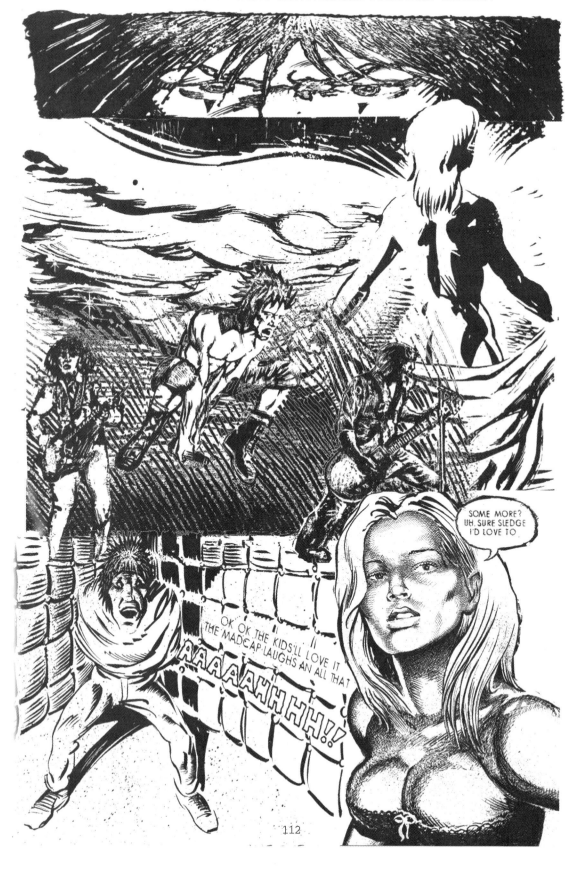

STONE COLD FEVER.

by J. David Spurlock dedicated to Steve Marriott

THERE IS AN ANGEL WHO GUIDES GOD's PEOPLE SAFELY
TOWARD HEAVEN AS THEY PASS FROM THIS LIFE

BUT THERE ARE THOSE WHO CHOSE TO LIVE THERE LIVES OUTSIDE GOD's PROTECTIVE VIEW

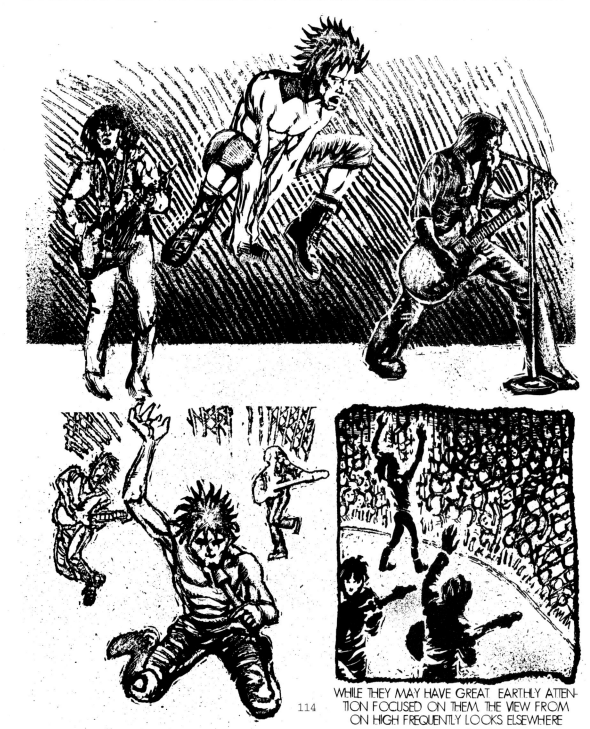

114

WHILE THEY MAY HAVE GREAT EARTHLY ATTEN-
TION FOCUSED ON THEM, THE VIEW FROM
ON HIGH FREQUENTLY LOOKS ELSEWHERE

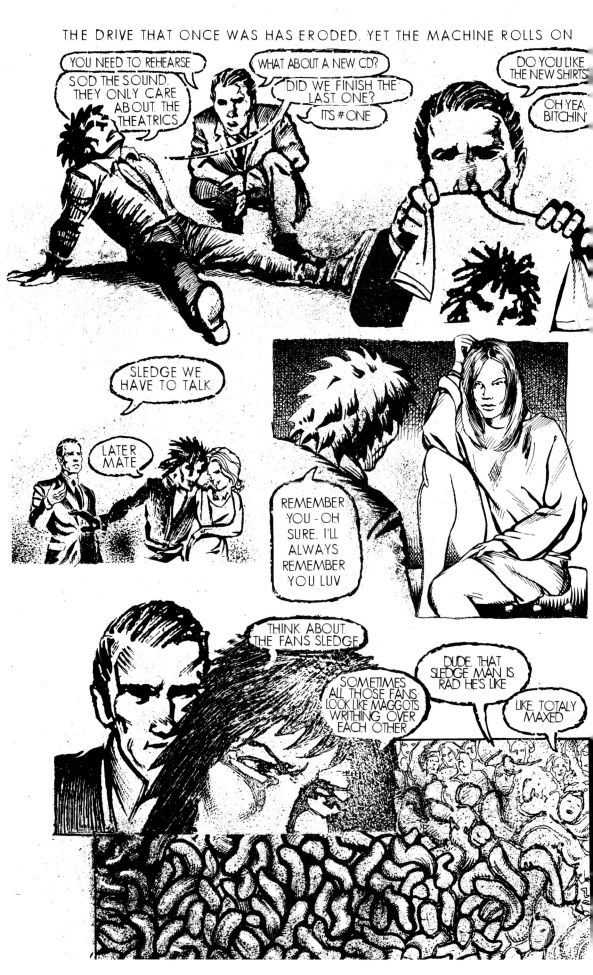

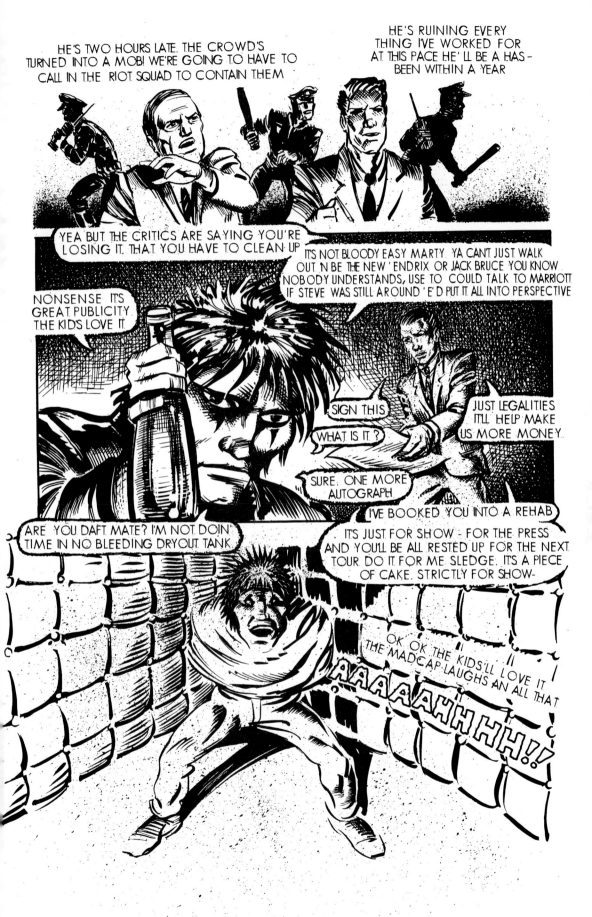

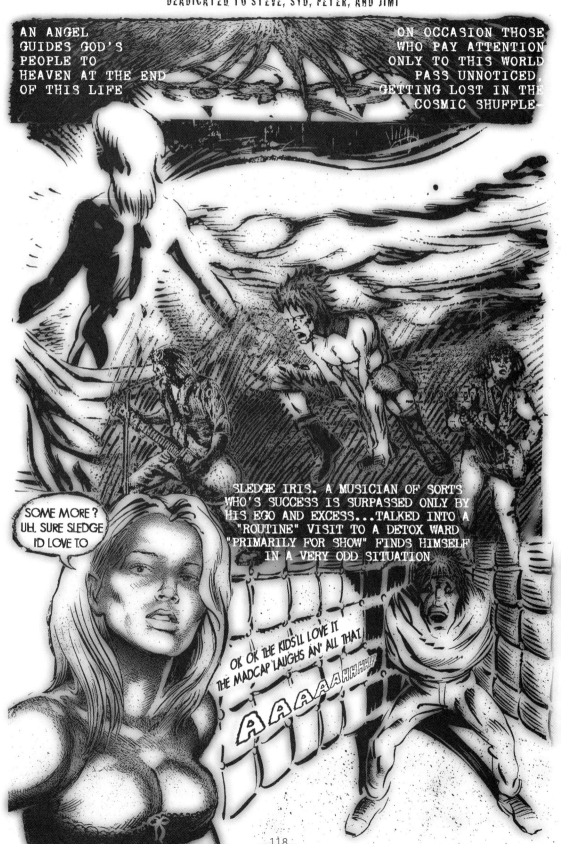

THE CONCLUSION OF
STONE COLD FEVER

A TALE OF SLEDGE IRIS By J. David Spurlock
DEADICATED TO STEVE, SYD, PETER, AND JIMI

AN ANGEL GUIDES GOD'S PEOPLE TO HEAVEN AT THE END OF THIS LIFE

ON OCCASION THOSE WHO PAY ATTENTION ONLY TO THIS WORLD PASS UNNOTICED, GETTING LOST IN THE COSMIC SHUFFLE—

SLEDGE IRIS. A MUSICIAN OF SORTS WHO'S SUCCESS IS SURPASSED ONLY BY HIS EGO AND EXCESS...TALKED INTO A "ROUTINE" VISIT TO A DETOX WARD "PRIMARILY FOR SHOW" FINDS HIMSELF IN A VERY ODD SITUATION

SOME MORE? UH, SURE SLEDGE I'D LOVE TO

OK OK THE KIDS'LL LOVE IT THE MADCAP LAUGHS AN' ALL THAT

AAAAAHHH!!!

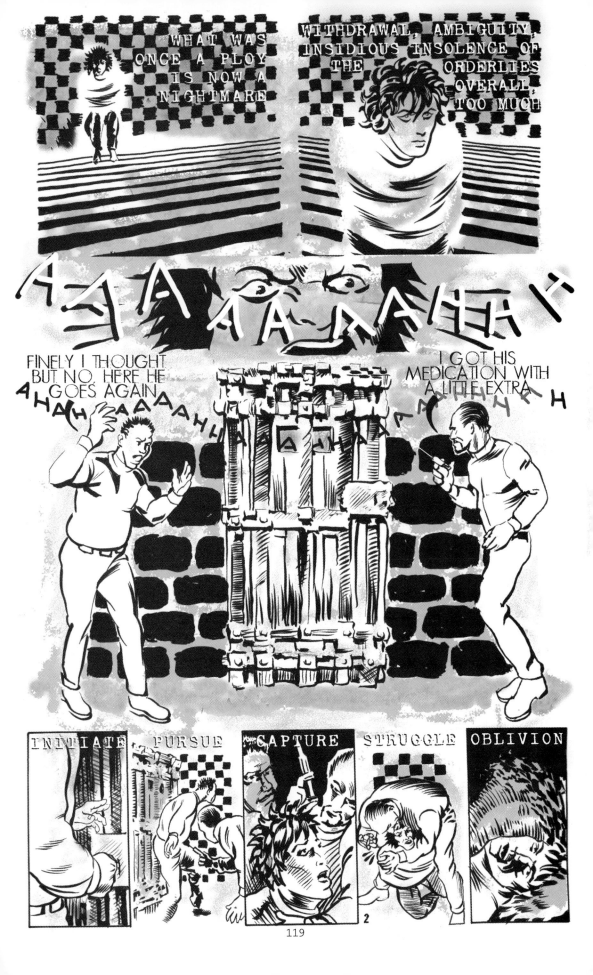

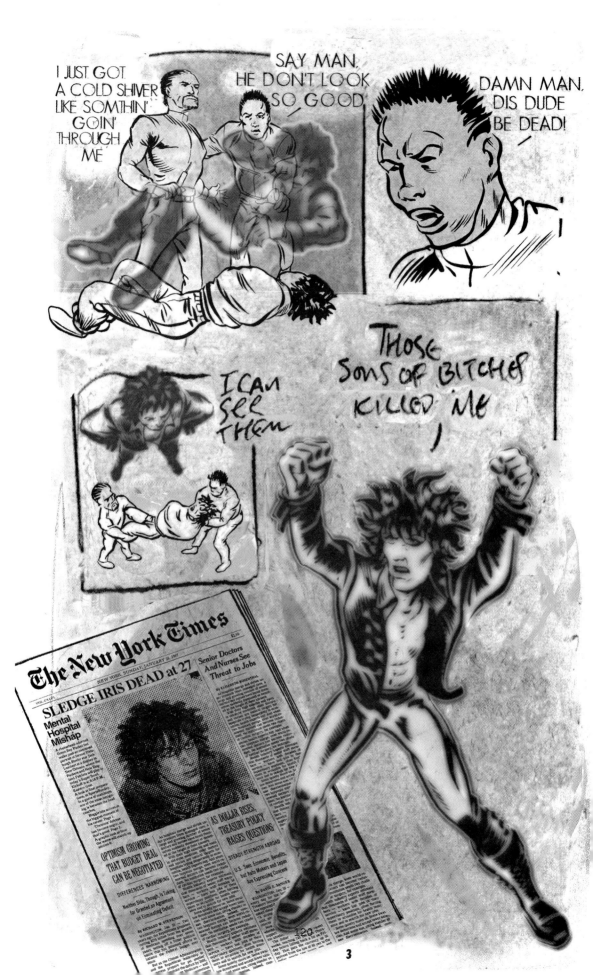

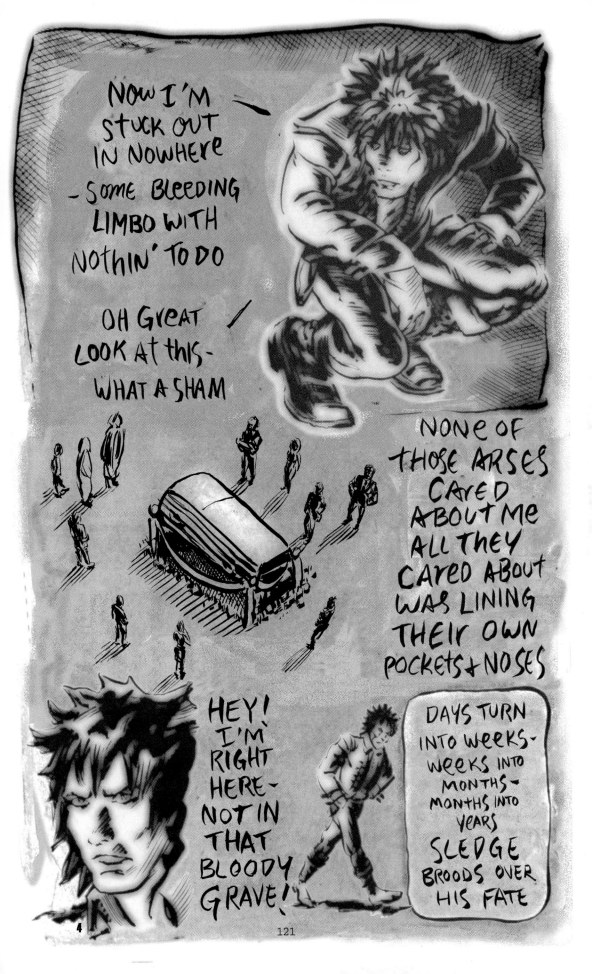

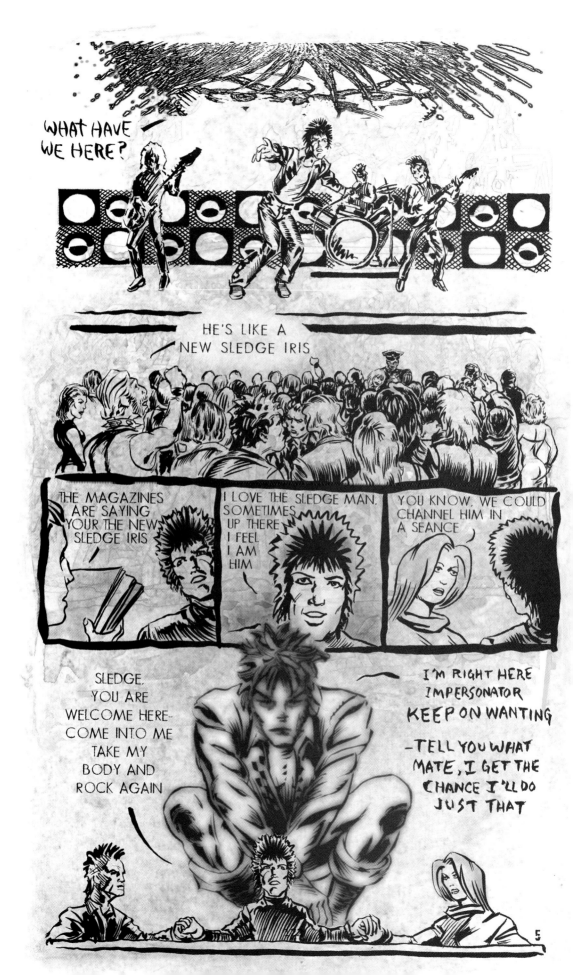

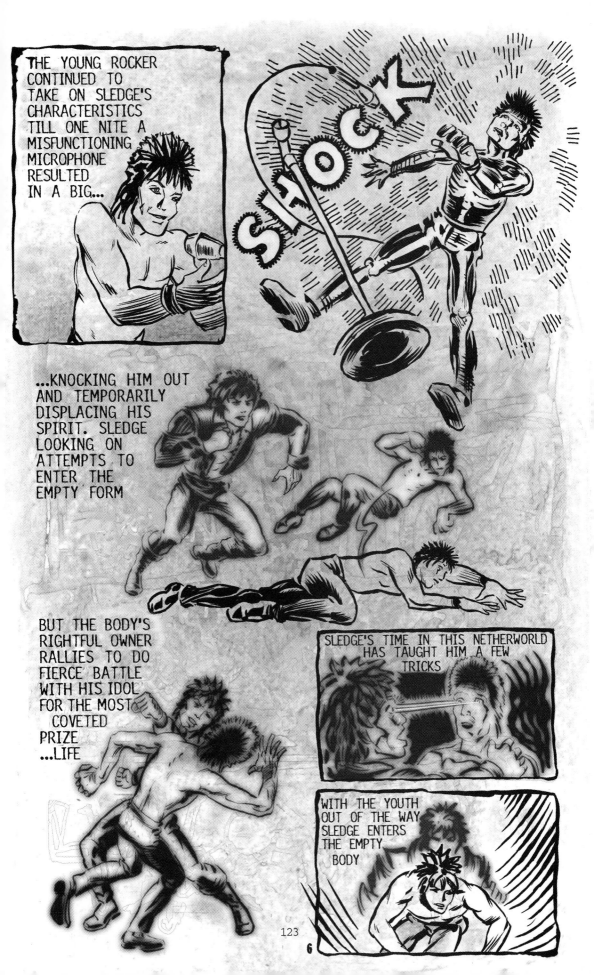

THE YOUNG ROCKER CONTINUED TO TAKE ON SLEDGE'S CHARACTERISTICS TILL ONE NITE A MISFUNCTIONING MICROPHONE RESULTED IN A BIG...

SHOCK

...KNOCKING HIM OUT AND TEMPORARILY DISPLACING HIS SPIRIT. SLEDGE LOOKING ON ATTEMPTS TO ENTER THE EMPTY FORM

BUT THE BODY'S RIGHTFUL OWNER RALLIES TO DO FIERCE BATTLE WITH HIS IDOL FOR THE MOST COVETED PRIZE ...LIFE

SLEDGE'S TIME IN THIS NETHERWORLD HAS TAUGHT HIM A FEW TRICKS

WITH THE YOUTH OUT OF THE WAY SLEDGE ENTERS THE EMPTY BODY

6

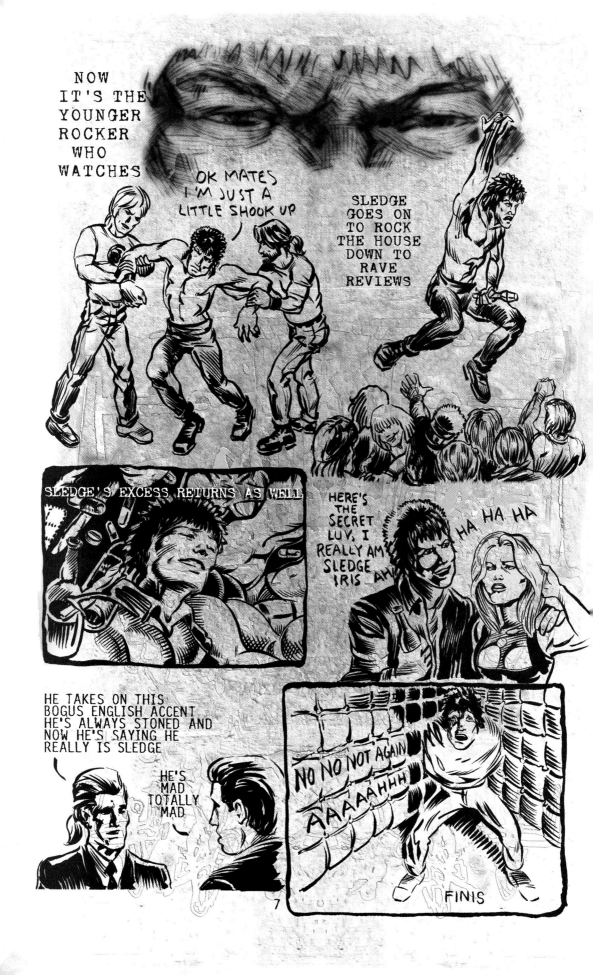

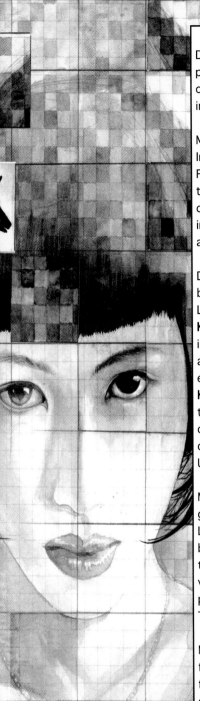

I NEVER LIKED TALKING

David Mack is the creator, author and artist of **KABUKI** published by Image Comics, and the writer and artist of **Daredevil** (one of the top ten best selling comics in the United States) from Marvel Comics.

Mack's work has garnered nominations for two 2002 International Eagle Awards in the categories of Favorite Comic Artist (Painted), and Best Cover Art of the Year (Painted), three Eisner Awards in the category of Best Painter, and both the Harvey and Kirby awards in the category of Best New Talent, as well as other awards and nominations.

David Mack is one of the only creators to be listed in both the Top Ten Writers List, and the Top Ten Artists List in **Wizard** magazine. His writing and art work on **KABUKI**, have earned him international acclaim for his innovative storytelling, mixed media painting techniques, and page design. **KABUKI** is available in seven different languages in addition to well over a million copies of **KABUKI** Comics, Paperbacks, and Hardcovers in print in the U.S. alone. Mack has toured and exhibited throughout, Europe, Asia, and America. He was the first American to be nominated for Germany's most prestigious Max-Und-Moritz award in the category of best imported Comic.

Mack's **KABUKI** books have been the subject of undergraduate and graduate university courses in Art and Literature, and listed as required reading. His work has been studied in graduate seminars at USC and hung in the Los Angeles Museum of Art. He's lectured at universities and taught classes in writing, drawing and painting, including a Masterclass at the University of Technology in Sydney, Australia.

Mack has illustrated and designed jazz and rock albums for both American and Japanese Labels (including work for Paul McCartney), designed toys and packaging for companies in Hong Kong, and ad campaigns for SAKURA art materials.

Recently, Mack has been working on the **KABUKI** feature film for 20th Century Fox. Besides writing the treatment, his film credits include, Visual Designer, Creative Consultant, and Co-Producer.

mack · david

MAKE

YOU DON'T KNOW ME

DOCTOR'S LOG.
CASE # 2001.

SOME SAY THAT THERE IS A VERY FINE LINE BETWEEN GENIUS AND INSANITY.

I'M NOT SURE THERE IS ANY LINE AT ALL.

SOME PHYSICIANS SAY THAT MADNESS IS IN SOME WAY RATIONAL BEHAVIOR THAT IS SIMPLY A REACTION TO AN IRRATIONAL SITUATION.

BUT THIS THEORY FALLS APART WHEN YOU STUDY SOME OF THE MORE EXTREME CASES OF RECENT SERIAL KILLERS.

-OR EVEN SOME OF THE DEFECTIVE AGENTS HOUSED HERE.

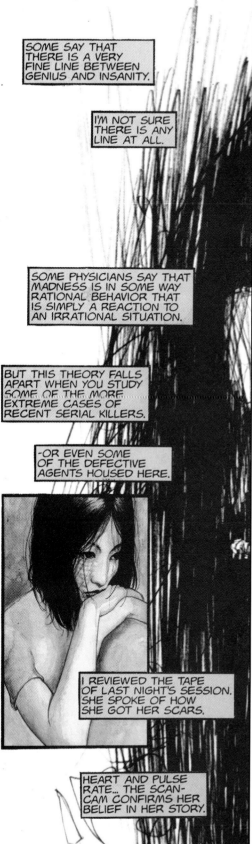

I REVIEWED THE TAPE OF LAST NIGHT'S SESSION. SHE SPOKE OF HOW SHE GOT HER SCARS.

HEART AND PULSE RATE... THE SCAN-CAM CONFIRMS HER BELIEF IN HER STORY.

WHETHER IT'S

EDGE: You're 29 years old. You have your own successful, critically acclaimed book that you write, draw and paint. You've traveled the world. You're working on a film adaptation of your **KABUKI** novels. What's next?

MACK: I have three main projects that I'm focused on right now. The first is an autobiographical type of story that will probably be called Self Portrait. The eight page story I did for this issue of **EDGE** is a preview. The art for **Self Portrait** will mostly be a mixed media of paint and collage. Much of it is taken from my personal journals and sketchbooks. The **EDGE** story is one of those.

EDGE: The other two projects...

MACK: I'm painting the new **KABUKI** story. I've also written an **ECHO** series for Marvel that I also intend to paint. **ECHO** is the deaf character that I created in a Daredevil story that I wrote. The series will deal with her Native American Mythology and the way that she perceives the world and the search for her place in it.

EDGE: Your artwork in **KABUKI** constantly changes in style and media. There are six volumes and each of them has its own visual feel with painted work that invokes fine art and collage more than what's expect of comics...

MACK: I approach the artwork on each project based on the tone of the story. I try to choose the best style or medium that I think supports the atmosphere of the script and best communicates the ambiance of the story. As a writer, I try to use the artwork as another tool of the writing. With **KABUKI**, each of the volumes fit into continuity and sequence with the other. Each **KABUKI** book is numbered on the spine. But each of these also has its own self contained story that explores different themes and deals with the next step of the evolution of the character. The **Kabuki** books are chronicling this character's life. And each volume is a different stage in her life. So I want each book to have its own literary tone, pace, rhythm, and atmosphere. In **KABUKI** I try to create my own, new, graphic language. A lot of this has to do with why I started doing comics in the first place.

EDGE: Why did you choose the comic book medium?

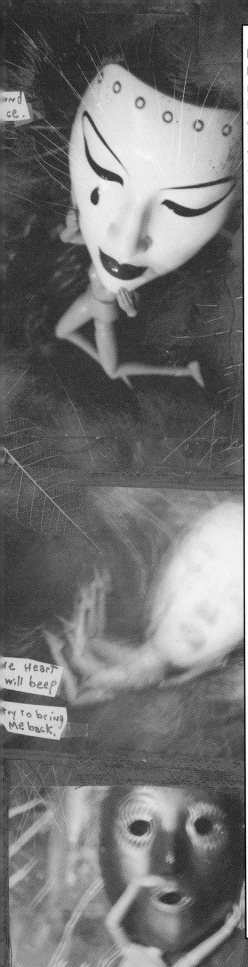

MACK: It's a hybrid that unites all other mediums. I've always been into creating stories, poetry, photography, sculpture, books, paintings, drawings and acting. I've enjoyed learning in all arts (even martial arts) and dodn't really draw distinctions. But as you prepare to leave high school, adults suggest that you specialize. They suggest what they think are "practical applications." Or they will suggest fitting your passions and skills into a college major. They may think that a passion for writing should translate into a major in journalism. But I wasn't really interested in limiting myself or fitting my interests into any conventional box or major.

With the help of my high school art teacher, I put a portfolio together to submit for an art scholarship. I had to submit ten examples of different media that I was proficient in. I had oil paintings, sculptures, photos, watercolors, inks, pencils, charcoals... I had one category left, and I thought that I would love to show that category as a proficiency in sequencial art—a story. I had read comics as a kid, so I decided to make a comic book as my final category. Once I immersed myself into the process of constructing and completing my first full comics story, I realized that I could integrate all other mediums into it. So at 16 years old, as a senior in high school, that was when I decided that I would work in the comics medium. I got several scholarships to different schools. I ended up not going to a specialized art school, but to a university. This was great because I was able to take a diverse array of classes and then apply them directly to my work in comics. It gave me a much broader range of inspiration and knowledge. I took Anatomy and Physiology, Japanese Language, Theater and Acting, Childrens' Literature, Philosophy and World Religions, and was even able to compete in the college Karate tournaments. I earned a BFA in Graphic Design and a minor in English. The Design degree covered all the other areas of art such as painting, photography, Art History, Sculpture etc. And Graphic Design was taught as an integration of type and image which is the way that I approach my comic book work. I began working professionally in comics my freshman year of college and continued to do so, constantly applying everything that I was soaking up along the way.

127

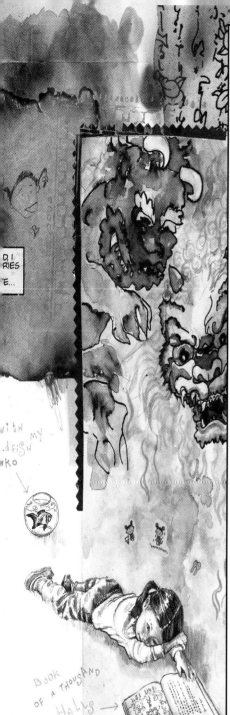

DI
RIES
E...

with MY
.d FiSh
KO

BOOK OF A THOUSAND Hells →

JAPAN HAS A HELL
FOR EVERYTHING.
ALL OF WHICH SERVE
MOSTLY TO FRIGHTEN
YOUNG CHILDREN.

I was an outsider in all of my classes. I was too design oriented to the fine art cliques and too fine art for the computer cliques. But I kept my focus on my personal work. I was working on **KABUKI** throughout college and I was applying all the knowledge from my classes directly into my comic book work. I finished the first story (**Vol 1: KABUKI: Circle of Blood**) when I was 21 and turned it in for my senior writing thesis.

EDGE: How did **KABUKI** begin?

MACK: I wanted to design a book that I could integrate all of my personal experiences, philosophies, ideas, passions, and interests into. I wanted to convey personal truths, but at a distance. I wasn't yet ready to tell a fully autobiographical tale. And I didn't want to fall into the trap of making the main character an idealized version of myself. So I made the protagonist a different gender. This gave me a veil through which to write very personal stories. I set the story in a different part of the world, different culture, different language. I was able to apply what I had learned from my classes in Japanese Language, History, and Mythology directly into the setting of the book. I could drape the intricacies of this culture over my own story. This way I could tell the story through metaphors. The universal truths could stand out, but the characters were ambiguous enough that the readers could see themselves in them, rather than just seeing me. "Give a man a mask, and he will tell you the truth", Shakespeare said.

EDGE: It is interesting that **KABUKI** was designed as a mask through which you express yourself, and that the **Self Portrait** story you included in this book is autobiographical.

MACK: A lot of the early **KABUKI** story was me dealing with the death of my mother when I was in college. My most recent painted **KABUKI** story, **KABUKI: THE GHOST PLAY**, has Kabuki communicating with her dead mother. While I feel like I can tell any personal story through the **KABUKI** series, I knew there would be a time when I would find it appropriate to strip away the veil. The **Self Portrait** story focuses a lot on me making sense of my early childhood and what I learned from my parents, and how early and surreal experiences have shaped my point of view.

While both are personal, they are not simply expression. They are designed to be interactive, to be completed in the mind of the readers. Different readers get different things out of my work based on what they bring to it. It becomes infinitely more powerful than expression. It becomes communication.

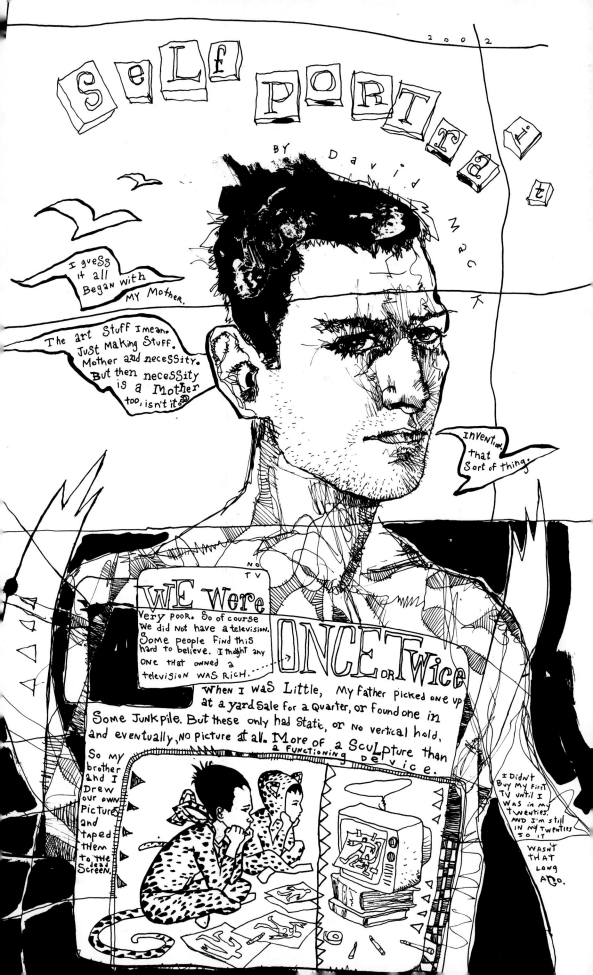

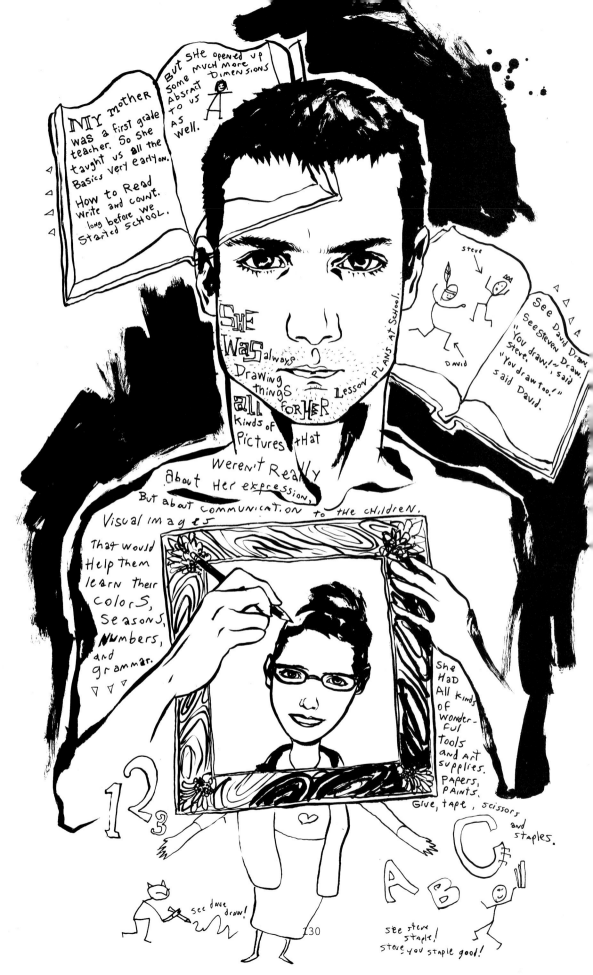

OLD BOXES SOON Became a favorite Media of mine. Empty cereal Boxes, tissue boxes, any kind of cardboard that I could cut up AND Re-fold

AND Tape INTO ANOTHER SHAPE. Toilet paper Rolls and PAPER Towel Rolls were a Real Find.

OTHER People's Garbage Became MY Treasure. Lead into Gold. A kind of Alchemy was Happening.

HOUSES, BOATS, Planes and SPACESHIPS! And even ROBOTS. I LOVED to MAKE things.

AS the discarded Boxes underwent their Transformation, A Part of Me evolved As well.

I began drawing and painting AS A WAY To put color AND Detail on the 3D Constructs.

MY cardBoard CASTLE.

Doors on castle wall can latch and open up.

insert cardboard wings thru Peanut Butter JAR.

Put plastic cup in front

ic cup

...wrapping roll.

insert cardboard wings and find thru Box.

Toilet paper Roll for Jet Engine stapled on wing.

Fold and Tape

TISSUE BOX

Empty SPOOL →

PAINT All White.

Bike reflector eyes

OPEN

Pencils As Axles

Peanut Butter lids for Wheels

RUBBER BAND Around Pencil Axle to Hold Wheel on.

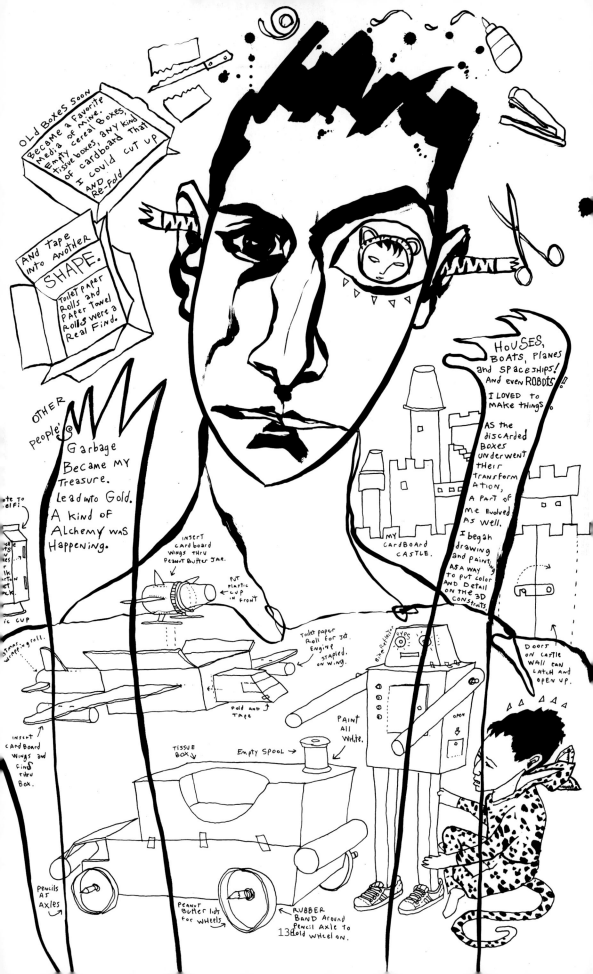

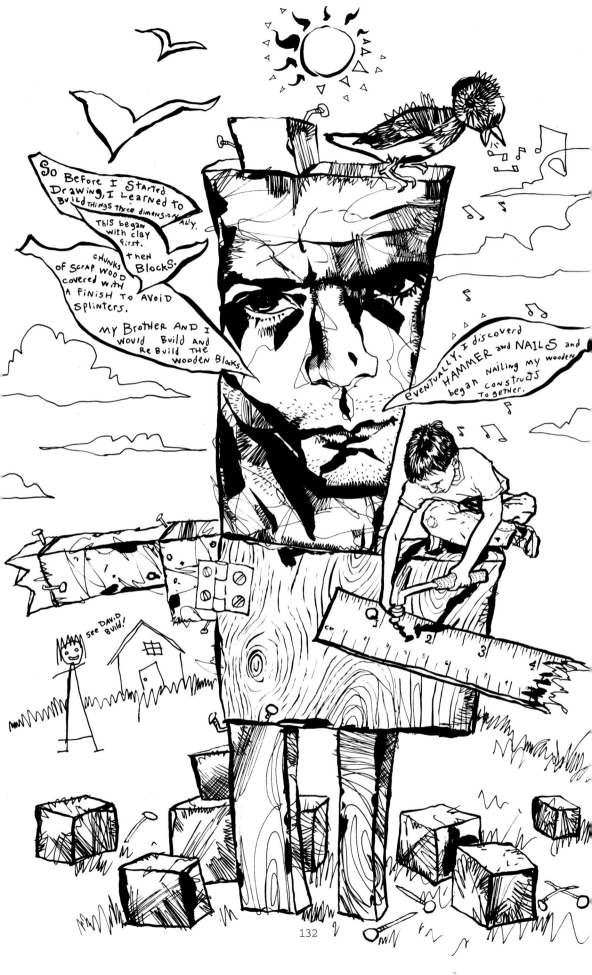

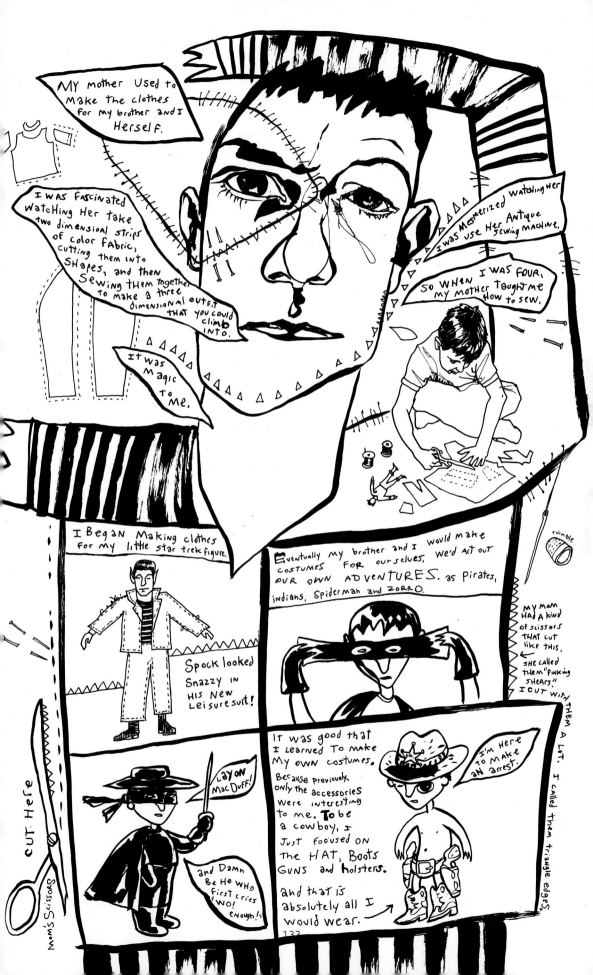

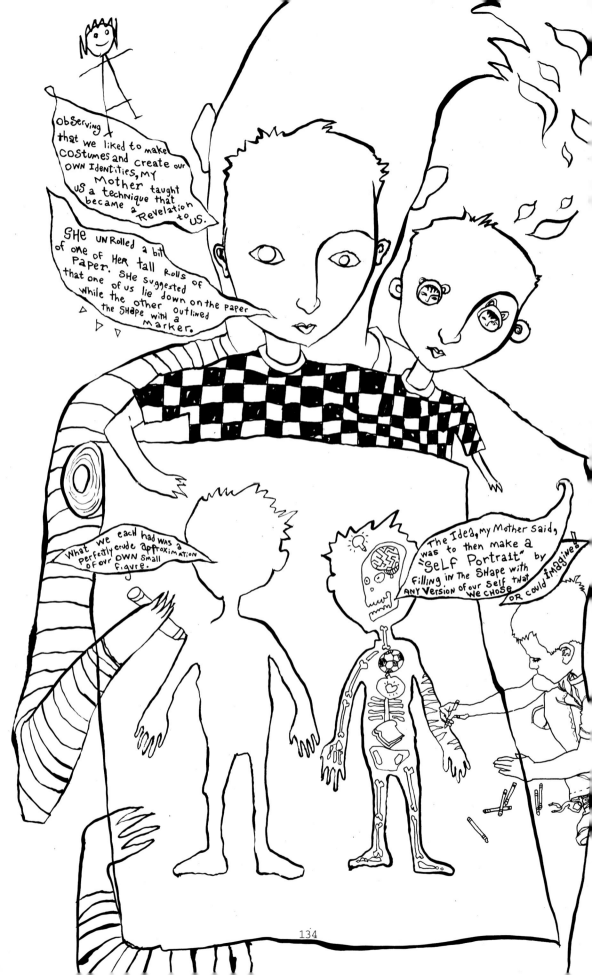

Observing that we liked to make costumes and create our own identities, my mother taught us a technique that became a revelation to us.

She unrolled a bit of one of her tall rolls of paper. She suggested that one of us lie down on the paper while the other outlined the shape with a marker.

What we each had was a perfectly crude approximation of our own small figure.

The idea, my mother said, was to then make a "Self Portrait" by filling in the shape with any version of our self that we chose or could imagine.

134

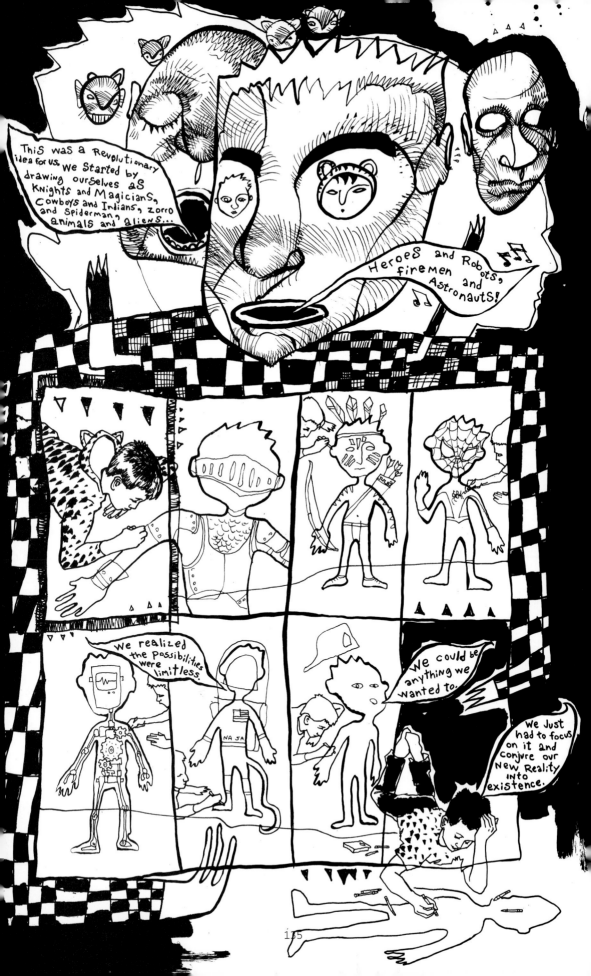

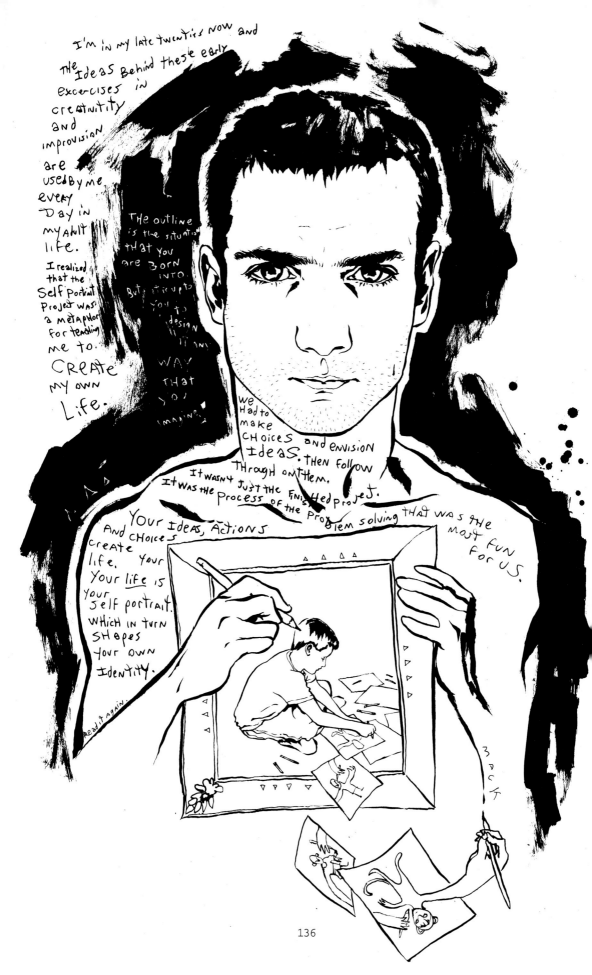

I'm in my late twenties now and the ideas behind these early excercises in creativity and improvision are used by me every day in my adult life.

I realized that the Self Portrait Project was a metaphor for teaching me to. CREATE MY OWN Life.

The outline is the situation that you are Born into. But it is up to you to design it in a WAY THAT YOU imagine.

We had to make choices and envision ideas. Then follow through on them.

It wasn't just the finished project. It was the process of the problem solving that was the most fun for us.

Your ideas, Actions And choices create life. Your Your life is Your Self portrait. Which in turn Shapes Your own Identity.

Read it again.

BACK

It was probably the most cinematic narrative of its kind, but, ironically, FROGS was created to be something else, something that defied labeling.

That was thirty years ago, yet the concept behind it is still as modern as tomorrow. Here's how it happened: In 1971, I thought it would be possible to publish a professional magazine about the comics medium and allied art forms, from animation history to zeitgeist filmmaking. Because it was my concept, my effort, and my financing, I used it unabashedly as a forum for experimental layout and typography, color and design exploration, maverick reproduction techniques, and some-times even a personal statement. It was my Frankenstein, but since that name had already been taken, I called it COMIXSCENE, then MEDIASCENE, and finally PREVUE.

Why experiment?

Years before I shaped a molecule of Marvel history, I realized that comics and their common format were still in their infancy. The devices that evolved during the dawn of the four-color form—panels, balloons, captions—had hardly changed in more than a half century. That stagnation, in a field predicated on the fantastic, was appalling. Even as a kid, I wondered why the wild imagery inside the panels was *not* matched by the form itself.

Music made its way from shellac to vinyl, from hi-fi to stereo. Movies ranged from square to Cineramic to 3-D. But the only perceptible changes in comics were their reduction from 64 pages to 48, then to 32, and finally to ever-increasing prices, starting with a dime and escalating to a handful of dollars.

The reason was that publishers and creators were either incapable of visualizing new formats or too complacent about the old one. As both publisher and creator, I had no excuse and conjured up a storm of experiments in a magazine that was in itself an experiment.

Cut to FROGS. In visualizing new narrative formats, I conceived what I called a *Story in a Single Image.* One way to accomplish that goal was in the approach I took with a plate drawn in 1978 for the PORT-FOLIO OF FINE COMIC ART. The piece was titled *The Silk Stocking Killer* and told a story—beginning, middle, end—in a single illustration, each stage defined by a different light source. I took another direction with FROGS: many images grouped so they could be viewed simultaneously as a single kinetic block.

The idea was a variation on an aspect of perception I realized during my SHIELD tour: that both facing pages of an open comic book are seen *in their entirety* within the viewer's peripheral vision. There are numerous implications to this aspect that make specific demands on storytelling technique, such as any visual surprise must be placed at the top left corner of the left-hand page. The reason, of course, is that placed anywhere else, it tends to draw the eye to that panel first, after which the viewer must return to the top left corner of the left-hand page—essentially reversing direction or travelling backwards through the story and compromising its dramatic intent.

As I began to visualize the concept, I realized that I could not only mitigate that problem, but use the viewer's random vision movement to my advantage: I could make the viewer *collaborate with me* in structuring the story, make him an interactive partner in the process of creation!

But I didn't realize the full potential of the concept until later. I started by defining the cardinal elements of the format:

—A simple story that could be expressed purely in images.

—Images that had a single, specific dramatic point and could be easily "read."

—Text was prohibitive because the mind cannot decipher small lines of dialogue or captions in peripheral proximities. Text could only be used iconographically.

—To help the mind comprehend and organize the images, I chose the most comfortable panel shape that can be discerned: the square.

—All panels would be the same-size.

How many was another matter—and that solution was predicated on the size of the magazine's double page area; in this case, 17x26". I determined that eight columns of six panels would perfectly accommodate my format requirements.

The next stage was to develop a story, one that would be enhanced by the two-color process in which the publication was printed. Black and red, I felt, would be fine; besides being the color of blood, red psychologically represented anger and hate. Immediately, a story materialized about a man in a straightjacket, confined to a padded cell. His only companion was a fly—and the tale concerned their relationship and the symbiosis between reality and dreams, sanity and madness. I called it FLIES. What else?

Unfortunately, red was the second color in the previous issue and could not be repeated in the one which followed. Soon after I had begun to lay it out, I shelved the story. The color of the new issue had not yet been selected, but I knew that it would be dictated by the nature of the experiment's story.

FROGS was the solution. The color was green.

During the comping process, I realized that the tale was more complex than I originally expected because I'd incorporated several flashbacks—or depending on the spectator's viewpoint, several flashforwards—to different temporal periods. To denote those timeshifts, I used a number of graphic devices, none of which (to my knowledge) had been utilized previously for that purpose in the comics format:

—radical color changes
—image matching
—lap dissolves using color images over black images

Because the frame was static throughout the narrative, I equated it with a movie or TV screen and felt that readers would do the same. For that reason, I felt a series of lap dissolves (a cinematic device used from the '30s-'50s to denote changes of place and time) would be entirely appropriate. To underscore that idea, I separated each column with a vertical line to help readers' eye movement and suggest the aspect of a film strip. Of course, the eight columns reading from top to bottom was what might be called the "director's cut," not

necessarily that of the viewer.

Because the cognitive process is so fluid, it was apparent that different viewers would have *different perceptions* of the story—and possibly as many ways to "read" it as well: top to bottom, bottom to top, right to left, left to right, four corners, spiral, ad infinitum. In other words, one basic story could be derived from a viewing process in a multitude of ways! To some, it could play out chronologically like THE GODFATHER. Others could assemble it backwards like MOMENTO. Still others might turn it inside out, like CITIZEN KANE.

I found that conclusion stunning. Although it is apparent that films can be edited in an almost unlimited number of ways, the decision about what statement is made is determined much more by the filmmakers than the audience. The truth is that film generally requires the *least intellectual participation* of its audience than many other mediums. In most graphic works, artists, writers, and editors present the material already structured and meant to be understood in only one way. FROGS was static and only marginally structured; its comprehension, however, depended entirely upon the cognitive skill, experience, and imagination of the viewer.

The concept, if not revolutionary, was evolutionary.

Check this out: I took it to the next stage by imagining each image as one of a series of slides run rapidly through a projector in a *different order* each time. The result of every possible combination is a staggering 48 to the 48th power. A mere ten images could be arranged in 3,628,800 combinations. The possible configurations of 48 images would create 12 trillion, trillion, trillion, trillion, trillion variations!

But, the technology to accomplish it would not be available for *three more decades*.

The story was a study in morbid psychology. I admitted it was not new, only the way in which it was told, and cited a number of facetious examples of how it would have been done by my contemporaries:

—As told by Stan Lee, it would be titled *Frogg, Son of Redip*. In it, the biology prof would spend a lifetime dissecting frogs in his lab. At the end, an enormous, slithery tongue zips the startled teacher out of the panel. The look on his face shows he's repented—but too late!

—As written by Gardner Fox, the professor would have destroyed the swamp's frog colony, but only after discovering they were really aliens from another galaxy, bent on conquering the earth. The prof decides never to mention it because no one would believe his story.

—As an Al Feldstein EC yarn, the biologist would have taken sadistic satisfaction in capturing and dissecting the specimens. One day, he does not appear in the laboratory and his students organize a search party for him in the local swamp. They find him on a giant lily pad, carefully hacked into sections, as though for the purpose of examination. Choke! Good Lord!

—As scripted by Denny O'Neil, the old prof would wipe out the entire frog population, upsetting the balance of ecology in the swamp, thereby creating an organic plague that dooms all humanity. In the final panel, a lone tadpole is seen looking toward the stars: When will man ever learn?

The following issue stated the experiment elicited the "widest spectrum of opinions in mail response" since I began publishing. Those who approved were excited by the concept. Those who didn't termed it a failure. And many just didn't get it at all. I wrote: "It is my feeling that the success or failure of FROGS is unimportant. What is important is the fact that it was published as an experiment, opening the doors for more of the same, perhaps expanding the perimeter of imaginative storytelling in the minds of fans and pros alike."

Numerous magazine editors (including Denis Kitchen, Roy Thomas, and Archie Goodwin at Marvel) made offers to reprint the experiment over multiple pages in their publications. I rejected them all as none offered any improvement over my original presentation.

FROGS would wait for the technology to catch up.

It may be a surprise to some that major advancements in communication during the history of mankind can be counted on the fingers.

—The first occurred when early man attempted to convey an idea by drawing lines in the dirt with a stick.

— Language, either spoken or signed, would be next in the progression to communicate on a grand scale.

—As pictures became more universal, symbols evolved; then, written language was developed.

—Gutenberg's invention of movable type around 1450 led to the supremacy of the printed word (a manifestation of writing); images were created with woodcuts.

—In 1816, the photographic process was developed by Nicéphore Niépce, capturing reality in black and white.

—In 1877, Thomas Edison discovered a method to record the voice, which could be replayed almost endlessly.

—In 1891, Edison used a series of progressive photographs to create the illusion of motion, in addition to extending the capability of the written and spoken word with the telegraph and telephone.

—In the 1900s, a cheap paper pamphlet combining text and images was published and, over the next few decades, become the comic book.

—In the 1920s, wireless telegraphy or radio allowed users worldwide to hear events as they occurred.

—In the 1930s, sound and imagery was transmitted by electrical waves and received on a device called television.

—In the 1990s, the internet allowed participants to communicate with creators by computer and interact with them in real time.

It is disappointing that, in the past ten years, the most innovative technology in mankind's history has yet to yield much that realizes its creative potential. Reproducing movies and animation on the computer screen simply restates the old and the obvious, but does not explore new territory, does not engage new formats.

That brings us back to FROGS, which has been dormant for three decades, waiting for the appropriate technology. It is presented here in a multiple-page format, much like it would have been had I allowed Marvel or others to run it as a standard left-to-right narrative (and, in this case, it also lacks the use of numerous dramatic and transitional color devices). It represents raw material in much the same manner as many comics which fail to employ the strengths of their format.

What you're looking at might be called the *before* version. To experience the *after* version—which allows the viewer to reconfigure the story *an unlimited number of times* to conform to their personal vision—check out www.steranko.com and make up your own mind if three decades was worth the wait.

STERANKO

FROGS!

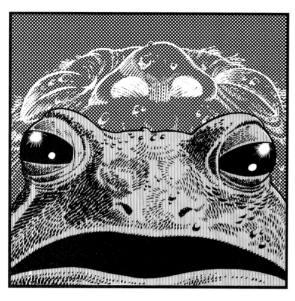
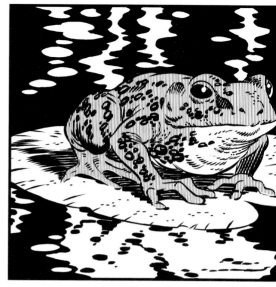

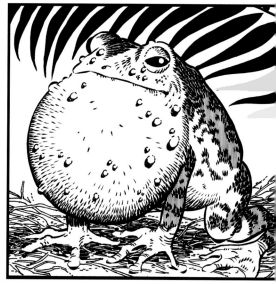

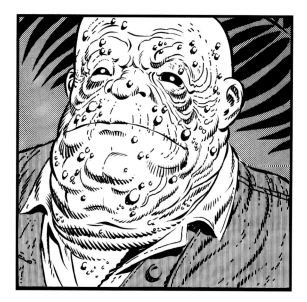

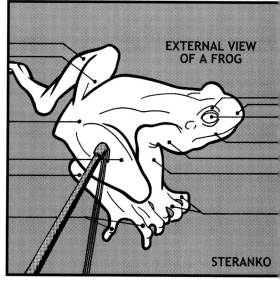

EXTERNAL VIEW OF A FROG

STERANKO

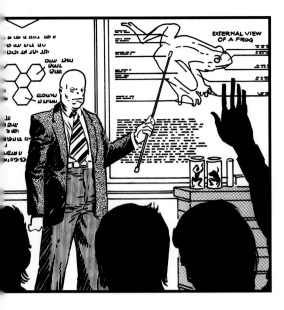

EXTERNAL VIEW OF A FROG

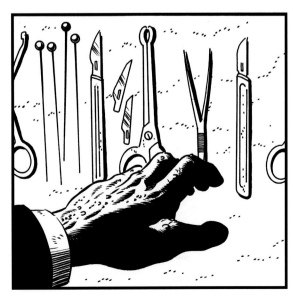

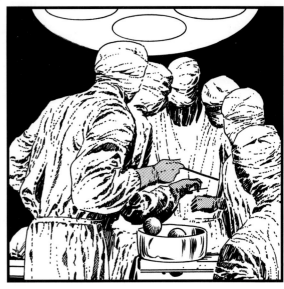

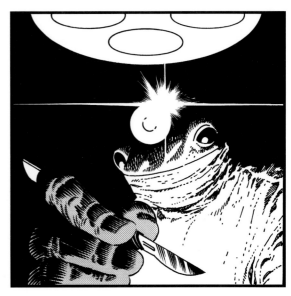

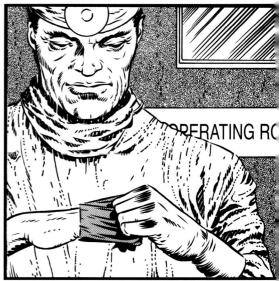
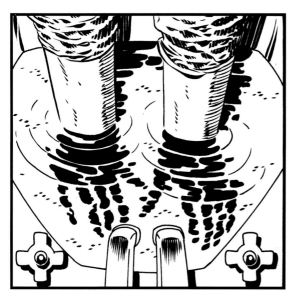

Stefano Ricci was born in 1966 in Bologna, where he lives and works. His drawings and comics have appeared in books and magazines both in Italy and abroad including **Frigidaire, Per Lui, Dolce vita, Avvenimenti, Linea d'ombra, il manifesto, Esquire, Panorama, Teléma, Extra, Glamour, HP, Follow me, Libération, Les Inrockuptibles, Internazionale, Alias, Lo Straniero, Télérama, la Repubblica,** etc). **Depositonero, centoventidisegni** (Mano and Fréon, 1999) and **Blackdepot/02** (Bries, 2002) are catalogs of selected works spanning his

first fifteen years of activity. In 1989 he published his first illustrated book, **Dottori** (Metrolibri), which was followed by **Ostaggi nello spazio** (Salani, 1994), **Don Giovanni** (Salani, 1995, nominated for the, Bratislava Illustration Biennale), **Il magnifico libro del Signor Tutto** (E. Elle, 1995) and **Lamioche** (Edition Demoures, 1999).

In comics, in addition to some short works, he has published **Tufo**, with text by Philippe De Pierpont (Granata Press,1994); *Strapazin*, n° 34

ricci · stefano

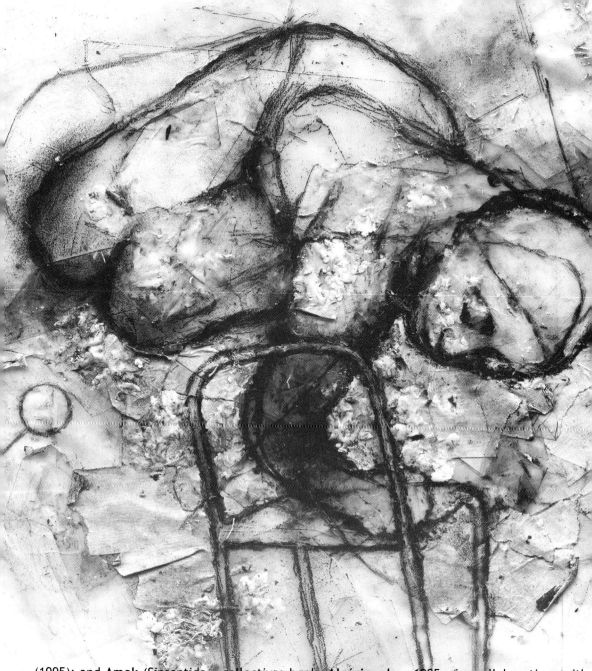

(1995); and **Amok** (Sinsentido 1996, and Semana Negra, 2002). Again in collaboration with Ph. de Pierpont, in 1995 he produced *Nina et Lili* for the collective book **Avoir 20 ans en l'an 2000** (also appeared in; **Mano**, n°1, 1996). For **Glamour** magazine he created *Anita*, with text by Gabriella Giandelli, which was subsequently published in editions of **Kappa**, **Fréon**, 1998; **Sinsentido**, 1999; and **avant-verlag**, 2001. For the

collective book **Algérie, la douleur et le mal** (Amok/BD BOUM, 1998) he wrote and illustrated *Safia Yacef*.

Through his chosen medium is drawing he has also worked in theatre, dance and the cinema. Since 1994 he has been lending his name to coordinated image projects and book series, which have earned him a mention in the **ADI Design Index 2000** and a nomination for the 2001 Compasso d'Oro award. Since

1995, in collaboration with Giovanna Anceschi, he has been publishing the **Edizioni Grafiche di Squadro** (Bologna) book series and curating the related gallery activities; in 1996 they founded the magazine **MANO fumetti scritti disegni.**

His EDGE story is a preview of his forthcoming series **Identikit**, with text by Valerio Evangelisti.

DID ANYBODY EVER SAY TO YOU "WHAT A CRIMINAL FACE"? I HEARD THAT SO MANY TIMES,
SINCE MY FACE GOT STAPLED TO A POLICE FILE, THAT I LOST TRACK OF EXACTLY HOW MANY.
THE TRUE PARADOX, NOW THAT I'M DEAD, IS THAT THERE'S NOTHING LEFT BUT MY FACE.

DESTINED TO SURVIVE THROUGH DECADES AND CENTURIES
ON THE FILED SNAPSHOT THE POLICE TOOK WHEN I WAS ARRESTED.

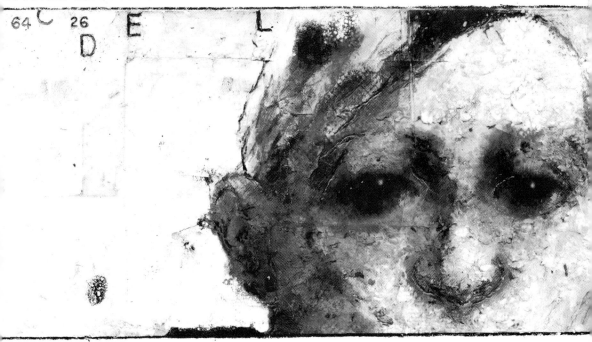

AND FOR DECADES OR CENTURIES, WHOEVER WILL SEE THAT SAME SNAPSHOT WILL SAY: "WHAT A CRIMINAL FACE".

I DIDN'T LONG FOR THIS KIND OF DEMI-IMMORTALITY. IT STUCK ON ME WITHOUT A WARNING.

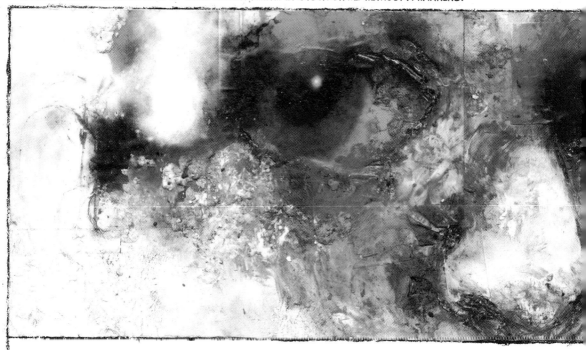

YOU MIGHT SAY: "THAT'S WHAT NORMALLY HAPPENS WITH SNAPSHOTS". RIGHT, BUT A FILED PHOTOGRAPH NEVER IS AN OBJECTIVE REPRESENTATION. IT PORTRAYS YOU IN A PARTICULARLY DRAMATIC SHARD OF YOUR LIFE.

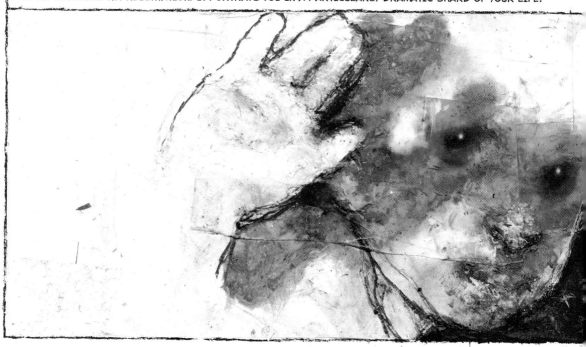

THERE'S NO OBJECTIVITY. IF AN IDENTIKIT IS BEING TRAPPED BY SOMEONE ELSE'S SUBJECTIVITY, THE FILED SNAPSHOT MEANS TO BE PRISONERS OF ONE'S ONE TORMENT AND HUMILIATION.

NDER WHERE ALL THE PICTURES THEY TOOK OF ME AS A BOY ENDED UP. THERE, I WAS SMILING
THE TIME. UP TO 12 YEARS OF AGE, I, GRAHAM YOUNG, USED TO HAVE THE OLD LADIES GO
DER ON ME WHILE GETTING TONS OF COMPLIMENTS. "A BLOND ANGEL", THAT'S HOW THEY
LED ME, ONE OF THE WONDERS OF THE GREEN CORNER OF BERKSHIRE WHERE I GREW UP.

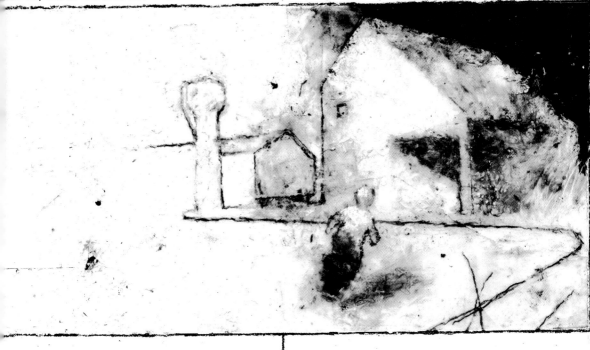

ME, WELL, I WAS CURIOUS ABOUT EVERYONE.

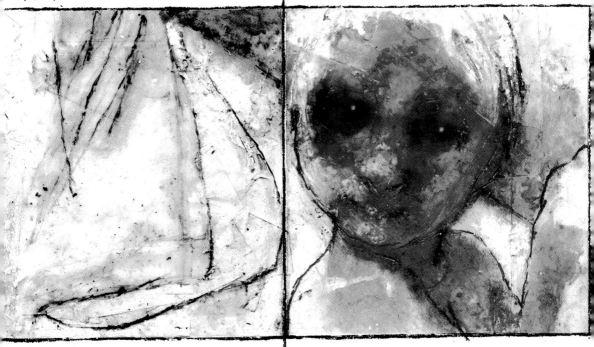

EVEN IF I DIDN'T HAVE ANY SPECIFIC ILLNESS, I HAD
TROUBLES OPERATING MY LIMBS CORRECTLY. THEY FELT LIKE
FOREIGN BODIES TO ME. ALL OTHERS AROUND ME, INSTEAD,
SEEMED TO HAVE A PERFECT MASTERY OF THEIR BODIES.

I LIKED PEOPLE. THAT'S RIGHT.
THE WAY THEY MOVED, THE WAY THEY ACTED.

OF COURSE, THE FAVORED TARGET OF MY CURIOSITY
WAS MY FAMILY. I FELT GOOFY, COMPARED TO THEM.

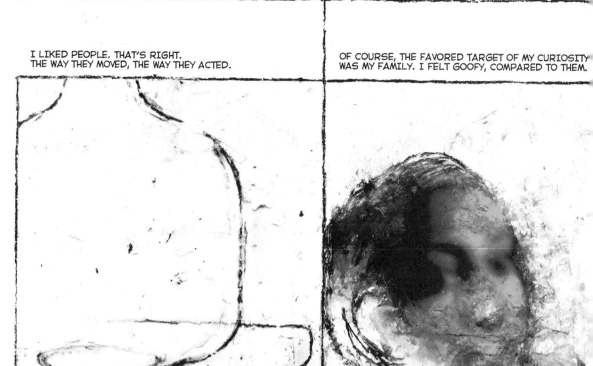

I ADMIRED MY FATHER WHEN HE WOULD SIT WITH EASE IN HIS ARMCHAIR, LEGS CROSSED AND NEWSPAPER
IN HAND. I ADMIRED MY MOTHER, AS SHE'D MOVE WITH ELEGANCE IN THE SMALL KITCHEN OF OUR HOUSE.

DON'T
STAY THERE
WATCHIN' ME ALL
THE TIME,
GRAHAM.

GO
PLAY, DO
SOMETHIN'.

152

MY LITTLE SISTER BEWITCHED ME MORE THAN ANYONE ELSE.
A BLOND-HAIRED CHUBBIE, NICE AS ME, BUT SO MUCH MORE MOBILE.

THE SKIN ON HER TINY HAND LOOKED TRANSPARENT, AND I LOVED THE MOTILITY OF HER FINGERS.

THERE HAD TO BE A SECRET BEHIND SUCH GRACE.
IT COULD NOT BE A SIMPLE MECHANICAL FACTOR. I HAD THAT TOO.

IT WAS BOUND TO HAVE SOMETHING TO DO WITH FLUIDS, WITH CHEMICAL COMPOSITION.

I NOTICED THAT IN ALEX, MY BEST FRIEND, MORE THAN IN ANYONE ELSE.

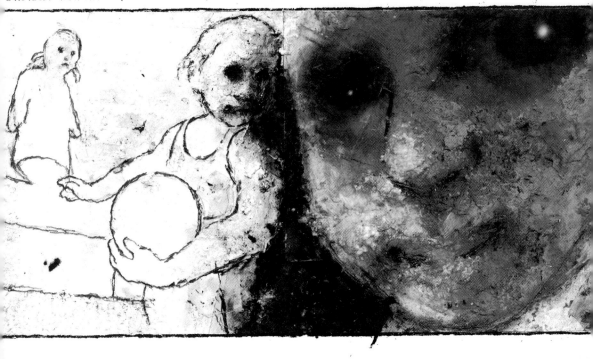

AGILE, ELASTIC, READY TO JUMP AND RUN. THERE WAS BUT ONE TIME
I SAW HIM DRAINED OF HIS WONDERFUL ENERGY.

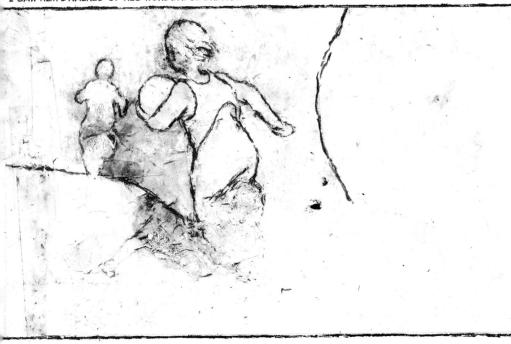

I HAD HIM DRINK SOME BEER THAT WAS FORGOTTEN IN A CELLAR AND HAD GONE SOUR.

IT WAS PROOF THAT CHEMISTRY RULED MUSCLES AND NERVES.
TO MASTER CHEMISTRY MEANT TO BE ABLE TO CONTROL MOTION.

AND ITS ABSENCE.

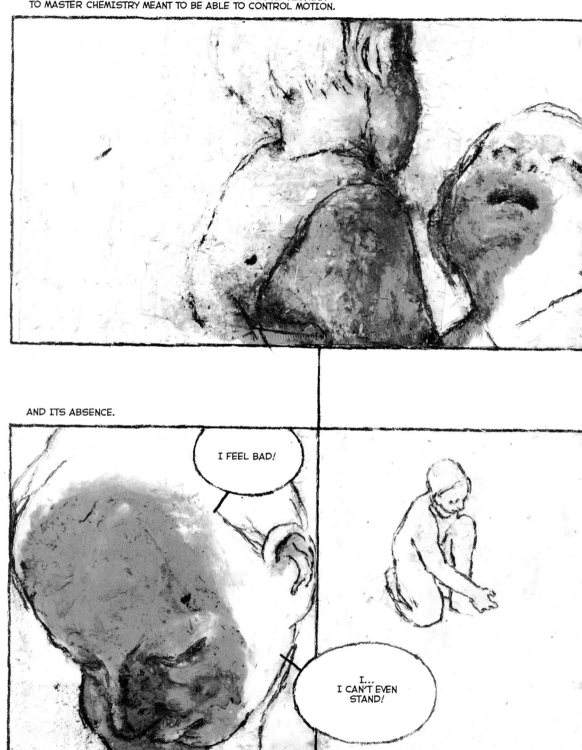

I FEEL BAD!

I...
I CAN'T EVEN
STAND!

I DECIDED THAT CHEMISTRY WOULD HAVE BEEN MY FIELD. THAT I WOULD EXPERIMENT ITS POWER TO COMMAND BODIES. SO I DID.

AFTER SOME EARLY ATTEMPTS, I HAD MORE PEACEFUL YEARS TO DEEPEN MY KNOWLEDGE.

BUT I HAD TO WAIT MUCH MORE TO BE ABLE TO TURN MY PASSION INTO WHAT WAS TO BE MY JOB.

IT WAS 1971. I WAS TWENTY-ONE.

END OF PART O

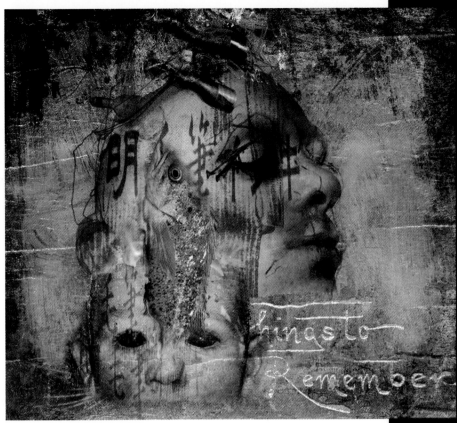

Bill Koeb is illustrator and painter who has exhibited in the New York and Los Angeles Societies of Illustrators' annual shows, Elon College, **Print** magazine, and in group shows in New York and San Francisco. He has illustrated stories and articles for numerous publications, including **Washington City Paper**, **Ray-Gun**, **Stick**, **Atlanta**, and **The Village Voice**. His work has appeared on book covers, CD's, and posters for concerts and plays. In 1995, Bill was commissioned to create original paintings for the movie **The Crow, City of Angels**, and from 1998 to 2001, he created over 40 illustrations for a Fireman's Fund print campaign, which appeared in, **Fortune**, **Business Week** and the **New York Times**.

In 1989, Bill received his first comics work from Dan Chichester, painting a story for Clive Barker's **Hellraiser** anthology. His comics work includes illustrating the mini-series **Faultlines** for Vertigo, Alan Moore's song, *The Hair of the Snake That Bit Me* for Caliber, and writing and drawing several short stories for Vanguard's **EDGE** series, which include: *Psychic Pedestrian* and *Time Stop*.

Born in Los Angeles, Ca. in 1965, Bill grew up in Southern and Northern California, and discovered a love of drawing at an early age when he saw comics in the late 60's. The first comic that he remembers reading was Batman 237 by Denny O'Neil and Neal Adams. From 1985 to 1987 he studied painting and illustration

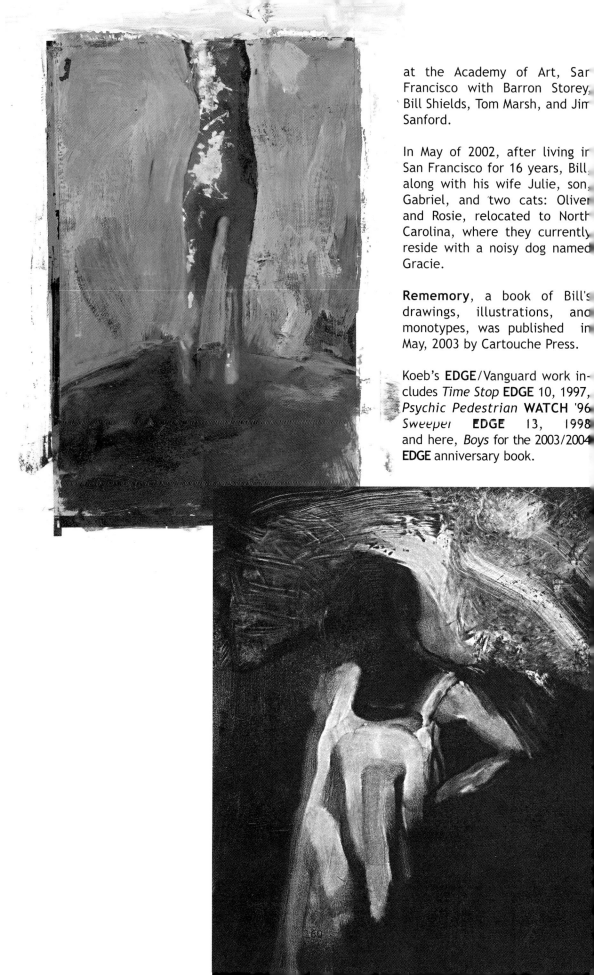

at the Academy of Art, San Francisco with Barron Storey, Bill Shields, Tom Marsh, and Jim Sanford.

In May of 2002, after living in San Francisco for 16 years, Bill, along with his wife Julie, son, Gabriel, and two cats: Oliver and Rosie, relocated to North Carolina, where they currently reside with a noisy dog named Gracie.

Rememory, a book of Bill's drawings, illustrations, and monotypes, was published in May, 2003 by Cartouche Press.

Koeb's **EDGE**/Vanguard work includes *Time Stop* **EDGE** 10, 1997, *Psychic Pedestrian* **WATCH** '96 *Sweeper* **EDGE** 13, 1998 and here, *Boys* for the 2003/2004 **EDGE** anniversary book.

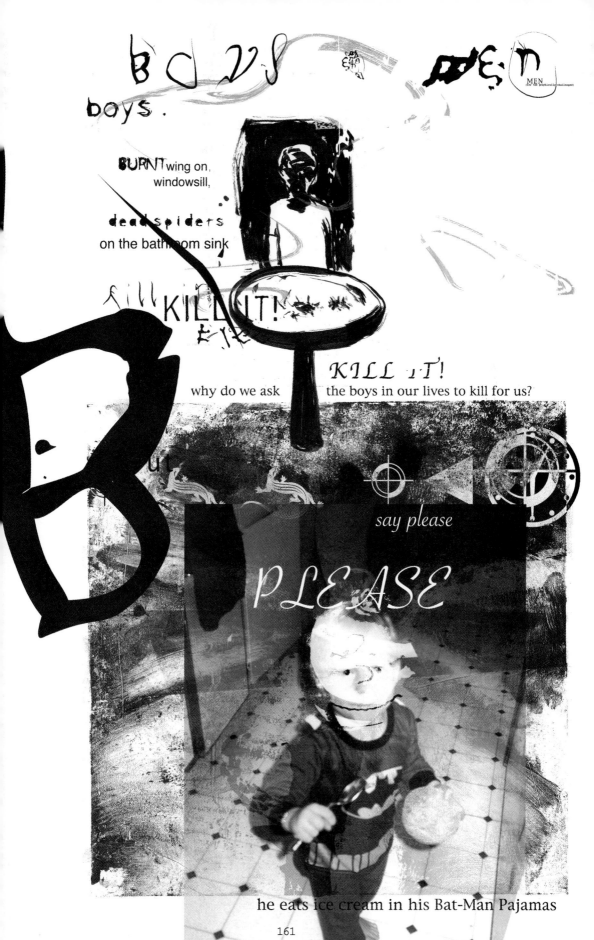

boys. MEN (for the graphically challenged)

BURNT wing on, windowsill,

dead spiders on the bathroom sink

KILL IT!

KILL IT!

why do we ask the boys in our lives to kill for us?

say please

PLEASE

he eats ice cream in his Bat-Man Pajamas

161

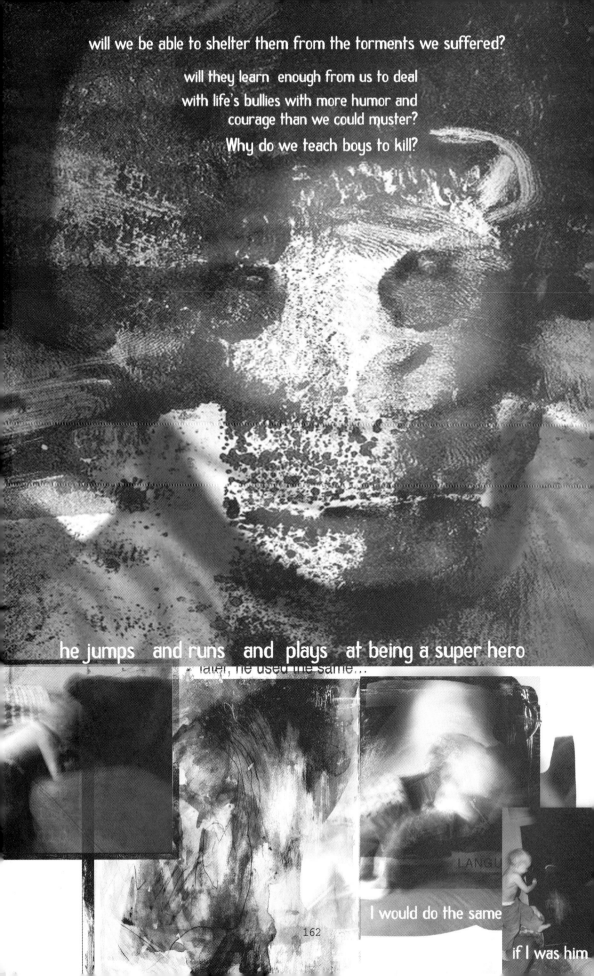

will we be able to shelter them from the torments we suffered?

will they learn enough from us to deal
with life's bullies with more humor and
courage than we could muster?

Why do we teach boys to kill?

he jumps and runs and plays at being a super hero

later, he used the same...

I would do the same

if I was him

itting and SPITTING! LUGEES

BASK...

DODGE...

PLAY...MAGAZINES
FIST
FIGHTS

...BOY MAGAZINES

what was...

call you out!
...as BONER?

what was...

quiet now

why do we teach boys to kill?

be sensitive

163

when a fight is imminent

work it in

where do our children go

PULL

more like try to kiss her

all of these boys
are dead?

so all
of LANGUAGE ese men

a tree, PARADISE serpamen

how teach boys ki

ROCKS on

he eats cookies with black frosting

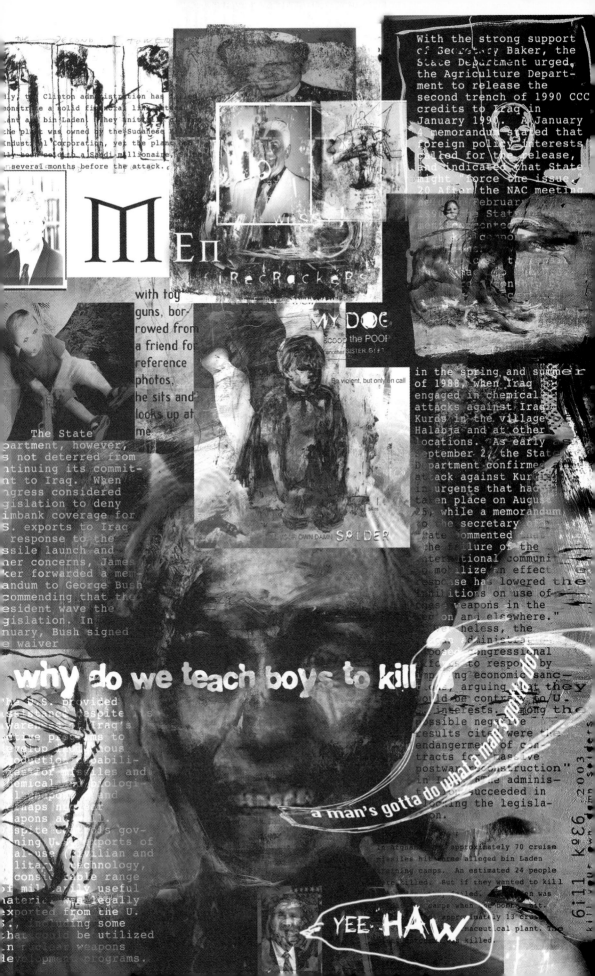

With the strong support
of Secretary Baker, the
State Department urged
the Agriculture Depart-
ment to release the
second trench of 1990 CCC
credits to Iraq in
January 1990. A January
4 memorandum stated that
foreign policy interests
called for the release,
and indicated that State
might "force the issue."
20 After the NAC meeting
held in February
1990, State
mented comp

MEN

fiReCRackeRs

with toy
guns, bor-
rowed from
a friend for
reference
photos.
he sits and
looks up at
me

MY DOE
Scoop the POOP
another SISTER GIFT

Be violent, but only on call

EAT YOUR OWN DAMN SPIDER

The State
partment, however,
s not deterred from
ntinuing its commit-
nt to Iraq. When
ngress considered
gislation to deny
imbank coverage for
S. exports to Iraq
response to the
ssile launch and
ner concerns, James
ker forwarded a mem-
andum to George Bush
commending that the
esident wave the
gislation. In
nuary, Bush signed
e waiver

in the spring and summer
of 1988, when Iraq
engaged in chemical
attacks against Iraqi
Kurds in the village of
Halabja and at other
locations. As early as
eptember 2, the State
Department confirmed
ttack against Kurdish
in urgents that had
taken place on August
5, while a memorandum
to the secretary of
ate commented that
the failure of the
nternational community
o mobilize an effect
esponse has lowered the
nhibitions on use of
ese weapons in the
gion and elsewhere."
heless, the
administrat
posed congressional
orts to respond by
posing economic sanc-
s, arguing that they
ould be contrary to U.
interests. Among the
ossible negative
results cited were the
endangerment of con-
tracts for massive
postwar construction"
in Iraq. The adminis-
t on succeeded in
ocking the legisla-
on.

why do we teach boys to kill

a man's gotta do what a man's gotta do!

U.S. provided
sistance despite
waren of Iraq's
tive programs to
evelop numerous
roduction capabili-
es for missiles and
emical biologi-
weapons and
haps nuclear
apons as all.
spite U.S. gov-
ning U.S. exports of
al use (civilian and
litary) technology,
considerable range
f militarily useful
aterial was legally
exported from the U.
, including some
hat could be utilized
nuclear weapons
velopment programs.

In Afghanistan approximately 70 cruise
missiles hit three alleged bin Laden
training camps. An estimated 24 people
re killed. But if they wanted to kill
led. en was
camps when bombing hit.
approximately 13 cruz
maceutical plant. The
killed.

YEE·HAW

kill your own insiders num. 936K 2003.11.19

hampton.justin

Since 1990, Justin Hampton has produced pop-culture-based illustrations for **RollingStone**, Interscope Records, **Sports Illustrated**, Dreamworks, **Village Voice**, **Maxim**, **Vibe**, **FHM**, **Premiere**, **ESPN** Magazine, **Details**, **Hustler**, **Blender**, The Paramount Theatre, **Bike**, **Scene**, **Guitar** **World**, **Snowboarder**, **The** **Seattle** **Weekly** and **The Rocket**, Dr. Martens shoes, Target and Nordstrom. But, the artist is best known for his Rock music posters. His silk-screened images include Bob Dylan, Nick Cave, PJ Harvey, Radiohead, Marilyn Manson, Blur, Tricky and Motorhead to name a few. His

posters have also appeared on the television shows **Buffy The** **Vampire Slayer** and **24** as well as in the movie **The Hot Chick** and can be seen in art galleries around the world.

His comic books **Twitch** and **Rat** have also received rave reviews. Seattle's Experience Music Project has acquisitioned the entire history of his prints and numerous originals for their permanent museum collection. His animated short **The Jaded Monk**, based on a character of his own creation, was accepted to the 2002 Seattle International Film Festival and the 2003 One Reel Festival. Justin resides in Seattle with his wife Kasia, two cats and a dog.

Sex on the Brain is dedicated to the late Scott Tolson. As well as assisting Hampton on the story here, Scott produced art for **Star Wars, Predator & Colors in Black** (Dark Horse) as well as work for Milestone/DC.

mcdonald.brian

Brian McDonald is an award-wining writer and filmmaker. His film **White Face** has run on HBO and Cinemax. His comic-book work includes contributions to **Colors in Black** (Dark Horse in conjunction with Spike Lee), **Tarzan, Lost In Space, Predator: Strange Roux** and a one-shot **Hellboy** spinoff, **Abe Sapien: Drums of the Dead**.

His comic-book series **Harry the Cop**, about police brutality hit the stands the first day of the 1993 Los Angeles riots following the Rodney King verdict. Pulitzer prize winning author Charles Johnson mentioned **Harry the Cop** favorably in the foreword to an African-American history book.

A teacher of story construction, McDonald is writting a book on the subject. McDonald made the cover of the **Seattle Weekly** and was picked as one of the "17 people to watch."

McDonald created the animated film **The Jaded Monk** with Justin Hampton.

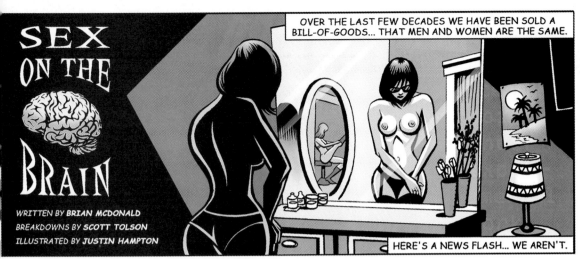

SEX ON THE BRAIN

WRITTEN BY **BRIAN MCDONALD**
BREAKDOWNS BY **SCOTT TOLSON**
ILLUSTRATED BY **JUSTIN HAMPTON**

OVER THE LAST FEW DECADES WE HAVE BEEN SOLD A BILL-OF-GOODS... THAT MEN AND WOMEN ARE THE SAME.

HERE'S A NEWS FLASH... WE AREN'T.

THERE ARE THE OBVIOUS DIFFERENCES OF COURSE.

BUT THERE IS ANOTHER DIFFERENCE, ONE, WE ALL KNOW ABOUT BUT NO LONGER TALK ABOUT IN MIXED COMPANY...WE THINK DIFFERENTLY

WE HAVE, ALL OF US, STRUGGLED TO UNDERSTAND THE OTHER GENDER WITH LITTLE SUCCESS.

IF YOU CHOOSE TO BELIEVE IN SCIENCE, THINGS LIKE FOSSIL RECORDS AND FACTS, YOU KNOW THAT MEN WERE HUNTERS...

...AND WOMEN WERE GATHERERS FOR MOST HUMAN HISTORY....

...AND WE EVOLVED TO HAVE TRAITS SUITED FOR OUR RESPECTIVE TASKS.

FOR WOMEN IT IS EASY FOR BOTH THE RIGHT AND LEFT HEMISHPERES OF THE BRAIN TO COMMUNICATE WITH ONE ANOTHER.

THIS ALLOWS THEM TO MULTITASK.

WHEREAS MEN ARE BETTER AT COMPART-MENTALIZING, FOCUSING ON A SINGLE TASK TO EXCLUSION OF ALL ELSE.

WOMEN HAVE MORE CONES IN THEIR EYES AND PICK UP MINUTE DETAILS THAT MEN OFTEN MISS.

YOU MISSED ONE.

WOMEN HAVE FAR BETTER PERIPHERAL VISION AS THEY WERE THE PRIMARY PROTECTORS OF CHILDREN...

...AND NEEDED TO BE WEARY OF PREDATORS.

I WOULDN'T TRY IT PAL.

BOTH MEN AND WOMEN ARE UNDER THE CONTROL OF POWERFUL HORMONES AND DRIVES...

...THAT HAVE EVOLVED OVER MILLIONS OF YEARS.

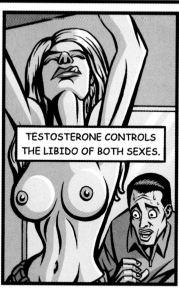

TESTOSTERONE CONTROLS THE LIBIDO OF BOTH SEXES.

MEN HAVING MORE OF THE HORMONE GENERALLY HAVE A MUCH STRONGER SEX DRIVE.

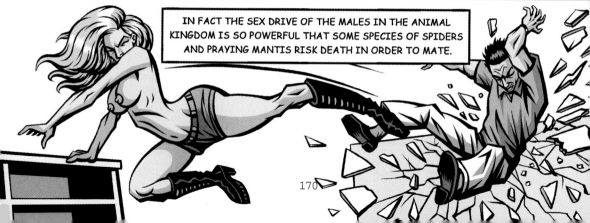

IN FACT THE SEX DRIVE OF THE MALES IN THE ANIMAL KINGDOM IS SO POWERFUL THAT SOME SPECIES OF SPIDERS AND PRAYING MANTIS RISK DEATH IN ORDER TO MATE.

170

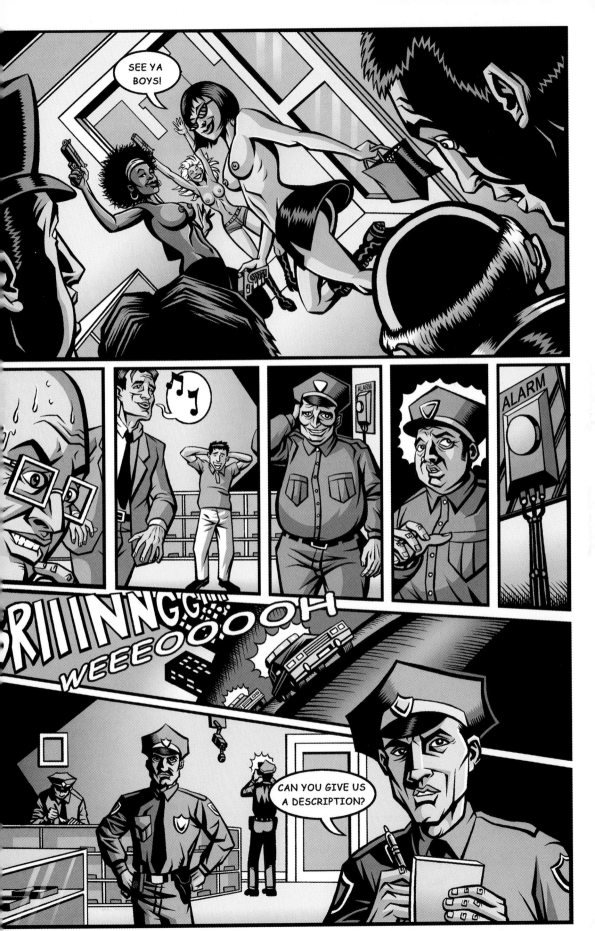

171

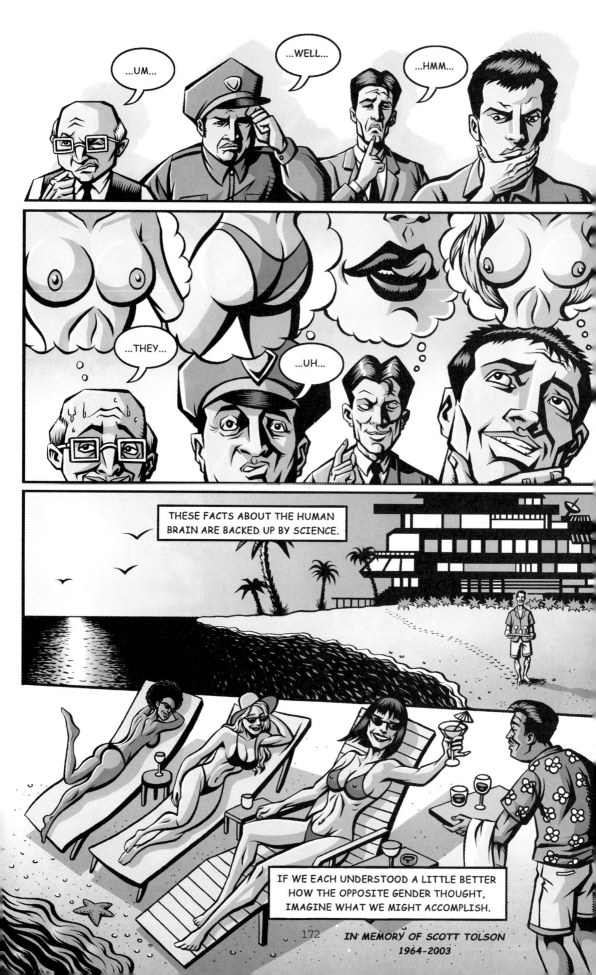

IN MEMORY OF SCOTT TOLSON
1964-2003

sienkiewicz.bill

interview conducted april 29, 1999 by j. david spurlock in the sienkiewicz digital command center

David: As both an innovative cartoonist and illustrator, you have shown quite a penchant for politically oriented works. Tell us about some of those.

Bill: The **Friendly Dictators** card set is about 36 different dictators. The United States government has either looked the other way, given free range or in some cases, even helped these dictators to commit atrocities in exchange for, what? Obviously the United States was getting something out of it. That set deals with those issues, people and polities. The **Coup de' tat** cards, details all the various and sundry Oliver Stone-type theories about the JFK assassination, including profiles of key mob members, Marilyn Monroe, FBI director Herbert Hoover, everyone! **Brought to Light** is a book about Washington's history of secret and covert activities including Iran-contra.

D: You did that with writer, Alan Moore.

B: Yes and in association with the Christic Institute, which is a non-profit, public interest legal center that works – through civil cases – to reveal how branches of our government have betrayed the people through secret wars, drug trafficking, assassinations and illegal use of tax-payers monies. I also did the **Strip Aids** book as well, which I co-edited with Trina Robbins. That included different pieces of donated artwork and benefited Aids sufferers. All of the fees and profits went to hospice care. It's great to do those kind of projects because, I felt that comics have been very good to me through my superhero work. The political works have a level of social conscience. I felt like I was giving something back. It gives comics an element of respect, to be about something, other than two guys in colored tights fighting--a possible vehi-

ART OF
CONSPIRACY

Opening Reception • Friday December 14th • 7-10 PM
Showing December 14-29
1102 E. Carson Street • Pittsburgh • 481-8660

Sponsored by WYEP-FM 91.3 in association with P.J. McArdle

WYEP91
Hear the diffe

le for social change.

got letters from col-
eges notifying me that
he **Dictators** set was
eing used as curriculum.
eggy Gordon and I did the
ig Budget Circus, which
as for Tundra.

: Also political?

: Yes, mostly about
he Bush/Reagan years, all
f the fallout from
rickle-down

political books.

R: Yes, **Brought to
Light** dealt with two
guys sitting in a
bar, casually

30
years
of
drug
smug-
gling,
arms
deals
and
covert
opera-
tions
that
robbed
america
and

co-
omics
nd also
bout politi-
al things
hat were
oing on in the entertain-
ent scene for candi-
ates. That was the first
ime I did any images of
ill Clinton.

: **Strip Aids** and
rought to **Light** were

talking about the atroci-
ties that go on. I had a
conversation with the pro-
ducer in Hollywood -that I
did the **American Pimp**
poster for...

betray-
ed the
consti-
tution

1 7 5

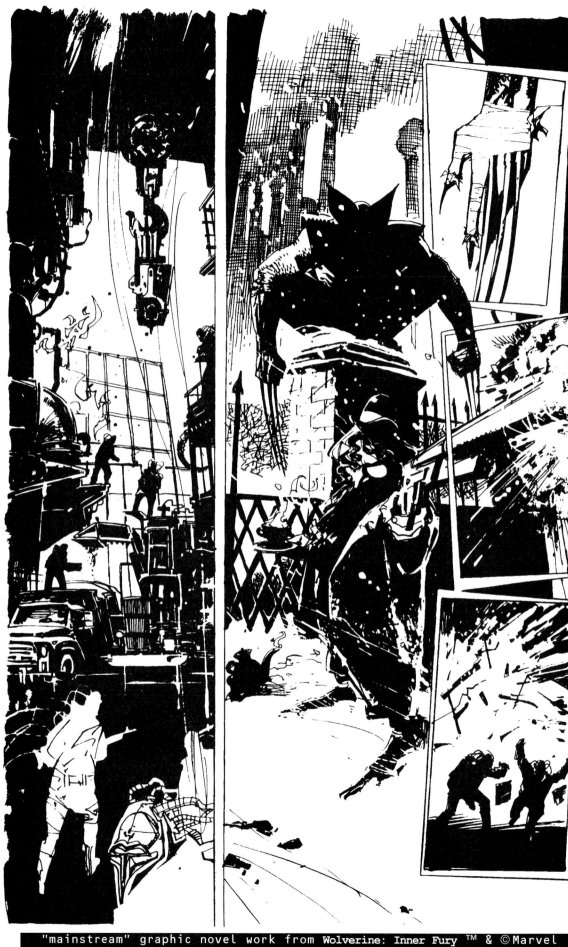

D: **American Pimp?**

B: A history of pimps in America. The producer had been talking to a mercenary who was involved with covert activities. The kind of stuff that was very hush hush, along the lines of the bombing in Laos and what **Air America**, that bad movie, was really supposed to be about. It wasn't a comedy, it was all about looking the other way and the collusion between the drug cartels and the government. So this producer showed the mercenary a copy of **Brought to Light**, and the guy couldn't believe this information was out there in comic-book form.

D: Other than the strength of the illustration, the card sets present a wealth of data that is such a fresh take. It's information that we don't get through the national media. Right wingers say the national media is liberal and I roughly agree with that. But when you look at this data and you see that it has not been presented nationally, it's like, there's a lot more left-wing information that we're not getting.

B: When you look at data and you see that it has not been presented nationally, or when it has been, the Right Wing goes on the offensive to discredit it.

D: In **Brought to Light**, a motif that was used to communicate deaths, was to not list them as numbers of people killed but, listed them in number of swimming pools full of blood, that had been shed.

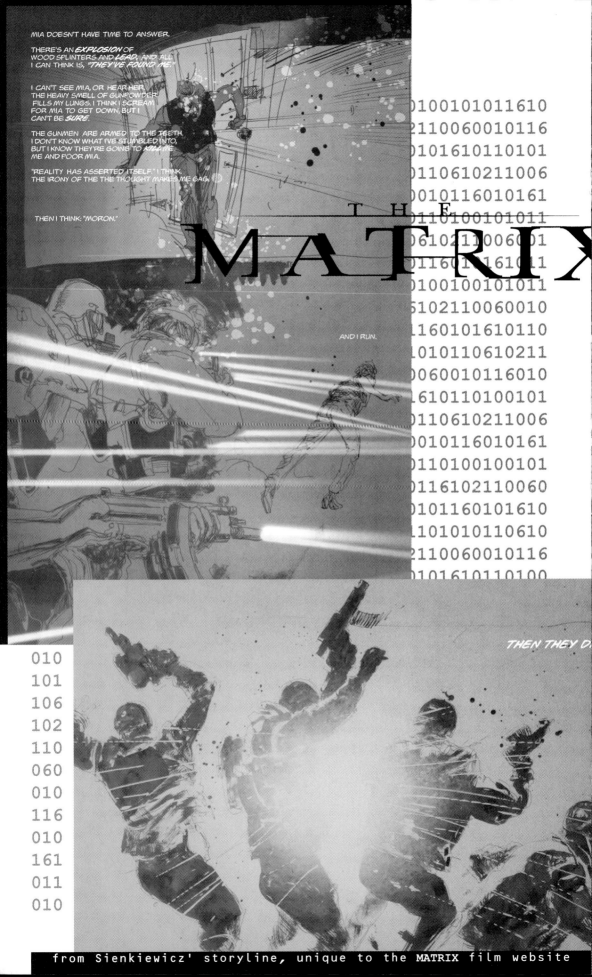

MIA DOESN'T HAVE TIME TO ANSWER.

THERE'S AN *EXPLOSION* OF
WOOD SPLINTERS AND *LEAD*, AND ALL
I CAN THINK IS, *"THEY'VE FOUND ME."*

I CAN'T SEE MIA, OR HEAR HER.
THE HEAVY SMELL OF GUNPOWDER
FILLS MY LUNGS. I THINK I SCREAM
FOR MIA TO GET DOWN, BUT I
CAN'T BE *SURE.*

THE GUNMEN ARE ARMED TO THE *TEETH.*
I DON'T KNOW WHAT I'VE STUMBLED INTO,
BUT I KNOW THEY'RE GOING TO *KILL ME.*
ME AND POOR MIA.

"REALITY HAS ASSERTED ITSELF." I THINK.
THE IRONY OF THE THE THOUGHT MAKES ME GAG.

THEN I THINK: "MORON."

THE
MATRIX

AND I RUN.

THEN THEY DI

0100101011610
2110060010116
0101610110101
0110610211006
0010116010161
0110100101011
0610211006001
0116010161011
0100100101011
6102110060010
1160101610110
1010110610211
0060010116010
1610110100101
0110610211006
0010116010161
0110100100101
0116102110060
0101160101610
1101010110610
2110060010116
0101610110100

010
101
106
102
110
060
010
116
010
161
011
010

When you think of swim-
ming pools full of blood
it makes the tolls easier
to assimilate.
B: It doesn't become
just an abstraction. It
takes an example of some-
thing that we're familiar
with. It takes a lot of
water to fill a pool. If
every body has 8 pints of
blood,- imagine just try-
ing to fill up a bathtub-
but a swimming pool!
Thinking in those terms
it's quite chilling.
D: Much of **Brought to
Light** was just the talking
head of the main character
-a government insider
that's had a few drinks
too many and is letting
his tongue get away from
him. To keep it visually
interesting, you turned
the character into an
eagle -representing
America. This takes us
into a political cartoon
direction and away from
the mainstream comic books
that brought your initial
success. Once you had the
audience, you turn politi-
cal cartoonist.
B: It's sort of the
theater of the absurd. If
editorial cartoonists
wrote a lot of what they
put in editorial cartoons,
they'd probably be held
for libel. But because
there is this tradition,
they can get away with a
lot, thank god It becomes
an incisive personal com-
ment. If you present
information in a very dry
forum, it may be accurate
but you're going to lose
people. I prefer going

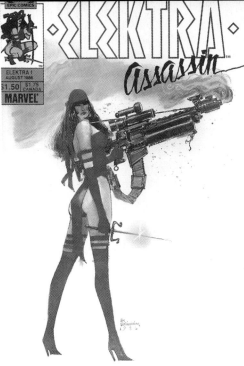

over the top. The images
may be absurd yet the real
subject is true horror. A
theory of mine, that the
truth of things, through
the lie, the exaggeration,
if you push it and make
something funny and darkly
comedic and go over the
top with it, that it will
be more true in some
respects because it's so
far away from reality.
You're not dealing with
the surface appearance of
it, you're dealing with
the underlying reality.
D: You use the term,
darkly comedic. Sometimes
you're darkly comedic,
sometimes totally comedic,
and sometimes you are
totally dark. Do you con-
nect the darker side of
your work with experiences
you had growing up?
B: There is definitely
a connection. Comics were
a place for me to control
my life. A place to put a
lot of what I was feeling,
a place to write and draw

Neal
Adams'
work
really
was a
sur-
vival
mecha-
nism.
It
gave
me
some-
thing
to
aspire
to and
spoke
to me
through
some
other-
wise,
pretty
f**ked
up
early
years.

things that I wanted to have happen or creating characters that *I* could control.

D: Because you felt totally controlled?

B: The environment I grew up in was very unsafe. I think it's part of the reason kids get into superheros--the sense of power and effectiveness. It's also an element of feeling safe enough to let your guard down. Because of the situation that I grew up in...

D: Your father was an alcoholic.

B: Well if he wasn't a board-certified alcoholic, he was certainly a heavy duty amateur. When he was there it was usually an oppressive, authoritarian situation. My mother didn't drive, she was an incredible neurotic and very much like a child. So, in essence I had to be more of the grownup.

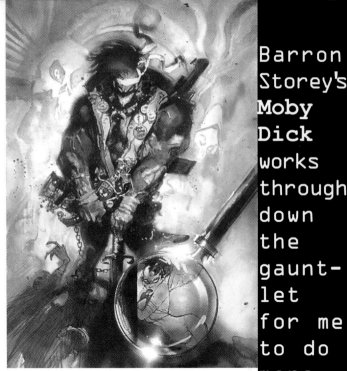

rron Storey's, Great White Whale

D: You felt you had to protect your mother?

B: Yeah, which is sort of classic. I think it's hardly an unusual situation for a lot of kids. Growing up and being five years old and having to get ready for school the next day and to run down stairs and to risk putting my five year old frame between a drunken six foot guy and this diminutive woman to protect her. You don't find that in the top ten list of things kids really want to be doing on a school night. Or any night, for that matter.

D: You needed normalcy.

B: Unfortunately that became my normalcy. It becomes the situation where things are incredibly provocative and unsafe, it's almost like there is a war scenario, where you're walking wounded, you are always waiting for the

Barron Storey's **Moby Dick** works through down the gauntlet for me to do more than just illustrate the movie or the book. He put such depth into his version -It challenged me to match it.

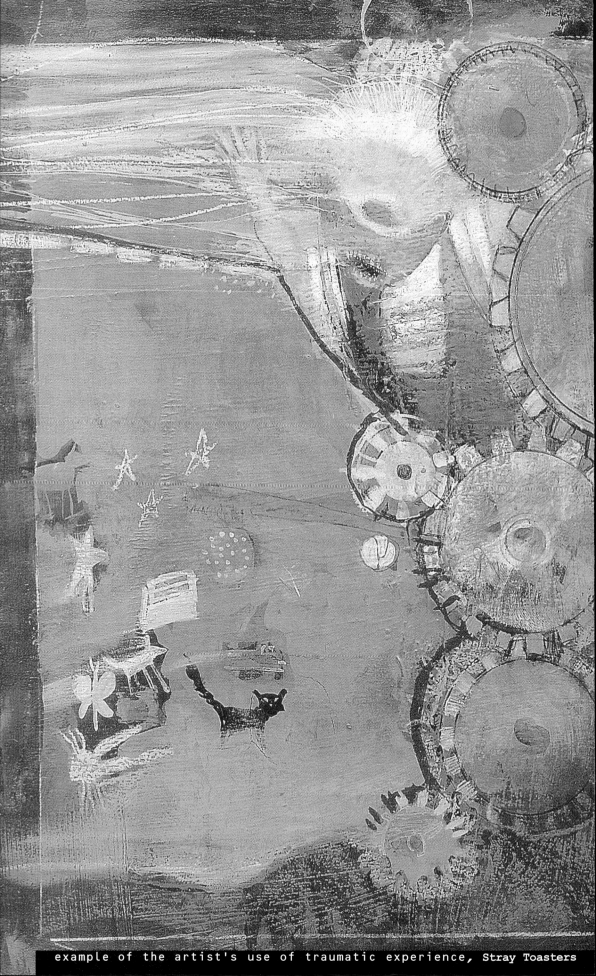

example of the artist's use of traumatic experience, Stray Toasters

other shoe to fall. You know where all the land-mines are, you know what to say or not to say to avoid them. Part of it is about being invisible. You fade into the woodwork. But that doesn't guarantee that some bomb isn't going to go-off someplace. So there was always enough of the ground shifting, of insanity and negotiating with that insanity to keep you on your toes in a very negative way.

D: Was Neal Adams a big part of the comics you read as a child.

B: Absolutely, he had to be the biggest comic-art influence on me, to the point people once criticized me for being an "Adams clone!" An inter-esting aside is that I didn't initially like his work. It was too radically alive and threatening. Not at all safe and familiar. I liked reading **Superman** by Swan, and **The Flash**. Carmine Infantino drew those pointing hands from the caption boxes. I loved that stuff. The crisp clean approach of DC's books really stayed with me.

 When Neal started doing the covers, that safety net was blown away. That's when I really started to get into Marvel comics. It's odd that with Kirby and Steranko doing their experimental work at Marvel, it didn't upset me at all. As a matter of fact, I expected far-out, grittier work from Marvel. DC was always the non-

gritty place, so for them to start getting edgy-by having Neal do the cov-ers—was more rocking to my world. We're talking about a young kid here, whose home life was pretty unsafe. So his need to have some place, anyplace remain constant and safe was pretty understandably excessive. even if that safe haven turned out to be, a comic book publish-er. As I matured, the sub-tleties of the characteri-zations in Neal's work started to be much more provocatively interesting to me. It wasn't all about just the surface anymore, there were nuances and subtleties I didn't see elsewhere. I can't recall the point when things started to turn around, but I went from despising his work to wanting to draw exactly like him. So many artists could do someone getting hit with a punch, but Neal drew the sense of coiled energy

with Kirby & Steranko doing their exper-imental work at Marvel -it didn't upset me. I expec-ted far-out grit-tier work from Marvel. DC was always my non-gritty, safe haven.

before the blow, and the flesh-swelling aftermath as well. Consequently, when people say to me, that they hated my work when they first saw it, but now love it, I understand what they mean, because that's how I came to appreciate Neal.

D: When you first started in comics, the Adams influence was obvious, but you'd already graduated from art school—

B: I never graduated from college. I just didn't go back. I had one more year to go and I started working professionally. After that, they wanted me to come and teach. I'd always intended to go back, but I don't think the school is there anymore.

D: You had been exposed to the work of various illustrators and fine artists at school. You wanted to integrate their influence into comics.

B: Well I wanted to integrate it into my art, maybe not specifically into the comics. At the time, I was getting into painters like Rauschenberg, Kurt Schwitters with found objects, Jackson Pollock, Richard Deibenkorn, Robert Motherwell... I also liked a lot of children's book illustrators - Pyle, Wyeth. I had a really wide, eclectic taste and it wasn't just about Neal Adams anymore. At that point, one of the articles that dismissed me as a clone, said that it looked like I had "learned to

draw from Neal Adams" period, that was it, end of review. Which wasn't the case. But his style to me, was comics, and i saw striving for his level as a good thing. I still do. So when I started doing comics, I went back to that, integrating Neal. As I was roundly dismissed as a clone, I felt it absolutely necessary to go into my own arena and all of the other things that I was interested in started to come out. I needed to define my own identity.

D: Your Jimi Hendrix bio-graphic novel, VOODOO CHILD, is a fantastic hard-cover edition that enjoyed wide distribution in comic shops, book stores and music stores. It also includes a CD of previously unreleased music. Did the project come through your rep?

B: Yes, Harvey Kahn, who was my rep. He repped me, Bob Peak, Bernie

...to risk putting my five year old frame between a drunken six foot guy and this diminu-tive woman to pro-tect her. It became like a war zone... you're the walk-ing wounded

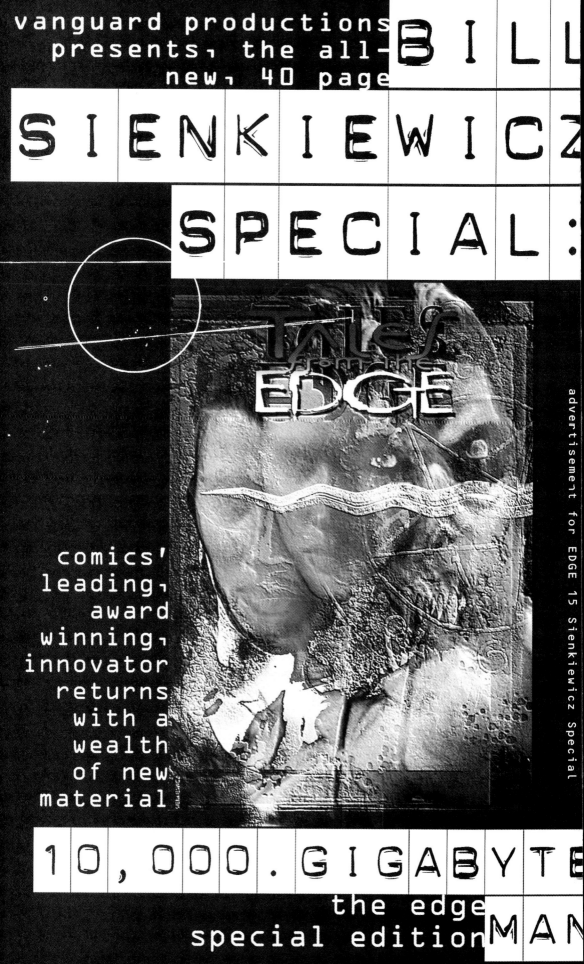

Fuchs and Nick Gaetano, at the same time. Marty Green wrote **VOODOO CHILD**.

D: Many parallels can be drawn between the experimental advances you've made visually with what Hendrix accomplished musically. This is one of the reasons you were the perfect artist to illustrate **VOODOO CHILD**.

B: I really wanted to push the artistic envelope on the Hendrix book. Marty Green and I both have strong opinions about what we wanted, and we both share a perfectionist's streak. I would have loved to have done *more* computer based tweaking. Hell, the subject is **JIMI-F**KING-HENDRIX** and it begged for experimentation. I wanted to go and do a full Frank Zappa Mother of Invention on it! ...More like **Moby Dick**... Of course, many people think Hendrix is one of the best things I've done. I'm overjoyed that people respond in that way. Like I said, I had to choose my areas to stand my ground aesthetically, or the book never would have come out.

D: **New Mutants** was a third or fourth string book you turned that into an important title.

B: I think it was important, for me certainly in terms of the style, and the readership. We got letters from people saying, "Stop him Jim, before he kills again." We got other letters from people saying, "this is great,

SHADOWS & LIGHT • Part 1

this is wild, really brilliant."

Love and War, was the Daredevil graphic novel I did with Frank Miller. Frank and I figured this was going to be our main project, but in the meantime we'd do this eight issue series, **Elektra Assassin** just to get a checks coming in regularly. It seems now that **Elektra** is remembered more than **Love and War**.

I started doing fully painted storytelling then. That's kind of where it really blew open for me. The success of those projects made even wilder pieces like **VOODOO CHILD**, **Stray Toasters** and others possible. I don't recall any fully painted graphic novels before **Love and War**.

D: You mentioned some of the fine artists you were influenced by, as far as illustrators, to look at your work, I would say the big three would be Ralph Steadman, Bob Peak,

Dave McKean is probably the most clinical artist I've met, very talented, while Simon Bisley is probably one of the most naturally gifted painters I've met. I admire them both.

and Barron Storey.

B: Peak was a virtuoso of mediums and styles, his versatility was awe-inspiring. More than anyone, that's who I feel the greatest link to. Rounding out a short list of influences and artists I admire are Frank Miller, Kyle Baker, Mort Drucker, Toppi, and Robert Baxter, a terrific illustrator/painter, teacher and friend.

D: What about Barron?

B: Barron, more than anyone, was influential in terms of following one's own course -in terms of personality- in really truly having a dialogue with the work and getting into a degree of finish and approach. He really lives his work, he really sweats over it. I always felt he was the least "commercial" commercial artist out there. It seemed that the assignments were almost incidental to a point of view he needed to express. I loved that because you got the actual illustrated subject-painted beautiful-ly- and you got Barron in the mix. He inserted himself into the assignments. He never takes pat solutions. He's really a fine artist, social critic, and editorial artist, trying to work in a field that is increasingly about none of that.

D: You seem to run a home for wayward toasters.

B: Definitely a bunch of strays, I've got 30 now.

D: How did this start?

B: I really love art deco. It's a great metaphor for people - it's something you take for granted in the kitchen and you plug it in, put the toast in it, turn it on and it does what it's supposed to do then you forget about it. There are people who view kids that way, "children should be seen and not heard." I sort of felt like humanizing dehumanizing elements via the toaster in my **Stray Toasters** graphic novel... there is some interest in turning it into a movie.

D: --**Big Numbers**?

B: There are days I think about finishing it.

D: How much is left?

B: Eight issues. It would be very daunting. When I was working on **Big Numbers**, I was shooting 45 different models, different people, and in the course of the series two of them died. They were both young. One drowned in a horrible freak accident and another died of colon cancer. They were not old but there were quite a few older people I was photographing, Stan Drake included. Also, the woman who posed for Christine, got married and moved away with her husband, who was in the military. That fucked things up. What could I say, "You're already married to **Big Numbers**, baby!" One of the younger kids posed for two issues, and between the second and third issues, reached puberty. Within the space of two months had bulked

up and grew six inches—
totally unusable as a kid.
 There were other
elements involved in the
stoppage of **Big Numbers**,
but suffice it to say,
the truth is far more mun-
dane than are the rumors.
I was also getting into
working with Harvey Kahn
and he was getting me
movie poster work, which
I'd always wanted to do. I
was burning the candle
through and through...It
was taking it's toll.
D: What movie posters
have you worked on?
B: I've worked on a
number for Europe, **Afraid
of the Dark**, **Highway to
Hell**. **Unforgiven**. **American
Pimp** and **The Green Mile**.
Other film work I've done
that's not poster related
has been on **The Mummy**, **The
Grinch Stole Xmas**, **Mission
to Mars**, others. I did a
signed print for the
Winter Olympics. The
Honeymooners Video cover,
a lot for **Penthouse**,
Variations, **Outdoor Life**,
Spin. **ESPN** magazine....
CD covers for RZA from the
Wu Tang Clan. He came up
with an idea for a solo
project about a superhero
rapper named **Bobby
Digital**. He'd seen my
stuff and wanted something
in a 70's sort-of-Shaft
essence. So I ran with it.
 Getting back to
Barron Storey, he's influ-
enced a whole gaggle of us
guys. McKean, Koeb, Kent
Williams, George Pratt...
D: Kent was showing
Barron's influence on
Blood, since then he's

really gotten into
Schiele.
B: Right. It's a wild
juxtaposition. What if
Schiele painted illustra-
tions for hardboiled detec-
tive fiction in **Playboy**?
It's like seeing Francis
Bacon's influence in the
ballet paintings of Bob
Heindel. Incongruous as
hell, but he makes it work.
D: Kent always had the
Jeff Jones influence too.
B: The same with Muth,
although J has a whole
different temperature to
his work. There's an ele-
gance and beauty to J's
work.
D: He has a Asian
influence. Very Zen. Now
he's doing the sumi-brush
black and white as well as
watercolor. I called him
when **Sandman** 74 came out
and told him it was one of
the all-time best, ever.
B: I felt the same way.
It really shows what this
medium is capable of.
D: With so much non-

Marty
felt so
freaked
out by
my
ideas
that
he
want-
ed
Will
Eisner
to go
over
every-
thing.
i laid
out.
It's
only
because
I was
curi-
ous as
to how
Will
saw
things,
that I
didn't
throt-
tle
Marty.

omics work available,
you've opted to ink other
artist's pencils. This
allows you to keep your
hand in the medium without
tying you up from the movie
posters.

: Some artists feel
that my inking others is a
waste of talent. I might
agree, if that's all I
did...it's not. Frank and
I are working on an idea
for a new series to do
together. We're just try-
ing to make time. We're
both excited to be working
together again. He's not
only talented, he's one of
the most genuinely warm
and aware people I
know...inking, pencilling,
there's also computer
stuff, writing... I enjoy
it all. I wish cloning
were possible, because
there aren't enough hours
in a day to do all the
things I love. I'm a lucky

ome of classic Marvel. The
fan in me is doing cart-
wheels, just like when I
inked Carmine Infantino.
Buscema and I did a number
of **Wolverines** together and
then **Silver Surfer**. The
other artist obviously,
was Neal Adams. I felt
like a young actor coming

Left:
por-
trait
of
Ethio-
pian
leader
Haile
Selasie

Below,
is one
of many
illus-
tra-
tions
for
Pent-
house

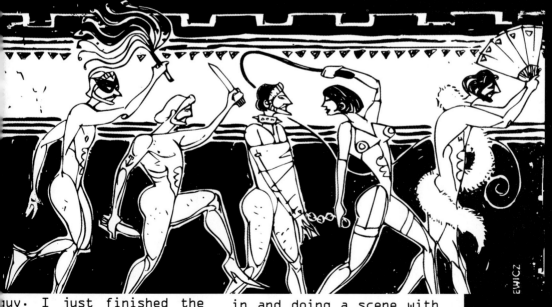

guy. I just finished the
Silver Surfer with J, had
a ball, but my two
favorites are: John Bus-
cema- The guy is the epit-

in and doing a scene with
Brando, -trying to hold my
own with the Godfather.
Talk about being
a contendah...

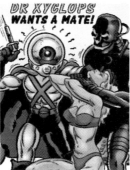

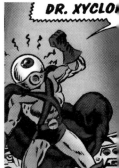